Sexing the Self

'This is an excellent book, persuasive and a pleasure to read. It performs an exciting turn away from some of the tiring oppositions that regulate debate in Cultural Studies, while modelling an unusually generous intellectual and political culture. This is a useful and *inspiring* work; I think that many students of these issues will find, as I have, their own projects both supported and critically extended by reading this book.'

Meaghan Morris, author of The Pirate's Fiancée: Feminism, Reading, Postmodernism

'Elspeth Probyn has made an important and highly original contribution to the problem of experience in feminism and cultural studies. She offers a way of relocating experience within cultural analysis without falling into the traps of so many contemporary strategies. This is one of those rare books which actually does advance theoretical and critical reflection. It should have a profound impact on some of the central debates in cultural theory and politics.'

Lawrence Grossberg, University of Illinois at Urbana-Champaign

How can the self be represented in Cultural Studies? Faced with the seemingly enormous difficulty of representing 'others', many theorists working in Cultural Studies have been turning to themselves as a way of speaking about the personal. In *Sexing the Self*, Elspeth Probyn retraces this evacuation of 'experience' as a critical term in Cultural Studies, and argues for a move beyond a crisis mode of representation, where no-one can speak for another. Probyn tackles the question of the sex of the self, an issue of vital importance to feminists, yet one which has been neglected by feminist theory, and suggests that there are ways of using our gendered selves in order to speak and theorize non-essential but embodied selves.

Arguing for 'feminisms with attitude', *Sexing the Self* moves across a wide range of theoretical strands, drawing upon a body of literature from early Cultural Studies to Anglo-American feminist literary criticism, from the emergence of 'the feminine' as a privileged term in cultural theory to the rampant self-reflexivity of post-modern ethnography, from 'identity debates' to Foucault's 'care of the self'.

Elspeth Probyn teaches sociology of culture at the Université de Montréal, where she is an Assistant Professor. She has published articles in a wide variety of journals and anthologies, including *Cultural Studies, Feminism/Postmodernism, Hypatia* and *Screen*. She is the General Editor of a series of books on culture and gender to be published by Routledge, and is presently working on a book on sexual 'choiceosie', and co-editing another on feminism and the body.

Sexing the Self

Gendered Positions in Cultural Studies

Elspeth Probyn

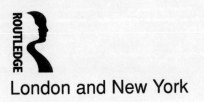

London and New York

First published 1993
by Routledge
11 New Fetter Lane, London EC4P 4EE

Simultaneously published in the USA and Canada
by Routledge
a division of Routledge, Chapman and Hall, Inc.
29 West 35th Street, New York, NY 10001

Typeset in 10/12pt Palatino by
Ponting–Green Publishing Services, Sunninghill, Berks

Printed in Great Britain by
T.J. Press (Padstow) Ltd, Padstow, Cornwall

British Library Cataloguing in Publication Data
Probyn, Elspeth
 Sexing the self: Gendered Positions in Cultural Studies.
 I. Title
 305.3

Library of Congress Cataloging in Publication Data
Probyn, Elspeth
 Sexing the self: gendered positions in cultural studies /
 Elspeth Probyn.
 p. cm.
 Includes bibliographical references and index.
 1. Women–Psychology. 2. Feminist theory. 3. Self.
 I. Title.
 HQ1206.P745 1993
 155.3'33–dc20 92–22143

ISBN 0–415–07355–3
ISBN 0–415–07356–1 pbk

For Calista

Contents

Acknowledgements

When I was writing this book I fantasized about this moment. As the signal of the end of a long project, the time of acknowledgments seemed like an impossible dream. However, now that I am here, I find myself stymied in my wish to remember with grace and gratitude all those who have helped me along the long and meandering route of this project, one marked by various personal achievements and losses. One of the former was that the research here was presented in a different form in my doctoral thesis where I examined what I then perceived as an interesting if under-theorized emerging trend of inserting oneself casually into theoretical arguments. I also managed to produce a thesis nearly totally exempt of my own presence.

In this version of that project some may find me both present and evasive, too much of either the one or the other. Neither can now be corrected so I will content myself with briefly acknowledging here some of the people whose presence has massively marked this work. I want to start by naming enormous absences who continue to move me emotionally and hence in my thinking, two women who both unfairly and accidentally died at different moments of their prime: my mother, Calista Probyn and a dear friend, Cicely Yalden. For helping me at the thesis stage I thank Maurice Charland and Gail Valaskakis, and Jane, John and Stephen Probyn for their encouragement.

I do not think that I am alone in experiencing a visceral dislike for that inert thing, the thesis. It is thus to those who helped me to remake the thesis into this present product that I owe the greatest amount of gratitude. First and foremost my deep thanks go to Marty Allor and Larry Grossberg who have inspired me and counselled me at every stage. I'm not sure how I would have gotten through this process without Marty's extraordinary capacity to put the 'care of the self' to work within theory, practice and everyday life. Larry's steadfast help and imagination were also essential to my writing. I also want to acknowledge the generous comments of Angela McRobbie and Meaghan Morris who read a previous version. To my colleagues and friends at Concordia University and then at

l'Université de Montréal, I give my thanks. In particular I want to mention Marilyn Burgess, Nina Leavitt, Chantal Nadeau, Beth Seaton and Martha Townsend. Thanks as well go to Rebecca Barden at Routledge. Funding from various sources has helped me along the way: the Social Sciences and Humanities Council of Canada Doctoral Fellowship, The Université de Montréal (CAFIR) and the Quebec Fonds pour la Formation de Chercheurs et l'Aide à la Recherche aux Nouveaux Chercheurs.

EP

Introduction: speaking the self and other feminist subjects

When I mentioned that I wanted to call this book, *Sexing the Self*, some erudite friends queried that it might sound like 'sexing chickens', a process that I'd never heard of and one that struck me as slightly disgusting. Growing up amongst the hill farms of mid-Wales, I had the opportunity of gathering eggs, grading them in an egg factory, cleaning out hen houses; in short, I've had the pleasure of all sorts of dealings with chickens but I didn't have the foggiest idea of how they were sexed. However, another knowledgeable acquaintance came to my rescue when she told me that the problem of chicken sex is an intriguing little philosophical puzzle. Apparently, the sex of chickens is not an obvious matter and hence requires specialist opinions which in turn are merely that, rough guesses as to the chicken's biological being.

While the sex of chickens is not a particularly feminist subject, the sexing of our selves as women in discourse is of immediate concern to feminists. Without belabouring far-fetched connections (although I do like the image of learned types bent over unsuspecting fowl), the project of this book is to examine how we can use our sexed selves in order to engender alternative feminist positions in discourse. The question of the sex of the self is of vital importance to feminists and I would argue that it has been left under-theorized within feminist theory. The self that I propose here is a doubled entity: it is involved in the ways in which we go about our everyday lives, and it puts into motion a mode of theory that problematizes the material conditions of those practices. Unlike the chickens which are presumably sexed one way or the other, once and for all, a gendered self is constantly reproduced within the changing mutations of difference. While its sex is known, the ways in which it is constantly re-gendered are never fixed or stable. One way of imaging this self is to think of it as a combination of acetate transparencies: layers and layers of lines and directions that are figured together and in depth, only then to be rearranged again.

As such, I see the self as material evidence of our fluctuating being as women; as a concept, this self designates a *combinatoire*, a discursive arrangement that holds together in tension the different lines of race and

sexuality that form and re-form our senses of self. When we speak our selves within theoretical contexts, these lines are rearticulated in various ways. The coherency of the self is opened up and its movement into theory creates the possibility of other positions. These moving lines can then be made to arrive at and hence construct alternative feminist enunciative positions in cultural studies. On the one hand, I cannot think of the self outside of the immediacy of being gendered; on the other, the movement involved in the recognition of gender must be refracted and put to work in figuring modes of speaking. This self therefore represents the process of being gendered and the project of putting that process into discourse. This is to say that the self is an ensemble of techniques and practices enacted on an everyday basis and that it entails the necessary problematization of these practices. The self is not simply put forward, but rather it is reworked in its enunciation.

As an object, the self has been variously claimed and normally left in a neutered 'natural' state, the sex of which is a barely concealed masculine one. And until very recently, when selves got spoken they were also taken as a-gendered although of course they were distinctly male. In the early tradition of cultural studies, the self was but one manifestation of an organic intellectualism, a voice which spoke of the authenticity of its own links to a class position. For instance, the self that can be clearly heard in Richard Hoggart's work spoke of various truths: societal, sociological and personal.

Without denying the force of these early cultural studies selves, as a feminist in the 1990s caught in the shifting of social and personal identities, their assurance is impossible to imitate. Without intimating that things were easier then, it is undeniable that the stakes involved in speaking our selves are considerable. As a sort of shorthand, I will sum up the stakes in the form of a question: 'Who speaks for whom, why, how and when?'

Taking Lawrence Grossberg's definition of the project of cultural studies, we can hear a more formal articulation of this question:

> Cultural Studies is concerned with describing and intervening in the ways discourses are produced within, inserted into and operate in the relations between people's everyday lives and the structures of the social formation so as to reproduce, resist and transform the existing structures of power.

> (1988a: 22)

Here the cultural studies theorist speaks in order to describe and intervene in the discourses that structure the relations between everyday life and the social formation. He or she does so in the name of a previously constituted group or class and his or her actions are aimed at transforming the structures of power that constrain at any given time. What remains

unspoken in this particular arrangement is a tangible sense of who is speaking and where they actually are speaking from. In another formulation of the project of cultural studies, Dick Hebdige focuses more on what is going on or, as Michel Foucault (1984c) put it, 'what are we?':

> We shall have to recognize that the fragmentation and dispersals that we're living through today require a new kind of integration and synthesis. We shall have to go beyond our bodies, beyond the pursuit of pleasure for its own sake and learn to cultivate instead a responsible yearning: a yearning out towards something more and something better than this and this place now.
>
> (Hebdige 1985: 38)

Here, as in much of Grossberg's own work, the theorist is part and parcel of what he describes and his stance within that situation is evident: his words are directed towards the figuration of 'something better'.

Without calling this a selfish action, it is nonetheless a self-motivated one if one understands that the self here is constructed within the social formation that it seeks to transform. In part, my attraction to both cultural studies and feminism as theoretical and interventionist projects is due to the ways in which they offer the necessary elements needed to think the immediacy of theory. Simply put, they allow me to conceive of thinking the social through my self. As such, they give me the theoretical tools with which to think through the pleasures and pains of my being in the social. However, the self cannot stop there. To appropriate a phrase of Barthes and turn it to my own concerns, the self *'is experienced only in an activity of production . . . it cannot stop . . . its constitutive movement is that of cutting across'* (1977: 157).

My project here is to rethink what the self might be in and for feminism. I want to reconstitute its force and reveal the material forces behind its motion. In previous articles I have implicitly worked through my own particular self in relation to distinct concerns: anorexia (1987); the gendering of the local (1990; 1993b); the death of my mother (1991a); and to body in general (1991b; 1992). Yet something central always seemed to evade me. It somehow seemed unseemly to speak of what drew me to these subjects: as I described these matters, I made them into objects separated from myself. In part, my reluctance to speak of my own motivation can be explained by the deep antipathy I have to the concept of the individual; in part, it may just be a personal quirk.

However, my idiosyncrasies aside, I must state that fundamentally I am drawn to these subjects both near and dear because I am convinced that gender must be represented as processes that proceed through experience. I am convinced that there are ways to talk about individuation without going through the individual and that I can talk about my experiences of being in the social without subsuming hers. Here I want to explore and

theorize those processes in which I am and you are implicated. While I am aware that to evoke the self is to conjure up a rather insalubrious ensemble of connotations, its weighty epistemological baggage, I want to set out ways of embodying a care of the self in speech and in writing. This care of the self is of necessity more than a personal endeavour; it must be constructed somewhere between my self and hers; it must be able to reach beyond 'me', beyond who or what 'I' am.

Of course, I am far from alone in recognizing that somehow we have to construct ways of thinking that are marked by 'me' but that do not efface actively or through omission the ways in which 'she' may see differently. At the same time, neither she nor me can be disallowed to speak our experiences. But we cannot pretend that this is an easy thing to do, that there is an unmediated innocence to the self. The possibility of the self rests within a filigree of institutional, material, discursive lines that either erase or can be used to enable spaces in which 'we' can be differently spoken. While we may immediately recognize our selves, the recognition of being gendered needs to be theorized in order to realize in wider ways the full strength of its force and possibility.

As one way of placing the self, I argue that it should be seen as a mode of holding together the epistemological and the ontological. I want to emphasize the importance of ontological moments of recognition – moments when I realize my gendered being. Consequently, I argue that the ontological must be met with an epistemological analysis. In putting these ontological moments of being to work within the elaboration of an epistemological analysis, I want to extend the reach of these momentary flashes of gendered selves. I want to stretch my experience beyond the merely personal, not as a way of transcendence but as a way of reaching her experiences, the experiences and selves of women. In other words, I want to put forward a mode of theorizing that encourages lines of analysis that move from her experiences to mine, and mine to hers.

This project is made possible by the theoretical legacy within which I work as a feminist theorist. And part of this legacy entails examining certain currents and theories for their positivity. I take this Foucauldian term very seriously – quite literally, I think and live and breathe within what these theories allow me to reach towards or perversely stop me from reaching. In setting out towards the self as I want to construct it, I will begin with a few propositions, a mode of theoretical advancement that I understand 'more in a grammatical than in a logical sense . . . not argumentations but enunciations, "touches"' (Barthes 1977: 156).

My initial proposition is that as theorists we don't know what to do with our selves. Caught up in the fragmentation that Hebdige describes, and as feminists are all too well aware, certain selves are historically discounted due to their gender, race and sexuality. In part, we don't know what to do with our selves because current cultural and feminist theories either reify

the experiential for its own sake, or reject its potential out of hand. It seems therefore that we find ourselves at a conjuncture where theoretically there is little to rest our enunciations upon. In part, this is what the 'crisis of representation' attests to. However, underlying this crisis there is for me a deeper evacuation of what 'experience' can be made to mean and how it may be put to work. After all, it is rather difficult to speak one's self in a theoretical context that tends to exclude the positivity of experience. Given this situation, many theorists seem to shoot from the heart and hope that the enunciation doesn't hurt too many people.

This is hardly a satisfying position for either the speaker or for others who might want to speak out. In moving backwards and sideways amongst various cultural theories I seek to retrieve some of the ways in which experience has been made to function. The obvious place to start is with the work of Raymond Williams. Here the experiential and his implication within it is the force that gets his, and then my, analysis moving. Williams' concept of the structure of feeling expresses the richness of what it means to work from within the felt facticity of material being. The tangible 'beingness' that animates his project allows me to propose that an ontological register is crucial to the whole critical enterprise. Without this recognition, this insistence on the immediacy of *what is* and *what must be*, there is for me little reason for cultural studies' existence; there is even less reason for my existence as a theorist. However, this ontological level cannot be allowed to stand still, or to be reified in the name of self-reflexivity. If I critique some of the practitioners of the 'new ethnography', it is because of the ways in which the force of the onto- logical is impoverished, paradoxically enough, through an insistence on the researcher's self. In a different but also restricting move, the erection by certain male theorists of the 'feminine' serves to stifle the possibilities of using the ontological, of putting our gendered selves to work.

If Williams inspires me to follow him in his 'ratifying sense of direction', the work of Michel Foucault on the care of the self sustains me in the further elaboration of the doubledness of the self. Appropriating Foucault and taking from Gilles Deleuze's riffs on him, the image of the *pli* (the fold, the bending upon itself), motivates my sense of how the self can be made to work. Recalling how for Foucault the processes of subjectification are the ways in which the exterior line of force is bent and folded upon itself so that the inside and the outside are rearticulated, I can then argue for the self as designating the ways in which the experiential is bent upon itself. Inspired by Michèle Le Doeuff, I propose that images of the self – selves in discourse – can be used to articulate alternative positions. This is to consider uses of the self not as reflections of 'me', but rather, as Stuart Hall states, 'as that of representation which is able to constitute us as new kinds of subjects, and thereby enable us to discover places from which to speak' (1990: 237).

Finally, I am brought back to the importance of imagination. Central to tracing the possibilities of the self is that pull of imagination which throws me into imaging other articulations of how we might be caught up in each other. The overriding preoccupation that haunts me throughout this book is how to rework the questions of 'who am I?' and 'who is she?' in ways that neither privilege 'me' nor discount how 'I' and 'she' are positioned in relation to each other. In order to realize the self as a 'limit-attitude' where we work at the very edges and ends of our selves in order to envision change, we must engage our imaginations more fully. Without blurring the material conditions of our differences, we can nonetheless stretch our selves to the point where we break into other realms of possibility. In other words, the question of 'who is she and who am I?' necessitates a fundamental reworking of the theoretical and social terrain in which we are positioned. This also entails a radical rethinking of how we use and position our selves. It is only at the extreme limits of who we think we are that we can articulate, respect and use our differences.

Although this project came to mind at the time of rather vicious debates about the impossibility of representation, its form here is not offered as a panacea to the very material woes of contemporary intellectual activity. It is, however, and in all modesty, a call to practise another mode of enunciation within cultural studies. It is a brief sketch of the possibility of another arrangement of selves, of a 'geography of the possible' that can be brought into being. It is a proposition for a renewed critical stance, one grounded in the care of the self, a self that finds its full expression in the care of others, in our communities as they are imagined and imaged into materiality. This is a project moved by the wish to extend the reach of questions about my identity so that they touch and embrace those about hers. Moved by the process of how my self and her self are differently sexed, we find in the work of our selves a new perspective and the opening up of other positions.

Chapter 1

A problematic
Speaking the self

WHAT TO DO WITH ONESELF?

One of the central problematics that has emerged from postmodernist debates is that of representation. From one side of the argument, Jean Baudrillard's denial of the possibility of representation deeply challenges many of cultural studies' assumptions, theoretical and commonsensical, about the stakes involved in speaking; of who speaks for whom, and why. As Baudrillard bluntly puts it, the death of a social to represent is, or should be, the death of sociological theory: 'The hypothesis of the death of the social is also that of theory' (1982: 9–10). Alongside these deaths, the question of who is speaking within theoretical accounts of the social is increasingly rendered transparent. Recalling Marx's distinction between representation as *Vertretung* (the political project of standing in for another group) and *Darstellung* (depicting the social), Gayatri Spivak argues that the critic as 'proxy' should be dislodged. The critic's position as a privileged speaker for class interests is undermined by the absence, or the indifference, of any constituency: 'the choice of and the need for "heroes", paternal proxies, agents of power – Vertretung' (Spivak 1988: 279). In turn, the problematic nature of being a proxy deeply troubles practices of interpretation, or at least those which seek to interpret the social for someone, or some group.

Now, it would be comforting to be able to state that this injunction against proxies only applies to male theorists, to middle-aged lefty heroes. Unfortunately, this is not the case and at the expense of alienating myself immediately, it's been a while since anyone seriously considered some cultural theorists as the proxy for whomsoever. However, the project of representing women has been a condition of possibility for feminism and continues to provide the underlying epistemological basis for the articulation of feminisms. Quite simply, it continues to be the ground upon and from which many feminists and feminisms speak. Yet this ground, or rather, the representation of women as horizon, is not only undermined by theoretical decrees, it is increasingly attacked by the 'public' – men and women alike.

The ambivalence towards feminism could be clearly seen in the aftermath of the 1989 massacre of fourteen women engineering students at the Université de Montréal; in fact, feminists were doubly hit. On 6 December 1989, a lone man in hunting gear entered classrooms at the Engineering Faculty (L'Ecole Polytéchnique), separated the women from the men and then shot them. Marc Lépine, the killer, clearly stated both at the moment of the shooting and in a letter that he wanted to kill feminists, that feminists had ruined his life. Later it was reported that these poor young women had protested that they weren't feminists, and much was made of the fact that they were bright, articulate women who wanted good jobs as engineers – that they didn't hate men. Amid all the public agony over why or how this tragedy had happened, some of the media turned to what became known as 'la récuperation', as they criticized feminists for 'recuperating' this event for their cause. Without forgetting either the actual pain of the massacre or the fact that most women are murdered or beaten or raped in their own homes and at the hands of husbands or acquaintances, we can move from this overall situation, or as it is called in Quebec, 'L'événement', and raise the very real problematics of feminist representation. Included in this event was the stated motive for the killing (that the women were feminists) and two denials of feminism (both in the reported words of the murdered women and then in the media's recriminations against those feminists who spoke their interpretations of the slaughter).

Feminist representations of the event fought against certain popular arguments which portrayed Lépine's actions as the isolated incident of a madman. Perhaps more importantly, many feminists took their own anguish as a discursive point of departure. (I should clarify here my use of the third person when I speak of feminist reactions. Although I teach at the university I was in London both during and after the event. Thus, I was informed from afar by the bloody bodies on the first page of the British tabloids, caught in the nightmare of trying to find what exactly had happened from the location of a geopolitical point not much moved by colonial happenings, however sensational they may be.) Back home, two of my colleagues, Danielle Juteau and Nicole Laurin, powerfully argued that in a racist and sexist society crimes against women and minorities make sense. As Québécoises watched the media search for motives, as the nomenclatures of 'un fou', 'un détraqué', 'un malade' piled up, a fairly common feminist response was: 'it's absurd, they are looking for a motive, but haven't they understood anything?' (Juteau and Laurin 1989: 206). The awful recognition of where we are as women, the terrible feeling as the very space of the university, of the streets, was rearranged in fear, brought forward another tone. There was no way of avoiding a sexed interpretation of the situation. As Juteau and Laurin wrote: 'This action was aimed at each one of us and at us all. . . . Fear, anger, fear, pain, fear, sorrow invade us . . . tearing us apart, piercing our hearts' (ibid.).

While there have since been many responses to the event at the Polytéchnique, ranging from feminist collections of articles (Malette and Chaloux, 1990) to pamphlets blaming feminists, the immediate feminist representation of the massacre turned on the *Vertretung*, the spontaneous move to speak of and to a collectivity of women; grounded in their own fear and anger, feminist academics and journalists spoke out and represented the anguish of all Québécois women. And at the same time, this movement of anger and sadness was portrayed as parasitic in some press accounts; represented publicly and perhaps privately as a speaking position located upon the dead bodies of fourteen young women.

In many ways this is but a very brutal exemplar of the larger debates within cultural studies over identity and difference and who gets to speak, from where, and for whom. The tone of these debates is also bloody, if less immediately tragic. A recent British example of this is the collection of essays edited by Jonathan Rutherford, *Identity, Community, Culture, Difference* (1990). While this book brings together many important interventions, the tenor is one of agonistics, if not downright antagonism. Among the many targets, the Left and white feminism are the most severely trounced for having erected a hierarchy of difference. Pratibha Parmar argues that white feminism's articulation of the politics of identity has 'given rise to a self-righteous assertion that if one inhabits a certain identity this gives one the legitimate and moral right to guilt-trip others into particular ways of behaving' (Parmar 1990: 107). According to Andrea Stuart, by the early 1980s, 'Being a feminist had come to say more about what you didn't do – eat meat, fuck men, wear make-up – than what you did do' (Stuart 1990: 32). Many of these writers are from a generation influenced by the writing and the political stance of Stuart Hall, and so it was not surprising that Hall's article was included at the end of the collection. There he argues for a theorization of identity that would be:

> constituted, not outside but within representation . . . not as a second-hand mirror held up to reflect what already exists, but as that form of representation which is able to constitute us as new kinds of subjects, and thereby enable us to discover places from which to speak.
>
> (Hall 1990: 236–7)

While most of the authors cite, refer and defer to Hall, it is strange to note the ways in which 'Identity' emerges as an articulation of a rather static and rhetorical use of difference; difference as a second-hand image of various theoretical battles among feminists and within the Left. It's as if in the late twentieth century, with the fragmentation of populist causes and political programmes as well as the commercial success of popular enterprises like 'The Environment', the project of *Vertretung* has given way to a rather vicious game of issues and individuals elbowing each other out of the way, each crying 'listen to *me*', 'hear *my* difference'.

At this point in the game, at this sociocultural and theoretical conjuncture, it might be beneficial to remember Jane Gallop's articulation of 'the necessarily double and . . . urgent questions of feminism: not merely who am I? But who is the other woman?' (1988: 177). Now, of course, the first part of this equation, the question of who am I?, has already generated a small industry as, increasingly, theorists turn to their own difference, to the 'I', occasionally trying to explicate the world metonymically from their own situation, at times merely embroiled in the exigencies of their own locales. From Valerie Walkerdine's analysis of herself as Tinkerbell (1986) to John Fiske's semiotics of his living room (1990), the 'me' generation lives on. As Laura Marcus puts it: '"Enough about you, let's talk about me"' (1987).

THE PROBLEMATIC OF THE SELF

In a charitable vein, one could ask, when faced with public indifference (be it manifested in the severe cutbacks in the educational systems or to the funding agencies for academic and artistic work, or just the widespread feeling that nobody really cares), where are intellectuals to turn to if not to themselves? It is, of course, easy to scoff at the idea of middle-aged tenured university professors, dressed in black leather jackets, cut loose from an ideal of the 'public' or 'organic' intellectual, desperately going through their personal crises of lost authority. However, individual crises sometimes meet up with a more general situation. In a sense, Dick Hebdige's theoretical statement can be understood as describing a fairly common sentiment: the '"we" is the imaginary community which remains unspeakable with the Post . . . there is no space to struggle over, to struggle from (or . . . to struggle towards)' (1986: 86–95). For instance, I was just recently agonizing over whether to go on a demonstration celebrating Gay Pride in Montréal and denouncing the police brutality towards the gay and lesbian community. Here was a space that desperately needs struggling over; however, while I know that marching is a very necessary form of struggle, it is not my favourite form of contestation; the 'solidarity' of large crowds makes me feel slightly uncomfortable, if not claustrophobic. Eventually I did go because a visible presence of gays, lesbians and bisexuals peacefully walking along through the downtown centre is an effective way of combating homophobia and heterosexism. However, as we proceeded along our route, it became obvious that many of these marchers were of another generation – the ten years separating me from those proudly 'out' dykes in their early twenties meant that the 'we' somehow died in my throat along with the chant, 'We're here, we're queer, we're fabuuulous'.

While the creation of a 'we' is a pragmatic political question, it is also and always a theoretical one. As Hebdige reminds us, and against the

gloomy scenario of nothing to say and nowhere to go, 'the "we" in Gramsci has to be *made* and re-made, actively articulated in the double sense that Stuart Hall refers to ... both "spoken" and "linked with", "combined". (It has to be at once "positioned" *and* "brought into being")' (1986: 95). However, in order to articulate a 'we', there must be certain conditions already in place.

We need to theorize a feminist enunciative position which could articulate a discursive space to speak from and something to say. This entails an examination of how we could put ourselves to work in theoretical contexts, in such a way as to produce both discursive and extra-discursive effects. As I have already suggested, there is something of an autobiographical turn currently taking place in cultural theory. If my tone in describing this moment is less than effusive, it is because I consider the possibilities of speaking selves to be great, and the liabilities of an untheorized return to the 'I' to be even greater. While I do not want to police uses of the personal within theory, I do think that the political and theoretical stakes at hand merit that the problematic of the self be carefully considered.

To continue on a rather negative note, I will offer some anecdotal evidence of the difficulty of speaking in the first person singular. Meaghan Morris has argued that, rather than being an expression of the personal in Jakobson's sense of the emotive and connotative functions, anecdotes can be made to serve referential functions:

> They are oriented futuristically towards the construction of a precise, local, and *social* discursive context, of which the anecdote then functions as a *mise en abyme*. That is to say, anecdotes for me are not expressions of personal experience, but allegorical expositions of a model of the way the world can be said to be working. So anecdotes need not be true stories, but they must be functional in a given exchange.
>
> (1988a: 7)

To return to my story, several years ago I mentioned in a conference presentation that I had been anorexic as a young girl. This was my first attempt to create a discursive *abyme* and thus throw into relief some of the theories that I had been grappling with by placing them within my own social landscape. The paper was in fact on anorexia nervosa and was taken from my master's thesis, which was a feminist discursive and historical analysis of anorexia. In a way, I had stumbled across the idea of doing my thesis on anorexia. The idea had been to do a discursive analysis of the Parti Québécois' White Paper on cultural policies – a subject more evidently worthy of a master's thesis in media studies. However, as I read more and more poststructuralist theories, I found that I was using my remembrances of being anorexic as a sort of touchstone; an unthought-out problematization of some of the stricter Althusserianism in vogue at the

time. In the conference paper I used Angela McRobbie's lovely analysis of the British girls' magazine *Jackie* as a springboard into my own argument:

> However, at the same time a small voice in me questioned what seemed to be the over-privileging of this particular text and the over-determination of the reader's experience. I mean, I read *Jackie* and I didn't go around yearning for boys and clothes and despising my female friends. In fact, buying *Jackie* was part of a small site of defiance and in a way solidified the group I hung around with. At that time in pre-Thatcher Britain, all state schools provided subsidized hot mid-day meals which were, as one might imagine, rather foul. In any case it became the thing to do to keep the 10 shillings for the week's meals and sneak up to town to buy chips, smoke a cigarette and read *Jackie*. This lasted for a while but gradually the group disintegrated – one of the group was pregnant, another spent all her time studying for the O Level Exams, one switched to a tougher (and more interestingly deviant) crowd, and I became anorexic.
>
> (Probyn 1987: 112)

While neither the content nor the style of my paper was exactly ground-breaking, a 'postmodernist' member of the audience subsequently stated that this personal mode of enunciation made him 'nervous'. Now it is obviously difficult to say whether it was my particular discursive striptease or, more generally, a dis-ease with feminist speaking practices that most displeased this particular individual. However, following the publication of the paper I was also roundly rebuked in print by a feminist reviewer. Apart from what she called 'my weighty words' of confession (when I stated that I was anorexic), she condemned my article and argument for lacking 'sweat and blood' (Szekely 1988). As if making postmodernists nervous and angering feminists by supposedly betraying the material weight of the female body were not enough, a mainstream sociologist recently summed up this same piece as a 'confession of anorexia', another example that in 'postmodern America, the natives are now writing their own ethnography' (Frank 1990: 148, 146).

What I want to take from this anecdote is the way in which these three different reactions, from three different theoretical agendas, all assumed that I was telling, or wanting to tell, the truth, in this case about the essence of my being. I found these reactions rather bewildering. First of all, and in a very general manner, anorexics (and perhaps even some ex-anorexics) are notoriously duplicitous; after all, anorexia involves living a myriad of lies (from pretending that you have eaten to reading others' horror at your body as admiration or even envy). Second, my particular argument concerned the ways in which women have historically and conjuncturally used anorexia as a way of negotiating the dominant discourses of their times (whether religious, economic, medical, or other). It was, therefore,

an argument against the idea that anorexia is a modern epidemic reducible to a causal paradigm of the direct effects of media discourses on women – i.e., that anorexic women represent the sad truth of our times. Third, and perhaps most important and obvious, the experience I presented in speech was, of necessity, a representation forged for the sake of my argument (my mother's reading of the article was that I had had a happy childhood; my sister's was a little more to the point as she pointed out the academic licence involved in the descriptions).

Without overly privileging or overestimating the virtues of my paper, since the rest of the article plodded off into the usual disembodied type of argument and thus conformed to a general pattern within feminist criticism of merely using the personal at the outset of an argument (Kennard 1981), I will use it and the reactions it raised to explore the 'problematic' of the self. In the Althusserian sense of 'une problématique', a problematic only exists in both the presence and absence of problems and concepts. If concepts cannot be found in isolation, the problematic is then a conjunctural question; it is never a universal or immutable configuration:

> it is only in the specific unity of the complex structure of the whole that we can think the concept of these so-called backwardnesses, forwardnesses, survivals and unevennesses of development which *co-exist* in the structure of the real historical present: the present of the *conjuncture*.
> (Althusser 1970: 106)

So the problematic must always be thought in its conjuncture, as necessarily structured by its conditions of possibility. It is in this sense that current uses of the self in cultural theory have neglected to consider what conditions of possibility support, displace or disarm any use of the personal within theoretical arguments. In the turn to the autobiographical as a panacea for the ills of criticism, speaking from the heart has replaced a much needed theoretical consideration of the epistemological and political stakes involved. To be quite simple about it, any contemporary use of the self within cultural theory stands among, and must contend with, the backwardnesses, forwardnesses, survivals and unevennesses of our theoretical historical present – with the theories and practices that have either written it off or celebrated it. The self has to be positioned in relation to the absence and presence of the concepts of truth, confession, experience, immanence, private and public, individual and universal, and of course, masculine and feminine as well as sex, sexuality and gender, women and men. As Marcus quite rightly asks:

> How can autobiography's emphasis on the individual, the development of the self and the confluence between author and textual 'I', be reconciled with political and theoretical perspectives skeptical of traditional concepts of subjectivity, individualism and textual authority?
> (1987: 77)

My concern is not with the genre of autobiography but with the particular conjunctural practice of incorporating the autobiographical within cultural theory, and I am similarly concerned with the theoretical terrain organized around concepts of subjectivity and textuality. Indeed, I will argue both here and in following chapters that the legacy of poststructuralist textual criticism is an evacuation of any ground upon which one could speak the self. In the rest of this chapter I am particularly concerned with the conceptualizations of experience that could serve as a horizon in speaking the self, and with their erasure within cultural studies' recent past. If we are to begin to take the problematic of the self seriously, we need to look for, or remember, an epistemological basis that could support theoretical uses of the experiential.

THE EXPERIENCE OF RAYMOND WILLIAMS

As Lawrence Grossberg argues, 'the specific shape of cultural studies can be seen in the extremely personal form . . . the problem of cultural was defined in terms of the problematic of participation' (1988a: 14). In particular, the experiences of Richard Hoggart and Raymond Williams as 'scholarship boys' marked early cultural studies, just as the experience of Stuart Hall as a 'marginal self' now influences contemporary cultural studies. Grossberg describes the situation of Hoggart and Williams as follows: 'caught between two worlds, two incommensurable languages, systems of relations and values, they struggled to make sense of their experience of belonging to neither fully' (ibid.).

However, the incorporation into theory of this experience of being within two incongruent worlds, was undermined by the arrival of structuralism. Hall succinctly describes the problems generated by the famous culturalist/structuralist split, as the division between a humanist Marxism and an Althusserian-inspired structuralist Marxism came to be known:

> whereas in 'culturalism', experience was the ground – the terrain of 'the lived' – where consciousness and conditions intersected, structuralism insisted that 'experience' could not, by definition, be the ground of anything, since one could only 'live' and experience one's conditions *in and through* the categories, classifications and frameworks of the culture.
> (1980: 66)

The enormous influence of structuralism and post-structuralism in cultural studies can be measured, in part, by the eclipse of the category of experience. Its sway, in turn, produced, and continues to produce, a rather uncomfortable position for the cultural critic. Even if the critic is vigilant to the fact that her experience is an ideological production,[1] the Althusserian trap still awaits: 'the men who would use an ideology purely as a means of

action, as a tool, find that they have been caught by it, implicated by it, just when they are using it and believe themselves to be absolute masters of it.' (Althusser cited in Slack and Whitt 1992: 581).[2] In even more pointed terms, there is Terry Eagleton's warning to those who point 'to "experience" – as though that, precisely, were not ideology's homeland' (1976: 15). Unable to ground him or herself in an experiential position in relation to the structures of the social, where does the critic speak from? The quick answer is that he or she speaks from in front of texts; as Grossberg describes it, 'the cultural critic must refuse participation in order to reaffirm a reflective distanciation' (1988a: 16).

A longer answer requires a deeper consideration of how indeed experience worked before it was written off within the 'logic of disintegration' (Dews 1987). In thinking about critical relations other than those of the critic before the text, I cannot imagine a better place to start than in front of Hereford cathedral:

> The bus stop was outside of the cathedral. I had been looking at the Mappa Mundi, with its rivers out of Paradise, and at the chained library ... Now, across the street, a cinema advertised the *Six-Five Special* and a cartoon version of *Gulliver's Travels*. The bus arrived, with a driver and a conductress deeply absorbed in each other. We went out of the city, over the old bridge, and on through the orchards and green meadows and the fields red under the plough. Ahead were the Black Mountains ... The bus stopped, and the driver and conductress got out, still absorbed. They had done this journey so often, and seen all its stages. It is a journey, in fact, that in one form or another we have all made.
>
> (Williams 1989b: 3)

This quotation immediately situates us before a vista of both geographical and theoretical magnitude. It is from Williams' 1958 essay, 'Culture is Ordinary', a text for which I have great fondness not only because of its stunningly simple premise but also because I too grew up in the Border country, in a village that sometimes seemed to be located in between England and Wales. It is a social landscape quite extraordinary for showing, and even proving, that indeed 'culture is ordinary'. That part of Wales, unremarkable for much and for many, as the rather scrawny sheep graze amidst a mixture of Roman ruins, discarded fertilizer bags and rusting farm equipment, speaks loudly of the ways in which

> Every human society has its own shape, its own purposes, its own meanings. Every human society expresses these, in institutions, and in arts and learning. The making of a society is the finding of common meanings and directions, and its growth is an active debate and amendment under the pressures of experience, contact, and discovery, writing themselves into the land.
>
> (ibid.: 4)

Coming late as I did to that landscape, I quickly realized – was made to realize – the complex ways in which the Border Welsh cultural configurations are written into the land. Upon my father's retirement from the army, we had moved 'back' to Wales although the 'back' was after several generations of Probyns had made and lost a beer fortune in the south of England. As a worldly ex-army brat and Canadian through my mother, it took me a while to concede that my vocabulary couldn't quite keep up with the intricacies of my schoolmates' knowledge of who belonged where in the filigree of Radnorshire life. It was an early apprehension of another of Williams' statements: 'the lived is only another word, if you like, for experience: but we have to find a word for that level' (1979: 168). It is precisely this level of the lived that we need to explore if we are to rethink and elaborate alternative enunciative positions in cultural theory. Without those words, those riffs along the register of the experiential, we remain in our awkward positions as clumsy subjects in front of the text. Just as I was excluded at times on the playground because of my inability to speak 'the lived' of Llandrindod Wells, so too will the lack of a theory of the experiential exclude us from being within texts, from arranging them after our hearts, from using our selves within cultural theory. By returning to Williams' work, to his critical practice and his tone, we can find the beginnings of such a theory.

In thinking through the ways in which the concept of experience can be articulated with that of the self in cultural criticism, I will propose an initial heuristic distinction and contend that experience can be made to work in two registers: at an ontological level, the concept of experience posits a separate realm of existence – it testifies to the gendered, sexual and racial facticity of being in the social; it can be called an immediate experiential self. At an epistemological level, the self is revealed in its conditions of possibility; here experience is recognized as more obviously discursive and can be used overtly to politicize the ontological. Both of these levels – the experiential self and the politicization of experience – are necessary as the conditions of possibility for alternative speaking positions within cultural theory. This is to argue beyond a paradigm wherein the critic's experience can be reduced to the expression of a guarantee of authenticity, wherein the ontological is seen simply as an ideological articulation of the 'will to authority'. What I want to bring out are the ways in which these sometimes real implications of the insertion of an experiential self can be checked by using experience epistemologically to locate and problematize the conditions that articulate individuated experiences. I am not arguing that 'experience' can be simply evoked, as an invocation of an inherent 'right' to speak; indeed, as Gayatri Spivak (1988) and other feminists of colour (for example, hooks 1991; Mani 1992; Minh-ha 1989) have forcefully argued, we know that one class's 'right' to speak of itself is based in the oppression and silencing of another's.[3] However, it

is equally important that an epistemological understanding of the self not be allowed to overwhelm the necessary ontological implications of the self. In a slightly different vein, Diana Fuss argues that the immediacy of the experiential, what she, in turn, qualifies as a neccesary essentialism, must be recognized: '"Essentially speaking", we need both to theorize essentialist spaces from which to speak and, simultaneously, to deconstruct these spaces to keep them from solidifying' (1989: 118). In theorizing the tension within the category of experience, created in the movement between ontological and epistemological levels, we can begin to conceive of more productive uses of the critic's self.

Despite these interventions, from the standpoint of the 1990s, and in light of the various theoretical interventions that have occurred since the early 1960s, Williams' abundant use of his self and the centrality of experience are quite shocking: at times they produce an almost innocent immediacy. At the same time, his use of experience (notably in *The Long Revolution*) tends to be underplayed by interpreters of his work.[4] The notable exception is Eagleton's attack in *Criticism and Ideology*: 'it is precisely this insistence on experience, this passionate premium placed on the "lived", which provides one of the centrally unifying themes of Williams' *oeuvre* – which supplies at once the formidable power and drastic limitation of his work' (1976: 22). In a rather *ad hominem* tone, which is, I suppose, most suited to the male attack on the Father, Eagleton writes that Williams' 'ponderous pauses and stiffly rhetorical inflections, his ritualising of a cluster of key terms to the point where they seem less public concepts than private inventions, suggest the movement of an unmistakably individual voice' (ibid.: 22–23). Eagleton quickly reduces this possible theoretical tension to the purely idiosyncratic: 'the inert language of academicism is in fact the stage of a personal drama, the discourse of a complex, guarded self-display' (ibid.: 23). Of course, Eagleton has since made his peace with Williams and in a footnote apologized for the 'unacceptably acerbic and ungenerous' tone of some of his remarks (1989: 11). Strangely enough, after his harsh words about Williams' linguistic style, it is Williams' writing ('it was quite as much "creative" and "imaginative" . . . as academic work') that Eagleton most praises:

> Words for him were condensed social practices, sites of historical struggle, repositories of political wisdom or domination; he has a Celtic feel for them, for their rich texture and density, and he himself spoke pretty much as he wrote, weightily, rhetorically, constructing and composing his speech rather than slinging it provisionally together.
>
> (ibid.: 8)

While Eagleton now lauds the personal commitment to Wales and to the 'ordinary culture' of the working class, his comments verge on the

nostalgic, without offering a true reappraisal of the critical role of experi-
ence in Williams' theoretical project.

In the interviews that form *Politics and Letters* (Williams 1979) the
questioners are more concerned with establishing the parameters of
Williams' rearticulation of historical materialism than with coming to
terms with the reach of his use of experience. While these interviews are
central to understanding the import of Williams' theories, to my mind, the
issue of experience should be understood as a major source of inspiration
in his work. In other critiques, Williams' use of experience is implicitly
acknowledged but it is rarely the central focus; experience is displaced
into an epiphenomenal role. Typically, as in Martin Allor's account of
Williams' early work, 'culture' takes centre stage:

> 'Culture' was rescued from a morass of multiple uses, and it was located
> as a key term: epistemologically as well as ontologically. The relations
> between text and social life were reframed in terms of the connections
> between experience and institution.
>
> (1984: 9)

The richness of Williams' work cannot, of course, be reduced to one term,
and it is precisely the explicit connections between 'text, social life,
experience and institution' that make his work so productive. For Allor,
the term 'culture' operates epistemologically and ontologically. It works
epistemologically because it designates the relations (or to use a later term,
the mediations) between individuals and social formations; it works
ontologically because 'culture' also refers to the lived experience of the
social formation over and above the structural elements of the social. Allor
critiques Williams for this ambiguity and argues that Williams' 'cultural
materialism . . . covers and collapses much of the theoretical and critical
space that it opens' (ibid.: 19). Allor argues that in using 'culture'
epistemologically *and* ontologically, Williams collapses the distinctions in
analysis suggested by these levels.

In contrast to these critiques, I want to focus on experience as a
keyword, and map the productive tension that Williams constructs
between the ontological and the epistemological. In other words, while
experience describes the everyday, or 'the way of life', it is also the key to
analysing the relations that construct that reality. Moreover, as a third
term located within an epistemological/ontological tension, the experi-
ence of the critic, of her 'lived' and of its connections to an object of
analysis, can be put to work to motivate alternative modes of intervention.

To hear the theoretical weight that experience can be made to carry,
listen to this central passage:

> We are used to descriptions of our whole common life in political and
> economic terms. The emphasis on communications asserts, as a matter

of experience, that men and societies are not confined to relationships of power, property and production. Their relationships, in describing, learning, persuading and exchanging experiences are seen as equally fundamental.

<div align="right">(Williams 1979: 137)</div>

We can see here Williams' unwillingness to fully subscribe to any simple version of the 'base/superstructure' metaphor. In questioning the primacy of the economic, Williams uses 'experience' in two ways: first, the materiality of day-to-day observations serves to show that 'men' are not only affected by the operations of the base; second, the structure of the relations of production becomes apparent when individuals converse about their experiences. In turn, the critic's experience is that there is something above and beyond the base's organization of everyday life, and that this something can be reached by paying attention to the exchange of individuals' experiences. What is even more striking about this passage is the tone of the first sentence: 'We are used to . . .'. Here, academic awareness mingles with a sense of the very lived conditions of these descriptions. At the same time that we sense the necessity of those 'economic and political terms' as theoretical thresholds, the inhabited actuality of the economic and the political is made clear in the following sentences. It is therefore 'as a matter of experience' that individuals know both the extent and the limitation of these elements in defining their lives.

Williams admitted that his use of experience was problematic. However, he continued to maintain that there was a connection between the organization of the social formation and the lived experience of it. In fact, he went so far as to state that experience of the social formation allows us (as critics and/or individuals) to recognize that we are not solely confined and defined within an undifferentiated relationship to power and production. It is a small step to assert that the various structures of society are interrelated, that, for example, the family and the economic are not separate realms, and that they are structured and experienced very differently along lines of gender, race and sexuality. The complexities of these interrelations can be seen to be behind Williams' seemingly simple statement that 'it would be interesting to locate the historical moment when men stopped crying in public' (1989b: 319). To answer this question of why, in general, men do not cry in public, one would need to analyse the emergence of the concepts of masculinity, public and private, in their material articulations to other structures of the social, as one simultaneously examined the experiential level of crying and not crying in public. For me, this analysis could not be disconnected from the fact that I do, at times, cry in public, and would require some investigation of how and why I can. So the experience of the articulation would (momentarily) precede, or at least be a necessary precondition of theoretical analysis: as

Williams states in *Politics and Letters*, 'What I said in effect was that we know this to be so about our own lives – hence we can take it as a theoretical assumption' (1979: 138). Here experience is seen as directly epistemologically productive; it is that which motivates a theoretical assumption, it is also that which empassions and politicizes cultural analysis. Used epistemologically, experience provides evidence of the interrelation of structural determination and individual relationships which compose the social formation. Experience is thus put to work as a theoretical first principle for the critic.

Part and parcel of this critical principle is the fact that one cares about the experiences of others. Continuing his remarks about men not crying in public, Williams goes on to note that 'the repression of tenderness and emotional response, the willingness to admit what isn't weakness – one's feeling in and through another; all this is a repression not only of women's experience but of something much more general' (1989b: 319). While this remark flirts dangerously with an essentialist notion of Woman as nurturer, I think that we can be generous enough to recognize the sense of Williams' remark as pertaining to the historical and material situation of women. Moreover, his comment raises the necessity for caring and tenderness within cultural criticism. As theoretical battles seem to become more divisive, and as the highly competitive circumstances and the material pressures of academic jobs work to repress collective research, the edge of cultural criticism seems to be aimed at individuals. Without sounding like the 'Pollyanna' of critical theory (I have been known to participate in the guilty pleasures of conference gossip), it sometimes seems that the *raison d'être* of intellectual work gets lost in the very serious game of theoretical rivalry.

However, as I have found in the sometimes sobering experience of teaching, the absence of a reason to theorize is soon filled by students wanting to know, quite rightly, how theories about culture can help them to understand their own experiences. Put very bluntly, our experience as critics and teachers should remind us to care first about how our theoretical agendas can articulate and allow for expressions of experience, both our own and others', 'one's feeling in and through another'. One of the most memorable experiences, if not the only one, that I can recall from my undergraduate education was when a very venerable professor broke down into tears as he was lecturing about André Malraux's *La condition humaine*. As he told us of his brother's death in the Resistance, many of the young twenty-year-old students experienced, for the first time, the interrelation of literature, war, anti-Semitism, and personal loss.

Lest there be any misunderstanding, it should also be clear that the stipulation of experience as a condition of possibility for critical enunciations cannot give way to a simple reification of either experience or the experiencer. To take experience in and of itself as the sole criterion for and

in speech leads to such reificiations. In fact, the experience of women certainly demonstrates that arguments based in a certain sense of experience can be the most vicious. As Williams states, 'in certain epochs it is precisely experience in its weakest form which appears to block any realization of the unity of this process, concealing the connections between the different structures' (1979: 138). Given the complexity of its articulations, and the fact that experience is always conjunctural, located in the backwardnesses and forwardnesses of the historical present, it is not surprising that the experience of being within certain circumscribed modes of existence sometimes serves to obscure the connections between structures. Here experience in its weakest form is vehiculed through common-sense statements. As our everyday language reminds us (when racist or homophobic comments are preceded by 'some of my best friends . . .', or when a wider comprehension of the experience of sexism is precluded by 'I'm not a feminist but . . .'), experience alone does not guarantee articulation with other experiences, or with the experiences of others. Indeed, 'in its weakest form', experience can also serve to mask the construction of its own ground.

From Williams, I will posit three analytic possibilities: first, that experience itself speaks of the composition of the social formation; second, that experience can be overwhelming and work to conceal the connections between the different structures; and third, that the critic's own experience can impel the analysis of his or her differentiated relations to levels of the social formation. I want to emphasize the fact that critics, like anyone else, are a part of the social and that their experience of it should be put to work theoretically; this is, then, to force back against the conclusions of experience in its simplest allusive sense, and requires 'a renewed awareness of the indissolubility of the whole social-material process' (Williams 1979: 138). This is not to reify the critic's experience; it is merely to recognize its positivity within a politicized theory of culture. It is to renew awareness and analysis of the indissolubility of the social because experience has already told us it is so. If the lived is to be anything more than just another mantra, another abstracted nod, then our experiences need to be put squarely in the terrain of the theoretical.

If this sounds prosaic, it is because it takes a certain amount of tenacity in the face of highly elegant arguments 'to recall an absolutely founding presumption of materialism; namely that the material world exists whether anyone signifies it or not' (Williams 1979: 167). While I am certainly not advocating a wholesale rejection of theories of signification, I am arguing that we need to elaborate a theory and practice of signification which could entertain the centrality of experiences of and in the material world. Against a tendency towards a position that 'it is only in knowing that we exist at all' (ibid.), we can counter with an insistence on what I am calling the ontological level, the felt facticity of material

social being. From his own experience, Williams states that one finds 'a certain kind of disturbance or unease, a particular type of tension, for which when you stand back or recall them you can sometimes find a referent' (ibid.: 168). It is at the ontological level that we can locate 'disturbance, tension, blockage, emotional trouble [which] seems to me precisely a source of major changes in the relation between signifier and signified' (ibid.). To take but a small example, we are constantly told what the signified of 'woman' entails (a certain way of looking and being, a certain type of love, etc.). At the level of experience, this is normally confirmed, but it is also torn apart. The experience of another woman and of other women can cause disturbance, tension, blockage, and even emotional trouble, as the taken-for-granted signifying relation is changed, as the signifier and the signified are ripped apart. At an ontological level, experience speaks of a disjuncture between the articulated and the lived aspects of the social and, at an epistemological level, experience impels an analysis of the relations formulated between the articulated and the lived. These two levels are then necessary for a project of analysing people's contradictory involvement in practices that go against their own (class, gender or racial) interests. While, of course, cultural studies later used Gramsci's understanding of 'hegemony' to describe the processes through which such consent is won, in Williams' work it is experience which first articulated the ontological and epistemological conditions of the actual involvement in contradiction.

The desire to account more thoroughly for the lived relations between the articulated and the lived is at the heart of the necessity to combine both ontological and epistemological levels within any analysis. This doubled insistence is expressed more clearly in Williams' concept of 'the structure of feeling':

> it is as firm and definite as 'structure' suggests, yet it operates in the most delicate and tangible parts of our activity. In one sense, this structure of feeling is the culture of a period: it is the particular living result of all the elements in the general organisation.
>
> (1979: 48)

The lived takes on the role of theoretical horizon as the bifurcation of experience (as both epistemological and ontological) is the condition of possibility that allows the critic to specify a structure of feeling. While the interviewers in *Politics and Letters* argue that 'the concept then tends to become an epistemology for gaining a comprehension of a whole society' (1979: 164), their description fails to emphasize that structure of feeling designates 'the particular living result of all the elements' (1979: 164). Before the structure of feeling is understood as solely epistemological, it should be remembered that as a term it is always paired and held in tension with an ontological level. An acknowledgment of the

ontological aspect of one's experience is necessary if one is locate 'those specific and definable moments when very new work produces a sudden shock of *recognition*' (ibid.). In other words, it is our experiences that enable us to construct a given structure of feeling, just as, as an analytic focus, the structure of feeling expresses and allows us to map the articulation of moments of being within structural determinations.

While structure of feeling captures the epistemological and ontological implications of experience in general, it also emphasizes the role of the critic's own experience, his or her specific shocks of recognition. While there is 'no natural seeing and therefore there cannot be a direct and unmediated contact with reality' (Williams 1979: 167), experience is nonetheless the key mediating term in locating the structure of feeling. Far from designating a leap of faith on the part of the critic towards a structure of feeling, grounded in the materiality of his or her own quotidian structure of feeling, the critic accepts, as a theoretical principle, the experience of others. In acknowledging the very basic point that the experiential is part of the critical enterprise itself, we move beyond the construction of experience as an object to be passively and impersonally studied. In stating that the experiential is imbricated within a critical stance, we can begin to see how it might provide direction, and a ratifying sense of movement. It attests to a clear point of departure, even as it is partial, in the sense of being partial to (and part of) a political agenda. We are drawn to recognize and research certain experiences (as they are articulated through gender, sexuality, class or race) because we have at some level lived and experienced them ourselves. Williams' 'shock of recognition' attests to this, and in a feminist framework, we can extend this term to talk about the shock of recognition of gendered experiences. Thus, the critical stance of the feminist critic is directed by and to the experience of being gendered. It is both individual – as Rosi Braidotti puts, 'it is like *that*, I am sexed' (1989: 101) – and it is beyond just me: women are sexed. The shock of gendered experience thus emphasizes the duality of experience as a term: it allows for the twinned question of who am I and who is she? This doubledness of experience that the feminist critic works with and through does not necessarily mean that women are bound together in the face of their differences. Nor does the centrality of the critic's experience necessarily reify her as the organizing principle of critical discourse. It merely serves to alert the critic that there is always something else going on.

In his description of the operation of the structure of feeling, Williams raises the centrality of this 'something else':

> In the study of a period, we may be able to reconstruct, with more or less accuracy, the material life, the social organization, and to a large extent, the dominant ideas. It is not necessary to discuss here which, if any, of

these aspects are determining; . . . To relate a work of art to any part of that observed reality may, in varying degrees, be useful, but it is a common experience, in analysis, to realize that when one has measured the work against its separable parts, there yet remains some element for which there is no external counterpart. This element, I believe, is what I have termed the structure of feeling of a period and it is only realizable through experience of a work of art itself, as a whole.

(1954: 21–2)

Here we can readily see that an epistemological analysis privileges particular configurations of 'the social organization'. That is, the structure of feeling designates the relations that articulate, at any moment, 'the material life', 'the social organization' and 'the dominant ideas'. While it may not be necessary to weigh which, if any, element is determining, it is necessary to determine the particular configuration formed by these three elements. However, in addition to this analysis, there is still more to be accounted for: there 'remains some element for which there is no external counterpart'. The structure of feeling then acts to articulate the determination of the structure with how the structure feels. Given the dual perspective of the structure of feeling, it is not surprising that the critic should recognize, at the moment of analysis, that there is 'something else' going on. The critic's experience is thus integral to realizing the existence of the structure of feeling.

To explore more fully the implications of the critic's experience in the analysis of a social text, I'll now turn to one particular instance of Williams' analysis; this example, from 'The Welsh Industrial Novel' not only identifies a certain form that centres on the expression of experience, but also is clearly marked by Williams' own involvement as a critic within the specification of this particular structure of feeling. Williams argues that the emergence of 'the industrial novel' is a particular historical development proper to the Welsh situation in the late nineteenth and early twentieth centuries. Anchored in autobiographical accounts of the time, it is a prime example of the expression of the experience of the economic and political factors underlying the Welsh industrial expansion and the profound changes that it brought about within the lived:

The movement towards the industrial novel is then, in this phase, a movement towards describing what it is like to live in hell, and slowly as the disorder becomes an habitual order, what it is like to get used to it, to see it as home.

(Williams 1980: 214)

Here the 'at once the representative and the exceptional account' (ibid.: 219) speaks of the social landscape as it is simultaneously a part of it. The experience of 'hell' both describes changing structures and raises what it is

like 'to see it as home'. This double recognition of the construction of the lived indicates, in Williams' words, 'a specifically Welsh structure of feeling' (ibid.: 221). This structure of feeling articulates through an auto-biographical voice the ontological and the epistemological: 'the lives of individuals, however intensely and personally realized, are not just influenced but in certain crucial ways formed by general social relations' (ibid.). Moreover, this essay raises the question of Williams' position in relation to the structure of feeling that he describes. One sees very clearly here a certain matching of experience as Williams, the critic, elucidates central figures in this form; figures which are also the ground of his own experience. At one point, he raises the very materiality of Wales: 'there is a structure of feeling which has one of its origins in the very distinctive physical character of the Welsh industrial areas' (ibid.: 222). The experi-ence of 'the whole work of art' (or, in this case, of a form of writing) is implicitly tied in with the critic's other experiences. In this instance Williams calls upon the 'familiar experiences of the hills above us [which] are profoundly effective, even when they are commonplace, in so much Welsh feeling and thought' (ibid.: 223).

The direct intervention here of Williams' experience of 'the hills above us' is far from simple; the physicality of the Welsh experience is used by Williams the critic to draw out one articulation of the structure of feeling. In other words, he can present the structure of feeling because he already assumes its presence to him – it is that within which he lives and writes. This situation then impels Williams to construct an analysis that would be 'not only a consciousness of history but a consciousness of alternatives' (ibid.). The articulation of the critic's experience and written accounts of experience thus allow for new insights about the emergence of a specific textual form. This movement between experience in the text and of the text is certainly part of the structure of feeling, but it is most productive when it is set in the overall context, within a broader tracing of the structure of feeling. In this particular case, Williams' experience works to articulate both the conditions of possibility of a particular form and the local need for that form:

> Against every difficulty – and the weight is shown to be crushing – the accents of a fidelity at once both visionary and historical are precisely achieved. It is a novel of voices and of a voice, and that voice is not only the history, it is the contemporary consciousness of the history.
>
> (ibid.: 229)

This recognition of a certain 'fidelity' does not reify the critic's experience of the text and context as some sort of guarantee of the authenticity either of the text or of the critic's reading. Rather, it directs us to look at the ways in which the critic's experience of what he or she describes is a crucial part of an overall critical intervention. Hence, the critic's

experience mediates between an ontological pull to define experience as primary and transcendental and an epistemological tendency to privilege structural determinants of knowledge. In opening experience onto its ontological and epistemological functions, as a critical term it takes on a wider analytic positivity; it is neither the metaphysical key to inter-pretation, nor is it the black hole of false consciousness. In putting his own experiences to work, Williams circumscribes 'a kind of appalling parody' which claims that 'all experience is ideology, that the subject is wholly an ideological illusion' (ibid.). Rather than dismissing experience out of hand, we can begin to see the potential that it carries both to designate the various levels of the social and to point to possible sites for critical inter-vention. Without being placed on a pedestal, experience can nonetheless give us somewhere to speak from.

ARTICULATED SELVES

Without reifying Williams' concept of experience as an ideal to be returned to, we can see that the way in which structuralism was taken up excluded the experiential moment in early cultural studies. In the move away from 'participation' as a theoretical framework, and to a 'semiotic-ethnographic model', the experiential aspect of the critic's involvement in theorizing is skirted as the attention turns to the distant figure of the 'audience':

> it was assumed that cultural studies had to address the question of the actual interpretations made (or at least offered) by various audience fractions, and that these differences were to be explained by the determining effects of already constituted social differences which constructed the experiential context into which individuals appro-priated the text, and from which they constructed their own meanings.
>
> (Grossberg 1988a: 16–17)

In this formulation of cultural studies, experience becomes an understood 'context' which allows individuals to 'negotiate' their own meanings of the text. It is, of course, an important element in the 'decoding' process; it is that which works against the masses being taken as 'cultural dupes'. Thus, 'social differences' allow for an 'experiential context' which is where 'texts' are 'read'. This experiential context is then the result of 'already constituted social differences' and as such it is an effect of the social. This sense of 'experience' is, however, located in the realm to be studied, as the critic looks on. It is this shift in perspective which differentiates an understanding of 'the experiential context' from Williams' 'structure of feeling'. Whereas the former is an important founding assumption in the theorizing of how individuals come to interpret texts, the latter goes further in describing the active relations within the structures of the social.

In other words, the experiential context is a domain that remains s[...] from the critic – he or she must take it into account but is not nec[...] implicated in it. The role of experience within the concept of structure of feeling, however, places more importance on the critic's implication – it situates where the critic stands, and speaks.

The difficulties that experience as a concept and as a category presents to cultural studies have recently resurfaced in discussions about reflexivity. Grossberg argues that the turn to reflexivity and autobiographical forms of writing is being offered as a response to the 'postmodern collapse of critical distance and the increasing uncertainty about the authority of intellectual and political voices/positions' (ibid.: 66). He sees these reflexive writing strategies as inherently flawed:

> reflexivity demands that the author reveal his or her determining biographical and sociological conditions ... such epistemologically reflexive writing forms assume that any text is ultimately a description of the author's subjective experience of whatever he or she is writing about. Consequently, the author must either offer an interpretation of the limitations of that experience, or incorporate the voices of other experiences. This merely reinscribes, not only the privileged place of experience, but the privileged place of the author's experience.
>
> (ibid.: 67)

Here Grossberg foregrounds the epistemological limitations of reflexivity. Reflexivity cannot be separated from the ways in which experience has come to be defined in cultural studies. Here experience is either un-knowable (the determining biographical and sociological conditions cannot be known), or misleading (the interpretation turns inward with the author interpreting the limitations of his or her voice). These limit-ations will remain in effect as long as experience is understood as an ontological category, an essential 'beingness' that is offered up to reflexivity. Thus, if experience is unable to be the ground of anything (as in Hall's description of it within structuralism), then reflexivity can only result in 'an endless and inevitable deconstruction of the communicative relation between text and subject' (ibid.). Reflexivity as an epistemo-logical strategy must remain ineffective as long as experience remains a repressed and untheorized term.

Grossberg's analysis of reflexivity as one dominant mode of the auto-biographical within cultural studies correctly focuses on the tendency toward solipsism. I want to ask, however, a parallel set of epistemological questions about the positivity of other modes of using the experiential within cultural analysis, as I focus on the possible enunciative positions that uses of the self may allow to emerge. In conceiving of experience as incorporated within a mode of theorizing and of speaking within theory, we are also brought to consider the ways in which its effects can be

'struggled' over. To recall Hall's definition of the ways in which articulation is an active mode of making connections is also to remember the conjunctural nature of articulation:

> [a]n articulation is thus the form of the connection that *can* make a unity of two different elements, under certain conditions. It is a linkage which is not necessary, determined, absolute and essential for all time. You have to ask, under what conditions *can* a connection be forged or made? So the so-called 'unity' of a discourse is really the articulation of different, distinct elements which can be rearticulated in different ways because they have no necessary 'belongingness'. The unity which matters is a linkage between that articulated discourse and the social forces with which it can, under certain historical conditions, but need not necessarily, be connected.
>
> (Hall 1986: 53)

Reconsidering experience and its use within critical practices as a form of articulation forces us beyond the culturalist/structuralist dichotomy of understanding experience. That is to say, experience may be made to work beyond either its romantic sense of 'authenticity' in the former, or its sense as an epiphenomenal product in the latter. Conceived of as an element of an enunciative practice, experience may, 'under certain conditions', make 'a unity of two different elements'. This is to emphasize, then, that the autobiographical, or the enunciation of experience, cannot be understood as a fixed condition; it may work as 'a linkage' which is not 'necessary, determined, absolute or essential for all time'. Moreover, theorized within a theory of articulation, the experiential may be pried from its commonsensical location in 'belongingness'. It then becomes possible to distance the autobiographical from a representational logic. Instead of representing a 'truth', a 'unity' or a 'belongingness', a critical use of the self may come to emphasize the 'historical conditions' involved in its *speaking*.

So I must work against traditional approaches to autobiography that stress the personal uniqueness of the (usually male) individual who writes his life, thereby guaranteeing his existence. As I discuss in Chapter 4, in some feminist critiques of autobiography it is the unique communality of Woman which is guaranteed by the female autobiographer. In taking the autobiographical form as a representation of that which can be said to exist, these approaches severely limit the critical usefulness of experience, the autobiographical or the self. However, these tendencies can be struggled against as I work to show, through theory and through practice, that a critical enunciation of autobiographical experience has 'no necessary belongingness'. In working against a notion of experience as the possession of an entity, we can begin to recognize and theorize the different effects that an autobiographical enunciative practice may allow. In so doing, I will argue that the autobiographical must be made to work

as an articulation between epistemological and ontological levels. As in Williams' use of experience, this analytic distinction is crucial in the construction of the self as a practice and as a speaking position.

To offer evidence of some alternative practices, listen to these auto-biographical voices. In her article 'The Chippewa and the "Other": Living the Heritage of Lac du Flambeau', Gail Valaskakis situates a range of epistemological questions about how the Chippewa nation were 'known' by anthropologists: 'we were very young when we began to live the ambivalence of our reality . . . Later I realized . . . that I was both an Indian and an outsider' (1988: 268). Within Hall's article on Althusser, his 'concrete lived' voice tells of teaching his son that he was 'black', not 'brown' (1985: 108–109). In *It's a Sin*, Grossberg remembers his Chassidic grandparents: 'I understood that when my grandfather chose to risk my grandmother's life rather than let her travel (i.e., work) on the sabbath, he was acting on the basis of their shared absolute commitment to a center they could only name – Jaweh – but never explain' (1988a: 63). In 'Some Sons and their Fathers', Hebdige recounts a moment in his breakdown when: 'braying like an ass at the moon on that mild Easter night I felt convinced that at last I'd found my voice' (1985: 37).

Now, to the state the obvious, Valaskakis, Hall, Grossberg and Hebdige are writing of other things as well as of their selves. While their projects vary, nonetheless their voices have certain linked effects. At one level, there is an ontological projection; their memories figure a realm of being that we can only know through their self-descriptions. Lodged in their theoretical arguments, these voices convince us of another level of abstraction: of their beings, their individual selves. However, we can also see that these uses of the self are not solely contained within the ontological; the point is not to construct an ontology of origins, nor to guarantee 'authenticity'. Rather, these images of the self are articulated with epistemological projects: Valaskakis' examination of the political and historical 'fixing' of the Indian as 'other'; Hall's argument for a marxist account that could specify a 'recognition of the self within ideological discourse' (1985: 107); Grossberg's use of the difference between 'fans and fanatics' as a way of analysing political and cultural critical practices (1988a: 63); and Hebdige's theorization of ways of effecting change in an articulation of new forms of masculinity (1985: 38). Thus as a realm of being is proposed, it is grounded in an historical conjuncture. Images of the self arise from the 'livedness' of the interaction of individual and social and then return as a critical tool to analyze and cut into the specificity of the social formation. As an active articulation of ontological and epistemo-logical levels, the experiential may enable an enunciative position which puts forward a level of being as the conditions of that being are prob-lematized. In this mode of speaking, the self is put forward not to guarantee a true referent but to create a *mise-en-abyme* effect in discourse.

In distinguishing these two levels at which the experiential may be made to work, I want to enable a use of the self which neither guarantees itself as an authentic ground nor necessarily rejects the possibility of a ground. The articulation of the ontological and the epistemological together then enables the enunciation of the experiential to have other effects; effects that within the framework of a critical speaking practice may be 're-inflected, detoured, re-routed and even hijacked' (Grossberg 1988a: 34) – in short, effects that can be worked with.

Theorizing the self therefore brings us to a recognition of the conditions of possibility for constructing the positivity of the critic's voice and experience. In articulating the levels engendered by speaking the self we can begin to consider the effects, the statements and discursive configurations that may be brought into play. As I discuss in Chapter 4, Michèle Le Doeuff's (1989) concept of the 'faire' of a philosophical image allows for a conception of the self as a discursive image which can work against its traditional location in the discourses of individualism. As the individual again resumes its ascendancy in the programmes of the New Right, it becomes all the more necessary to struggle over more emancipatory uses of the self. As Michel Foucault's last work on the self makes clear (which I use in greater depth in Chapter 5), in certain historical conjunctures the self has had very different uses. Following Foucault, we can recognize a form of caring for the self which has been superseded by a confessional mode of regulating the self. While we cannot return to a past historical period, we can articulate strategies of the self which allow for trans-formations to be effected upon ourselves and the political body (Foucault 1988a). Again, it is crucial to emphasize that this Foucauldian use of the self is articulated out of different discourses. We must remind ourselves that what we take as universal (the things about the self that we take for granted) are the result of very precise historical changes. But it is in rearticulating the possibilities of using our selves that we may, in Fou-cault's words, 'show which space of freedom we can still enjoy and how many changes can still be made' (cited in R. Martin 1988: 17).

The stakes involved in theorizing critical uses of the the self are high. Perhaps most importantly, a renewed theorization of experience sets out the conditions of possibility for the construction of a new, empowered speaking position within cultural theory. Far from being a self-indulgent affirmation, the experiential can be made to articulate both ontological and epistemological levels of analysis. In so doing these levels are opened up for analysis as they can be made to speak of, and cut into, the conjunctural moment. This articulated analytic-critical practice empha-sizes the social distinctions and experiential differentiations of gender, class, ethnicity, race, sexual preference, economics and age. However, speaking the self does not claim to represent 'differences' as fixed essences. In other words, an ontological pull is checked by the epistemological

insistence precisely on the theoretical exigency and social conjuncture from and for which the self is spoken. As we can see from the examples previously cited, the self does not have to stand in for all other blacks, Jews or Indians. Thus the critic's experience may be turned into an articulated position which allows him or her to speak as an embodied individual within the process of cultural interpretation. This does not mean that critical activity becomes focused on a reflexive account of one's experience of oneself; this is not a proposal for an endless deconstruction of the subject/text relation. As an enunciative position within cultural theory, the self can be used to produce a radical rearticulation of the relationship of critic, experience, text, and the conjunctural moments that we construct as we speak of that within which we live.

NOTES

1 Ideological dilemmas are, of course, common. In fact, it is around such commonplace matters as lipstick that they are often forcefully felt and lived. While issues of style may be either considered as trivial or blown up into massive sites of resistance, in mundane ways, they can be used to bring high-flung theories of ideology down to ground. See, for example: Rosalind Coward (1985); Angela McRobbie (1988); Blackman and Perry (1990).
2 For an interesting analysis of the ways in which Althusserian structuralism was taken up in cultural studies and of its effect upon the notion of the individual, see Slack and Whitt (1992).
3 I am using the term 'class' here in a rather larger sense than usual. Colette Guillaumin's theorization of women as a class (1978) allows for a conceptualization of groups of individuals which are constituted as 'classes' through social relations of appropriation.
4 Without going into all the various critiques and readings of Williams, I should nonetheless mention: O'Connor (1989); Grossberg (1975); Green (1975); Samuel (1989); Higgins (1986); and Eagleton (1989). For feminist uses of Williams see: Lovell (1989); Lisa Jardine and Julia Swindells (1989); Michele Wallace (1990); Grover (1992).

Chapter 2

Problematic selves
The irony of the feminine

Of late, I have ceased to be amazed when I encounter a strange 'she' in a critical text. These 'shes' pop up from pages I know to have been written by men, and seem to have no immediate referent; they merely refer to an abstract problem, replacing the gender of the distant third person singular. Quite often, these 'shes' are written by conscientious male colleagues eager to avoid sexist writing practices and they jostle with 'hes' as well. It's hard to be overly critical in these cases, as the 'she' is obviously an effect of good intentions. However, they are still disturbing; in fact, they remind me somewhat of Buñuel's nameless and doubled female spectres in *Cet obscur objet du désir*, the pragmatic she and the enigmatic *elle* floating through the text. On a more concrete level, these 'shes' awkwardly carry the burden of a universal but masculine history; they certainly do not refer to a specific and material female experience of that history.

Beyond the discrete charm of these linguistic entities, there are larger questions at stake concerning the widespread emergence of the feminine in cultural theory. As Sally Robinson has quite rightly argued, we need to 'question the "logic" buried in the move away from Man, and toward Woman – or better, what that move puts into play in terms of a discursive economy of subject–object configurations' (1989: 48). While the thrust of Robinson's critique is psychoanalytic and aimed at Derrida, my path here will be slightly different. Continuing my investigation of the category of gendered experience and its uses within cultural theory, I will first consider the role female experience played in the development of Elaine Showalter's gynocriticism. Then I will argue that the concept of the feminine, as it is used in the critical projects of authors such as Paul Smith, Alice Jardine and John Fiske, negates the epistemological and ontological positivity of gendered experience.

I want to posit the necessity of thinking experience in all of its doubledness; of its use to feminist cultural theory at both epistemological and ontological levels of analysis; of continually thinking in the tension created by the movement between the questions of who am I and who is she? This is then to confront the sheer difficulty of gendered experience

both as it is lived and as it is put forward as a critical *a priori* for feminist cultural analysis. Of course, this discussion will make it evident that it is indeed hard for men to position themselves within feminism; as K. K. Ruthven has complained, 'I object to a strategy which situates men in such a way that the only speaking positions available to them are those of tame feminist or wild antifeminist' (1990: 9). However, it will also be clear that re-theorizing experience problematizes a speaking position of a general-ized woman in feminism. This is to move towards a position where we could '"see difference differently", to look at women with eyes I've never had before and yet my own' (de Lauretis 1987: 137). On a very anecdotal level, this is to remind ourselves that being a woman and being with women are not necessarily the same thing. The experience of being in an all-women space, be it working out at the YWCA or hanging out at a women's bar, both attests to a shock of recognition ('wow, there are only women here'), and produces a *frisson* of uncanniness (as I look at her with eyes I've never had before but that are now quite my own). In other words, being *with* women is not natural, is not a given; in fact, in our culture, it is ideologically produced as strange, as lacking something (like a male referent). In short, being able to think the doubledness of who am I and who is she is something that has to be worked at, both theoretically and affectively. And for me, it is also increasingly necessary to admit and to put into discourse the longing that is created in the movement of alterity between she and me; this is not a longing to be the 'other woman' (this is not a proposal for yet another 'wannabe' stance); rather, it is to work to incorporate this longing into my speaking position as a female feminist theorist.

LITERARY SELVES

Feminist American literary criticism has always accorded a central role to experience. More specifically, the gendered experience of the female reader has been an important critical principle. As Jean Kennard recently noted, 'If feminist criticism has demonstrated anything, it has surely demonstrated the importance of the reader to what is read' (1986: 63). This accent coincides with a Barthean emphasis on the reader; however, it is not at the cost of the Author, who remains quite firmly on centre stage. Against Barthes' statement that 'Writing is that neutral, composite, oblique space where our subject slips away, the negative where all identity is lost, starting with the very identity of the body writing' (1977: 142), American feminist literary criticism has held on to both the female body who writes and, (or) as well as, the one who reads. Moreover, the focus on these bodies extends beyond the disciplinary boundaries of literary criticism and into other realms of the lived. Situating the institutionalization of feminism, Jacqueline Rose identifies the key role that literature played in

the early history of American feminism: 'Literature served as a type of reference point for feminism, as if it were at least partly through literature that feminism could recognise and theorise itself' (1987a: 10). Rose, a British psychoanalytic feminist, immediately makes explicit the political possibilities of American feminist literary criticism. In stressing the 'American' here, she argues that literary studies had a greater impact on the American women's movement than elsewhere; one only has to think of the tremendous impact that Kate Millett's *Sexual Politics* (1970) had in galvanizing the 'second wave' of feminism in the United States. As Rose states, American feminist criticism had constructed an 'historically attested link between writing and the domain of the personal' (ibid.: 12). The strength of this link may, in part, explain the hostility of some feminists to Barthes' position. For instance, Barbara Christian vehemently critiques 'the death of the author':

> Now I am being told that philosophers are the ones who write literature; that authors are dead, irrelevant, mere vessels through which their narratives ooze; that they do not work nor have they the faintest idea what they are doing – rather they produce texts as disembodied as the angels.
>
> (1988: 72)

Christian's anger is quite understandable; it is galling, to say the least, and especially for an African-American critic, to have the theoretical status of the Author deconstructed at the moment when African-American women writers are slowly gaining their place as subjects within literary studies. More generally, however, an articulation of the personal, the political and literary is, for Rose, both problematic and productive:

> What has come to be known as the Anglo-American account of literary selfhood originally had a crucial reference point to the outside of the institution (the link between feminism and the politics of civil rights), even as its largely individualized and normative aesthetic base has gone hand and hand with a contraction into an increasingly academic base.
>
> (Rose 1987a)

Just as many theorists worry about the evacuation of politics in some American appropriations of cultural studies, Rose and others fear the loss of a political project as feminism increasingly comes to be situated within the academy, and, in particular, within departments of English. However, as younger women trained in feminist criticism and committed to 'other' literatures slowly replace some of the retiring tenured males, it may be premature to write off the political possibilities of literary studies. It is also crucial to hold on to that founding principle of the American feminist literary tradition: that the gendered experience of reading is the point of departure. As Rose points out, the notion of 'literary selfhood' operated

first and foremost as an articulation between the 'lay reader' and her book. In general terms, we can acknowledge that girls read more than boys and that they also tend to read more novels. As Tania Modleski argues, 'girls and books' has been a common trope in much cultural criticism:

> It is the vivid *image* of girls prostrate on chaise-longues, immersed in their worthless novels, that has provided historical preparation for the practice of countless critics who persist in equating femininity, consumption, and reading, on the one hand, and masculinity, production, and writing on the other.
>
> (1986: 41)

This debasement of the practice of reading 'worthless' novels is certainly true, but outside of the ideological articulation of the equation of books, women and lowly cultural forms and practices, it is also true that, compared with the teenage boy collecting records, the young woman is more likely to be reading. While this distinction is partly based in economic realities (boys have better-paid jobs than girls), it is not far-fetched to say that girls and young women also first turn to books in the hopes of better understanding their personal lives. I can certainly remember avidly reading all sorts of novels as a girl as I tried to figure my situation and as I tried to imagine a way out of it. Later I turned to reading only women authors and then also lesbian novelists, again gaining pleasure and hoping to find in the text a momentary articulation of possibilities deeply buried in the narrowness of my life.

In her theorization and attention to the woman reader, writer and critic Elaine Showalter's work is exemplary. As an early advocate of the 'lost' history of women's writing, Showalter developed an interpretive project that centres on the relation of women reading women. Although she has been called a 'separatist' (Ruthven 1990), her work is better described as gender-specific than gender-exclusive. However, while women's writing is the object for Showalter, her concern is also with how this writing is, in part, structured by male contexts. Showalter emphasizes the ways in which women's writing and reading take place within patriarchal institutions (within the university, or at home). In her article, 'Women's Time, Women's Space: Writing the History of Feminist Criticism', Showalter gives a history of the development of American feminist literary criticism interwoven with her own biography and development as a critic. It is an historical account that is powerful precisely because it is clearly grounded in experience: Showalter's; a movement's; and, potentially, her readers'. Furthermore, these disparate experiences are articulated in the history of a theoretical project of analysis. Situating this history as one which 'takes in events on many levels of women's daily lives' (1987a: 33), Showalter emphasizes the connections between the politics of the women's movement and the study of literature:

While feminist criticism could not have existed without the galvanizing ideology and power of the women's movement, the women's movement would not have occurred without a generation of women who liked books – graduate students, assistant professors, faculty wives, highly educated products of the academic expansion of the 1960s – whose avid, devoted, socially-reinforced identifications with fictional heroines were coming into conflict with the sexist realities they encountered everyday.

(ibid.: 35)

Showalter here firmly locates the intersection of a larger political movement and the beginnings of feminist criticism. This historical backdrop is crucial to understanding the moment of conflict and contradiction that was the condition of possibility that allowed for the academic study of women's writing. The 'everyday' for Showalter designates both the wider historical time and the immediate and ontological experience of that history. Situated between these two historical levels, women readers (the 'highly educated products') experience the contradictions of their existence. In other words, through their literary experience, individual women came to recognize the 'sexist realities' (in all their multiplicity) of their everyday lives. In contrast to Williams' emphasis on the immediate experience of the interrelation of structures, Showalter privileges the reading experience that allowed women to realize certain aspects of the social formation. Reading served to provoke a gendered shock of recognition and the basis for a longing for something, or someone, else. Unfortunately, Showalter does not elaborate the material determinations that produced 'a generation of women who liked books'. In contrast to women of colour and lesbian writers and critics, like those in the anthology *This Bridge Called My Back* (Moraga and Anzaldua 1981), or as in Mab Segrest's *My Mama's Dead Squirrel* (1985) to name but a very few, white middle-class heterosexuality does not feel the need to specify its materiality, perhaps in part because it implicitly believes itself the norm.

While it is a very privileged experience, we can nonetheless follow the way in which Showalter places the experiential within a certain determined relation of text and reader. It is the experience of reading as mediation that allows for an ontological recognition of the structure of the everyday. This ontological moment is situated in the immediacy of the text's relations to the social formation and is central to Showalter's elaboration of 'gynocriticism'. Showalter explains that she invented this word (and sanctioned it by saying that it was a translation of 'la gynocritique') to 'describe the feminist analysis of women's writing' (1986: 218). The project of gynocriticism can be seen to issue directly from women's daily experience as articulated through literary or critical practices:

The interest in women's writing ... that is crucial to gynocritics preceded theoretical formulations and came initially from the feminist critic's own experience as a writer and from her identification with the anxieties and conflicts women writers faced in patriarchal culture.

(1987a: 39)

In this way, gynocriticism can be seen to be grounded in an implicit realization of the ontological moment of writing and reading; again, through reading one could experience that welcome shock of recognition that other women had experienced the same things. In very simple terms, the solitary woman reading was not alone. Reading women's writing revealed both the literary and the literal conflicts always, and differently, facing women living in a deeply patriarchal culture. Showalter tells her own story: as an isolated graduate student/faculty wife/mother, she could connect with other women through reading women's experiences. Although I am of a younger generation than Showalter, I can still vividly remember my literature classes filled with young women reading dead men as an elderly male professor lectured (at) us. While Sartre was prescribed reading, de Beauvoir was extramural excitement. However, in one way or another, a 'literary self' emerges as a mediation between the everyday structure of life and the textual experiences of other women. Produced in the interaction of 'real life' and diegesis, this reading 'being' operates ontologically. The experience ignited in reading can then become the ground for an epistemological analysis of the ways in which being gendered also always lies in the disavowal of women's experiences as sanctioned knowledge. But to get there, there must first be an ontological moment of recognition of oneself as gendered. The term, a literary self, thus describes the priority of an ontological operation whereby women recognized themselves, their beings *qua* women, in the experience of reading other women.

The ontological priority of this gendered reading self is not without problems. While it is important to retain the ways in which the experience of reading may allow for the experience of a sudden realization of the implications of being a woman, this moment can be romanticized into a universal truth about women in general. The unspecified nature of whose (white, straight, middle-class) experience presents, to my mind, serious limitations, as does the rather single-minded view of how and where women read. Reading Showalter's description of that generation of women readers, I find myself wanting to know precisely what they were reading and where and how they read. In the library? At home and in-between various chores? Were they like Janice Radway's women in *Reading the Romance* (1984) who use books in order to shield themselves from all the pressures of being a housewife and a mother? What I am asking for here is definitely not a general model of women reading that

accords with some quintessential feminine social nature (as in Modleski's rendition of how women watch soap operas, 1983), but rather some differentiated details about the ways in which women actually do read and a specification of the pressures put upon them which result in specific patterns and uses of time for reading. In other words, how does the reading of commuting office workers differ from that of graduate students? Even if we were only to take the case of women graduate students, we would be forced, through our own experiences and those of others, to state that there are important differences about the stature of reading and the experience of reading like a woman. For instance, I started my graduate student career while I was still working full-time as a waitress. In between the gruelling schedule of split shifts, I would go to the nearest bar in order to do my academic reading. This allowed me to get some work done but also to feel that somehow I wouldn't be a waitress for the rest of my life; in addition, it accorded me a strange status with my fellow workers, one that could hardly be said to revolve around a communality of female experience. My point here is that while reading allows for the possibility of the recognition of an ontological moment where one feels gendered, it still has to be put to work in order to reveal the specificities of that structure of feeling.

Given these problems, strangely enough the most vociferous questions about Showalter's type of analysis come from some (white, middle-class) male critics as they try to move into feminism. Their various misunderstandings, however, may serve to clarify key tenets within Showalter's project. The movement of 'men into feminism' has been most obvious within literary critique, as several well-known male critics have taken up, in various ways, feminist critical tools. For instance, here is one of Jonathan Culler's attempts to come to grips with feminist criticism:

> For a woman to read as a woman is not to repeat an identity or an experience that is given but to play a role she constructs with reference to her identity as a woman, which is also a construct, so that the series can continue: a woman reading as a woman reading as a woman.
>
> (Cited in Showalter 1987b: 125)

While Culler quite rightly emphasizes the importance of the interaction of individual women with that larger entity, Woman, he denies the larger possibilities of women's experiences. Moreover, for Culler, this interaction is always caught within the mechanisms of deferral: women cannot attain the identity of Women, thus assuring that 'the series can continue'. 'Identity' is then an overdetermination that can be located in the structures of the psycho/social. He therefore misses an analytic insight into how these structures are presented experientially to women through reading women. The sudden shock of recognition of oneself as gendered is reduced, in Culler's hands, to one version of essentialism.

However, in Showalter's project, it is clear that this ontological literary self is produced in the interaction of the experiential and the text; it does not define a feminine essence. Key to Showalter's elaboration of a literary self is the articulation of the immediate experience of being a woman, literary experience, and experience of the wider (patriarchal) social formation.

If Culler misses the way in which the ontological moment inspires the work of a gendered reading, Terry Eagleton loses the theoretical and epistemological potential of the way in which gynocriticism articulates experience. This is not to say that Eagleton shuns feminist literary criticism; in fact, he has added to his career by appropriating feminist theory. However, in his response to Showalter's 'Critical Cross-Dressing' article (Eagleton 1987b), Eagleton prefaces an account of his own working-class experiences at Cambridge with a caveat: 'In seeking to address these issues not in the first place abstractly or theoretically (thus risking one form of appropriation), but in terms of my own experience, I shall inevitably appropriate the issues into that experience' (ibid.: 133). Eagleton here pits experience against experience, but his tales of trials with the upper classes at Cambridge carry little theoretical insight, and, in actual fact, he doesn't really appropriate any issue of import. Indeed, his response consists solely of a theoretically uninformed tale of his experience. Eagleton seems to want to use his experience to prove a moralistic point: that one shouldn't spurn potential allies (like Eagleton). In this way, experience is reduced to accounts of a supposedly personal truth. This then begs the question of 'what is your identity *for*?' (June Jordan, cited in Parmar 1990: 111). Showalter's close and generative critique of Eagleton's use of feminist criticism is subsumed in the name of Eagleton's experience. At best, Eagleton's response to Showalter is evasive; he does not reply to Showalter's remarks. At worst, Eagleton's attitude dismisses feminist work which has theorized and problematized the role of experience. At one point in Eagleton's tale, he explains why his working-class Cambridge friends are now politically on the Right: 'Because their politics were so closely bound to an intense, bitter personal experience, they couldn't survive the changes brought about by later middle-class affluence' (Eagleton 1987: 134). Paradoxically, just as he speaks it, experience is reduced to a lower realm, 'close and bitter'; it fails in the long run to inspire anything but later 'cynicism'. Showalter says that what she wants to find in *The Rape of Clarissa* 'is any sign from Eagleton that there is something equivocal and personal in his own polemic' (Showalter 1987b: 130). While there does seem to be something personal in Eagleton's account, it certainly is not couched within a concept of experience that could extend the very notion of criticism.

If experience is made to work ontologically in the construction of a reading and analytic self, it also has an epistemological function which

needs to be more clearly emphasized and developed. This is to stipulate that experience has to be understood, spoken and theorized on several-levels; its validity and its analytic usefulness always tested, as Showalter says, 'on our own pulses' (1987b). We can use this little exchange between Showalter and Eagleton to raise some of the problems inherent in a notion of experience used to signify an unproblematic relationship between a practice (reading) and an ontological state (being a woman, or a working-class man). What needs to be further developed is an epistemological analysis of that mediation between reading and the recognition of oneself as gendered; an awareness of one's social position as a woman.

One of the founding tenets of gynocriticism could be said to be working along these lines. Showalter identifies this early impulse: 'gynocritics has been linked from the beginning with the enterprise of getting women into print' (1987a: 39). This material concern articulated with the theoretical focus on 'the difference or specificity of women's writing' (ibid.). A concern for increasing the availability of women's writing may seem merely reformist, and, in fact, the canon debates have tended to sidetrack the deeper epistemological potential of examining the specificity of women's writing and the particularities of the significa-tion of gendered practices of reading. However, all too often, the place, or the absence, of women writers is explained away by reference to 'patriarchal society'; the repressive hypothesis is trotted out in all its splendour. But the early point of gynocriticism's attention 'getting women in print' is important for at least two reasons.

First, publishing unknown or historically 'lost' books by women allows for the circulation of 'submerged' knowledges. With the pro-liferation of women authors, the reification of the few is diluted. In this way, 'the Great Authors' (Austen, Sand, Woolf, etc.) are placed in a context of female writing. Placed in a context of other than white greats, in the presence of writers such as Zora Neal Hurston and Sojourner Truth, or next to lesbian writers like Radclyffe Hall or Violette Leduc, we can begin to get a better picture as we gain a wider heritage. More importantly, in reading these women writers together we can begin to trace out what is sayable at any one moment. Far from evoking a commonality, the proximity of a wealth of women writers begs the question of their differences, and hence of our own. Second, the literary canon is shifted by the availability of women writers. While this may sound like liberal pluralism, sheer numbers also have a material consequence. The project of circulating submerged women writers takes on an epistemological edge within the academic institution; a different canon constitutes itself as 'a new object that can be charted by new laws' (Showalter 1987a: 39).

Gynocriticism's privileging of the material necessity of 'discovering'

the work of women authors and of putting them into discursive and non-discursive circulation (analysing them, citing them, publishing them, etc.), can thus be seen as potentially constituting one of the conditions of possibility for an epistemological rupture within, and outside, the discipline. Moreover, gynocriticism also centres on the experience of women doing criticism within the structures of the institution. This means raising brute material questions to the level of the epistemological; of asking questions like the following within an epistemological framework: what does it mean to do lesbian literary criticism in a straight/mainstream department? What type of knowledge has to be in place in order to allow for the emergence of other knowledges? Will the 'mainstreaming' of feminist literary criticism enable serious analysis of the work of authors who are native women and women of colour? These are all equally epistemological and political questions and with the (limited) recognition of the possibilities of feminist criticism within institutions and with the gradual increase of women teaching in the university, theorizing the specificity of women's experience becomes both more complex and more pressing. And as departments slowly become less homogeneously white and heterosexual, the question of the critic's experience comes to the fore. Showalter's emphasis on the critic's experience allows us to posit two necessary levels of analysis: first, experience can describe the material conditions of the reading process (the position of the woman critic within the institutional exigencies of the university, and the demands of political activity outside the classroom, and at home); and second, it designates relations among gendered selves that the text enables.

If indeed men are serious about getting into feminism, Showalter lays out two levels of experience which they must recognize: 'The way into feminist criticism, for the male theorist, must involve a confrontation with what might be implied by reading as a man and with a questioning or surrender of paternal privileges' (1987b: 126–127). These demands can be rearticulated to argue that the male critic must theorize the ontological implications of his experience – the immediate experience of 'reading as a man' – as well as the epistemological possibilities of that experience – how 'reading as a man' could disrupt prescribed categories of knowledge, rather than being coterminous with them. A serious analysis of 'reading like a man', just as one of reading as a woman, must also examine the different nature of the mediation between the practice and the text. This in turn is to raise the ways in which, for instance, gay men may read differently. It is to recognize that reading is a social practice performed in conjunction with other social technologies that produce our experiences as women or men, straight or gay, and so on. As Richard Dyer has argued of 'camp', there is 'a characteristically gay way of handling the values, images and products of the dominant

culture' (1986: 178). Craig Owens (1987) quite rightly points out that the social position of a gay man cannot be read, nor will it engender the same reading, as a straight man's. While Owens does not elaborate on the ways in which gay men's experience (as well as those of straight and gay men of colour) might extend gynocriticism's insights into the relations of experience, text and reader, he does raise the deep necessity for female feminists not to perpetuate homophobia and racism by lumping all men's experiences into one.

Notwithstanding the very real lacunae in the ways in which gynocriticism is sometimes played out in the institution, we can acknowledge that as a critical practice and theory, it implicitly raised the role of experience at both an ontological and an epistemological level. While the privileging of the ontological moment of women reading tends to get in the way of a more extended analysis of the relation of women's experience imbricated in the product and process of reading other women, this tendency can be checked by focusing on gyno-criticism's insistence on the material and epistemological structuring of the reading self. At an ontological level, the experience of reading calls forth a literary self which articulates the experience of the text with the daily experience of the reader. The political force of this equation should not be minimized; it is a crucial and generative moment which articulates and recognizes the potential of women's everyday existence. This ontological impulse, however, needs to be checked before it becomes a privileged transcendent moment; it must be held in tension with an epistemological index of the material conditions of women's reading and writing. Experience should be *explicitly* spoken and theorized at these two levels of abstraction. This means that women's experience of criticism and as critics within the academic institution must be recognized as an index of the calculus of experience, gender, knowledge and structure. Gynocriticism's early insight into the conditions of possibility that structure women's written production is equally an initial recognition of the relation of experience to structure. In privileging epistemological and ontological uses of experience we can, therefore, clarify the stakes involved within feminist literary criticism: at an ontological level, the literary self is revealed as a key construction and analysed as an articulation of the experience of the text and the recognition of oneself as gendered; at an epistemological level, the moment of women's experience, that shock of recognition of being gendered, can be analysed to reveal certain conditions of possibility of categories of knowledge; the experiential can be made to speak of both the said and the unsaid which structure women's lives and which produce specific knowledges about the social.

Experience would reveal the reader in her gendered specificity as it is used to designate the interrelations of structures. Far from entailing an

essentialist epistemology, a critical feminist use of experience moves the analysis to the material conditions involved in experiencing the text. And in that movement we also need to focus on the longing stitched into the act of women reading women. Here we find a double articulation of self; the shock of recognition of my self as sexed is made possible by a wider shock of gender, in all of its specificity, as it renders possible the analysis of the social operations, or technologies, involved in becoming gendered.

As in Hall's understanding of the work of articulation, using experience in its doubledness ensures that it does not become a claim to universality. As women reading women, and as female feminists reading women reading women, we are constantly asking 'under what conditions *can* a connection be forged or made?' (Hall 1986: 53). Thus gendered experience is pried from its naturalized setting; individually we are gendered as women, but we may also recognize the process of being gendered within the texts of others or of ourselves, or on the faces and the bodies of other women. This 'other side' of the articulation of gender does not equal a homogeneous entity that we could call the Experience of Woman. As Hall argues, 'The unity which matters is a linkage between that articulated discourse and the social forces with which it can, under certain historical conditions, but need not necessarily, be connected' (ibid.). What matters (as an object of analysis) is the way in which the moment of reading and the experience of being gendered can serve as a linkage between the text and the social conditions that engender text, reader and reading. In putting these experiences to work, we can see the outlines of a critical analysis that seeks to render explicit the mediations between the text's insertion into the lives of women, the structural constitution of their social formations, and the female critic's acknowledgement of her own gendered experiences and those of other women. While the early attention gynocriticism accorded to the moment of experience is important, it becomes clear that an extended analysis of the potential of experience in and through reading pushes at, and goes beyond, the limits of criticism framed within strictly literary terms.

MEN-IN-FEMININE-ISM

In thinking about the role of gendered experience in cultural criticism, and the problematic of whose experience counts, Gustave Flaubert's famous comment, 'Madame Bovary, c'est moi', comes to mind. As an early evocation of the irony of the eternal feminine, the conflation of Flaubert and his literary creation brings to mind the problematic of men in feminist textual criticism. Andreas Huyssen uses this statement to argue against the 'gender inscriptions in the mass culture debate':

woman (Madame Bovary) is positioned as reader of inferior literature –
subjective, emotional and passive – while man (Flaubert) emerges as
writer of genuine, authentic literature – objective, ironic, and in control
of his aesthetic means.

(Huyssen 1986: 189–190)

The metaphorization of the masses, and hence, mass culture, as feminine
is hardly a new trope, although Baudrillard (1983) does give it another
twist when he argues for the implosion of objectivity, characterized in the
name of the feminine. However, while Huyssen critiques the polarization
as well as the gendering of the poles: objective/masculine; subjective/
feminine, for others, the feminine serves as a substitution of the feminist.
The metaphor of the feminine can be perfectly at home within a purely
literary criticism that undermines the gendered experience of reading as
mediation.

As male critics become more fascinated with feminist criticism, be it for
reasons of intellectual curiosity or the more mundane exigency of keeping
up with the latest theory, the feminine and the feminist have become
entwined in interesting ways. The feminine beckons while the feminist
resists. Consider, for instance, the strange situation in which Ruthven
finds himself. At the same time that he realizes the need to recognize
feminist literary criticism, and indeed writes a book on it, he also writes
that:

Feminist terrorism is a mirror image of machismo. Unregenerately
separatist – men are the problem, so how could they possibly be part of
the solution? – it offers the vicarious satisfactions of retaliation and
reprisal in a war of the sexes for which the only acceptable end is
unconditional surrender of all power to women.

(1990: 10)

Thus, feminism emerges as an abject object; both desired and repulsive. As
such, feminism as a theoretical project and practice comes to be depicted
in the all-too-familiar attributes (and fear) of the feminine. Ruthven's
comments on feminism recall, among others, Nietzsche's words: 'female
voices are raised . . . which make one tremble' (cited in Heath 1986: 50).
Underlying these feminine/feminist voices is the knowledge that 'there
are threatening and medically explicit statements of what woman *wants* of
man' (Nietzsche, ibid.).

Nowhere is the presence and absence, the lure and the rejection, of
feminism so clearly seen as in the debates around postmodernism. Here
well-intentioned art critics like Craig Owens find feminist artists (such as
Barbara Kruger and Sherry Levine) to be 'doing' postmodernism, while
feminist theorists go unheard (of): 'if one of the most salient aspects of our
postmodern culture is the presence of an insistent feminist voice . . .
theories of postmodernism have tended either to neglect or repress that

voice' (Owens 1983: 61). Jonathan Arac put it in a nutshell with his statement that 'almost no women have figured in the debate, even though many analysts include current feminism among the figures of post-modernity' (1986: xi). While Arac bemoans their absence, he does not entertain the thought that maybe some feminists, unbeknownst to him, have already looked at postmodernism and that they didn't like what they saw. Writing in *The Village Voice Literary Supplement*, Michael Bérubé sardonically comments:

> So either the question is whether pomo should acknowledge the feminists in its midst, or whether feminism should acknowledge the postmodernism sitting next to it on the bus and mumbling to itself about Max Headroom and identity politics.
>
> (1991: 14)

Meaghan Morris' (1988a) brilliant strategy of listing pages upon pages of feminist postmodernist work obviates the need to cite all the feminists who have been or continue to be in the midst of postmodernism. My interest here, however, concerns not so much the absence of feminists in postmodernist accounts but the ways in which some postmodernist literary critics have appropriated feminism. More specifically, what I will examine is the way in which feminism gets turned into the feminine at the expense of the positivity of feminist theorizations of experience.

The 'da-fort' game that many postmodernists play with feminism (now you see it, now you don't) can be most clearly seen in the ways in which certain aspects of feminism are taken up while others (and other femin-isms) are completely ignored. The good object/bad object constructions are echoed as some feminisms come to count as 'interesting' feminism. In Owens' account, for instance, feminism is French feminism (as it has been defined in America, excluding French materialist feminists). As Rose has argued, male identity in the postmodern state is formulated as a precarious construct that needs the feminine (if not the feminist) as 'other' as never before. She cites Fredric Jameson's sad lament: 'if he has lost a self – himself – he cannot know it, because he is no longer there to know it' (Jameson cited in Rose 1987b: 31). Rose correctly points out that while 'he, himself' is lost, he knows where to find 'her':

> Like the pre-mirror child, Jameson wanders the new city space and cannot find, or know himself, there. Which does not prevent him from knowing the woman ... he refers to 'Marilyn herself', named on an earlier page as Marilyn Monroe, but offered here with all that familiarity which makes the woman so available for intimacy, so utterly 'knowable' one might say.
>
> (Rose 1987b: 31)

In her discussion of Oliver Sack's book, *The Man who Mistook his Wife for a*

Hat, Rose considers the transition from the modern to the postmodern. Central to her argument is the way in which, from Freud to Sacks, a 'problem of representation' is turned into a problem 'of knowledge around women' (1987b: 30). It is then hardly surprising that, in this era of multiple crises of representation, we should be showered by male formulations of 'shes'. As Rose points out, there is a joke implied in Sack's title which is:

> clearly at the expense of the woman who finds herself caught in a perpetual crisis which flouts the limits of anything recognisable or knowable as a world, while also undermining the very site of knowledge itself.
>
> (ibid.)

Rose's insights can be extended if we consider the role, or rather the absence, of gendered experience within some postmodern projects. Rose critiques Jameson and others for the ways in which their 'model seems to become strangely divested of some of the most difficult aspects of the psychic itself . . . the glaring omission of any question of sexual difference' (ibid.: 31). However, it's not so much the problematic psychic which worries me here as the devalorization of the experiential as a key feminist problematic. Furthermore, I would argue that it isn't that sexual difference is absent here, but rather it is that a certain articulation of sexual difference subsumes all other possible difference(s). Jameson needs the feminine to be still, to render woman as an object; 'The symbol first "represents" the object and then "becomes" it' (Rose 1987b: 30). Thus the isolated feminine *becomes* that which can allow for the masculine decentred and postmodern self. The joke is again on women as we are presented as both 'utterly knowable' ('so available for intimacy') and also as the guarantee of 'the limits of knowledge'. This move from woman as metaphor to the feminine as an ontological category may guarantee the postmodern male his decentred self; however, it doesn't leave much room for the experience of women as historical subjects.

From Jameson's quest for his own identity around the figure of the feminine, I now want to turn to other manoeuvres around feminism. As another man searching for his identity, this time in feminism, Paul Smith's work represents an uneasy articulation of poststructuralism and a nearly desperate need to be included in the women's room, or at least in feminist theory. While Smith is an easy target (this is, after all, the male co-editor of *Men in Feminism* who wants to 'actively penetrate' feminism), his proposed project of theorizing feminism and agency merits some attention. Moreover, if Owens seeks to create the feminine as the optimistic term within postmodernism, and Jameson needs her for his self, Smith presents feminist theory as the last hope of the academy. However, in order to do so (to save English from itself), Smith must first rearrange and (re)name feminism:

the area known as feminist theory (that is, the area concerned with poststructuralist and deconstructionist theorizing) might come to be seen as the bearer of whatever further political promise feminism offers in the academe.

(1987: 33)

In this rather curious move, feminist poststructuralist theory becomes distinct and better than plain old feminism. All of a sudden, other feminist theories pale, along with any sense of actual, material and political battles conducted by feminists within and without the university. If it were not so serious, Smith's contention could be seen as quite funny:

> The intellectual task of understanding feminist theory is not a problem since feminist theory is situated within the array of poststructuralist discourses with which many of us are now perhaps over-familiar.

(ibid.: 35)

The stakes, however, are indeed serious and one first has to ask why, if feminist theory is just boring old poststructuralism, Smith wants it so and needs to formulate it in this way. For all of his sweeping generalizations, Smith remains strangely hesitant in his propositions, either couching them in the conditional tense or putting forth a panoply of 'suggestions' about what is to be done and by whom:

> Perhaps the suggestion is that males who would be feminist need to undertake to write and speak as if they were women, to explore their relation to the imaginary, to mime the feminist theoretical effort of undermining the male economy by deploying the very excess which that economy has neglected.

(ibid.: 37)

Reading between the lines, we can sense some anxiety here: men can know feminist theory, yet they cannot know that which fuels it. He really does want to get in but just can't – the exterminating angel this time excludes him. The anxiety, however, is created by Smith's own argument; he posits a tautology which, in turn, bars his entrance. It is, of course, that stock player, a feminine imaginary, which emerges as the monstrous barrier to men's access into feminism. To be fair, Smith also comes close to positing a viable theoretical articulation of men and feminism when he raises this quite crucial observation:

> Perhaps we can assume that one of the initial problems for men in feminism is that it has often tended to think of the revindication of the specificity of women's bodies, or of women, as either a theoretical error or as at best a provisional and strategic gesture. One of its effects has been to absolve men feminists from the responsibility of speaking their own bodies.

(ibid.)

While Smith is not the first to formulate such an observation (as I have often remarked, along with other feminists, why is it that male students and colleagues always assume that only women have 'gender'?), it would indeed be a promising start if more men tried to 'embody' their theoretical writing. But Smith immediately loses the potential of his suggestion by shifting 'the body' to 'the imaginary'. Again, because of his own theoretical slide, he is then 'stumped by that question, the only answers at which I could guess seeming unlikely to be "correct"' (ibid.). And surely enough, to my mind at least, his tentative answer isn't anywhere near 'correct': 'we men might think that the writing of our imaginary would be exactly a pornography, the manifestation of our imaginary relation to the maternal body . . . is our imaginary anything but a pornographic defense against the mother's body?' (ibid.). But it's not just that his response is 'incorrect' (it is also quite weird); rather, it is his seeming incapacity to think the materiality of his body and his experience as a man in relation to social technologies of gender that is bewildering.

What is of theoretical interest here is Smith's construction of feminism as a certain articulation of poststructuralism which is, in turn, founded in the imaginary and the feminine. In tying feminism to the feminine as an ontological category, Smith then finds that as a man he can't get 'into feminism'. However, at the same time, he desperately wants to because, in his words, feminism 'has been perhaps the most effective and sustained contestatory discourse of the last twenty years or so' (1988: 152). In his search for a theory of the 'subject' which could go beyond Althusserian interpellation and articulate a more productive sense of 'agency', Smith thinks that he has found his lost cause in feminism. He states in his conclusion to *Discerning the Subject* that

> The 'subject', in the widest catchment of feminist discourse, has been formulated both in terms of its experience as dominated 'subject' and also as an active and contestatory social agent.

(1988: 152)

The irony, of course, is that feminism is lost to him precisely because of the way he has constructed it. He cannot quite move from experience as fixed (the stable category of the dominated subject) to a conception of the multiple and fluctuating experiences of being gendered. In setting up the male imaginary as pornographic, Smith implicitly posits masculine and feminine ontological categories, locked into a binary logic. In so doing, Smith loses the dynamic role of experience which provides such a productive tension within feminism and which makes possible both epistemological and ontological analyses of the social. Unable to grasp the essential fluidity of experience within feminism, and yet drawn to its political promise, Smith then proposes that men could become the 'contestatory' agents of feminism. According to this plan, men would

'help to subvert, unsettle and undermine the (seemingly rather fast to settle) laws of discourse. Not, of course, to undermine feminism itself, but only a process of settling, solidifying' (Smith 1988: 39). The place of men in feminism would be to remind us that 'difference is a material constituent of social life' (ibid.). In this role, men could 'help the effort to forestall the academic institutionalization of feminism' (ibid.). Men, or rather, male intellectuals, then become the referent signifying 'real life' even as they are unable to get beyond their 'pornographic imaginaries'. Perhaps most ironic of all, Smith sets himself up as an academic rebel as he engages with a discourse (that he has named) 'whose laws I can never quite obey' (1987: 38).

If Smith constructs feminism as 'the lack', the desired object which recedes before him, his co-editor in *Men in Feminism*, Alice Jardine, locates male theorists as already central to feminism. At one point in her experimental piece called 'In the Name of the Modern: Feminist Questions "d'après gynesis"' (Jardine 1988), one of the female voices is scripted to say:

> Wouldn't male intellectuals be upset if they knew the extent to which feminists read their texts – 'how' they write – as symptoms of patriarchy, regardless of or perhaps in tension with, 'what' they write.
>
> (1988: 180)

Jardine is certainly one feminist who reads 'their' texts carefully. Her privileging of the feminine within the work of certain French philosophers does not, however, extend to a critical analysis of the feminine's relation to the material concerns of feminism. Her description of 'gynesis' makes this clear:

> Th[is] project grew out of my earlier work on what I called 'gynesis' ('gyn' – for woman; 'sis' for process): the seemingly necessary and inevitable putting into discourse of the 'feminine' and 'woman' by those writers and theorists (especially in France) exploring the epistemo-logical configurations of modernity in the West.
>
> (ibid.: 184)

Jardine's writers and theorists are primarily the French 'Masters' (or as we say in Québec, 'les boys'): Lacan, Derrida, Deleuze. Her stated intent was to bridge the Atlantic, to bring them over here, and her project has been terribly successful as the general inflation of the feminine in North American theoretical circles continues to grow. The well known Franco-philia of New York intellectuals aside, *Gynesis* displays a strangely epic tone as well as a teleological pull in its insistence on 'the seemingly necessary and inevitable' and 'perhaps unavoidable ... new kind of discursivity on, about, as woman' (Jardine 1985: 26). We are squarely in the realm of the discourses of a few. However, there is no analysis of the

particularities of the Parisian intellectual system which could give us a clue as to the material conditions of possibility for this mainly male hierarchy. Nor do we gain any insights about the conditions that produce such little visibility and support for feminist research. Jardine's neologism and her argument in *Gynesis* recreates what I have called the ontological category of Woman. She states that modernity's 'crisis-in-narrative' has brought about 'a vast self-exploration' which includes a 'reincorporation and reconceptualization of that which has been the master narrative's own "nonknowledge"' (ibid.: 25).

In other words, the feminine is back policing the edges of modernity and the entrance into the postmodern. She, the feminine, as one of the 'nonknowledges', is now located within the narrative-in-crisis:

> This other-than-themselves is almost always a 'space' of some kind (over which the narrative has lost control), and this space has been coded as 'feminine', as woman. It is upon this process that I am insisting . . . the transformation of woman and the feminine into verbs at the interior of those narratives today experiencing a crisis in legitimation.
>
> (ibid.)

But Jardine describes the feminine without examining the traces left by its operations: the feminine as the 'other-than-themselves' is coded as woman. However, coding does have effects. And Jardine's account of the feminine in post/modernity is problematic precisely because of the absence in her argument of an analysis of the effects, both discursive and non-discursive, entailed in being coded as other. What indeed does it mean to be transformed into a verb? While verbs may be more active than nouns, these textual operations remain silent about the historical materiality and the epistemic violence that so often accompany being discursively constructed as other. The feminine here merely seems to describe a certain theoretical turn to be found in the work of some male theorists. Furthermore, the feminine is not made to, or not allowed to, speak of the effects of her new discursive home. Nor is the emergence of the feminine examined in its epistemological possibilities; rather, Jardine simply states that 'the valorization of the feminine' comes with 'her obligatory, that is historical connotations, as somehow intrinsic to new and necessary modes of thinking, writing, speaking' (ibid.).

The feminine then reappears as other as she is repositioned amongst the ruins of modernity's project of representation. Indeed, this image calls to mind another one, that of René Magritte's painting, *Memory*, which depicts a woman's head with blood flowing down one side. As Marilouise and Arthur Kroker, active proponents of 'processed feminism', describe it, '*Memory* is postmodernism *par excellence*: here there is no hint of representational logic' (1985: 6). In tune with Jardine's use of the feminine, this bleak painting was chosen by the Krokers as the cover for their issue of the

Canadian Journal of Social and Political Theory on 'Feminism Now'.

Along with hyper-postmodernists, Jardine cannot quite understand 'what makes feminists so suspicious of these male theorists' ever-expanding "feminocentric" logic – a logic posited by them as necessary to break out of Western ethnocentric definitions of identity, representation, and truth' (1988: 184). One would have thought that feminist hesitations were quite easy to grasp; simply put, using the feminine as the edge against which to think the immutable truths of the West reinscribes her, once again, as other. In Jardine's own words, the 'obligatory connotations' of the feminine are put into discursive circulation (1985: 24). To be fair, she did hope that these connotations (the feminine as the passive other to a whole set of oppressive dualisms) would be questioned. Obviously something failed, because Jardine was later forced to admit that 'woman and the feminine (let alone women) are now disappearing from the debate altogether within a larger, violent reaction against all forms of otherness' (1988: 184).

It seems to me that this conclusion was assured in advance by the use of the feminine as an ontological category. As such, the feminine cannot trouble epistemological equations that historically have been assured by the category of woman as other. The use of 'the feminine' (in all her historical connotations) cannot disturb the basis upon which men have historically spoken. The figure of the feminine silences women as it gives men even more to say and a comfortable place from which to speak. Thus she stands as a fixed position against which a decentred self can be constructed (Jameson), or she gives other male theorists the excuse to discourse at length on the difficulty of feminism. In none of these ways does the feminine actually allow feminists to articulate historical and material experiences of women as discursive points of departure. In fact, in many ways, looming on the theoretical horizon, the feminine forecloses the formulation of new ways of analyzing the mediations between categories of knowledge and the lived status of the social. As a critical term, 'it' (this 'she' who is a he) serves to replay a status quo grounded in sexual difference as Woman and the masculine as the norm. In this way, the feminine works against the positivities of either an ontological or an epistemological analysis. Both Smith and Jardine construct rather unyielding and unwieldy notions of the feminine. Given Smith's own attention to his position in (or near) feminism, one would have hoped for an analysis of the feminine conducted at an ontological level. What are the effects of this posited being, the feminine, upon his own construction of self? Given Jardine's project of documenting the feminine in philosophic texts, one would have expected an epistemological analysis of the feminine or, at least, an analysis of the relations between the feminine, as the knowable within philosophy, the place of women's experiences *qua* women in feminist constructions of knowledge. However, untied to any extended

theoretical analysis, the feminine merely exists as the shell of other (poststructuralist) arguments.

Unfortunately, the feminine is also being uttered from other domains outside of, but influenced by, poststructuralist literary theory. A case in point is John Fiske who, of late, has emerged as one of the more institutionally powerful figures in the Americanization of cultural studies. His work is of interest here because of the different liabilities entailed by his articulation of the feminine; it has also been marked to an exceptional extent by literary models of textuality. At one level, Fiske's feminine is indicative of a larger impasse within contemporary cultural studies, one that centres on the problematic of how to use and account for individuated experience. One of the effects of this impasse can be most clearly seen in the paucity of theoretical vocabulary and a tendency toward vacuity at the level of enunciative practices. Most striking is the way in which some versions of (sub)cultural analysis tend to turn out rather 'banal' descriptions of cultural resistance. As Morris has argued, we often hear that

> people in modern mediatized societies are complex and contradictory, mass cultural texts are complex and contradictory, therefore people using them produce complex and contradictory culture.
>
> (Morris 1988b: 19)

This 'vox pop style' in cultural studies tends to automatically proffer 'redemption' (ibid.: 21). And nowhere is resistance so all-consuming, and redemption so automatic as in the work of Fiske. Recently, resistance has been gendered as the feminine within his particular reading of cultural studies and 'she' offers redemption to the teeming female masses in front of the tube. In *Television Culture* (1987), Fiske discusses gendered uses of television: men watch *The A Team* while women watch (and resist) soap operas, rendering soaps a 'feminine narrative' and 'the action series as a masculine narrative' (1987: 179). Fiske's analysis is actually more of a secondary reading of viewing habits, as he constructs his argument through other people's research. His construction of the feminine thus comes from elsewhere (mainly from the work of Shere Hite and Nancy Chodorow) and it is then articulated to his analysis of viewing habits. The rather peculiar construction of the feminine that emerges from his particular and limited pastiche of feminist arguments is posited as the key to understanding resistance.

The underlying framework that supports his analysis of the feminine is the classic subcultural model of resistance. Thus the text of the soap opera is more open to subcultural readings because, unlike the realist narrative, it makes sense of the world in relation to 'the ideologies of the reader, and through them, to the dominant ideology of the culture' (ibid.: 180). Contrary to realist narratives (e.g. men's action series), the genre of soap opera, 'with no ending lacks one of the formal points at which ideological

closure is most powerfully exerted ... their world is one of perpetual disturbance and threat' (ibid.). According to Fiske, the textual and polysemic system of soaps is more amenable to subcultural readings. Here Fiske ignores the fact that this subcultural analysis was originally concerned with the potential or hypothetical readings generated through (mainly) class position. As Angela McRobbie's (1980) critique of subcultural analysis succinctly points out, this model tended to overlook other determinants than class, such as ethnicity and gender. Fiske's use of a feminine, however, does not extend a critique of the historical blindness on the part of male theorists to gender; he merely posits an equivalence of gender and genre.

Strangely enough, given his aspirations for resistance, Fiske's segregation of genres into masculine and feminine actually works against crediting women's intelligence and skill as television viewers. In constructing these texts as quintessential feminine narratives he downplays the ability of women as readers to find 'feminine' meanings in the face of texts that are not specifically women's genres. For example, there is no discussion of how lesbians manage to construct interesting scenarios even given the most traditional and heterosexual of programmes. Reified as essentially feminine, soap operas become the site of simply found pleasures. For all of Fiske's vaunting of the resisting and negotiating reader, there is little room for any active semiotic manipulation, let alone warfare, in his model. These texts construct their feminine readers, rather than the other way around: 'the soap operas show how . . . power may be achieved by feminine values' (Fiske 1987: 188). In other words, Fiske names various cultural products and practices as inherently feminine, which then produce a feminine being: 'Feminine work, feminine viewing practices and feminine texts combine to produce decentered, flexible, multifocused feminine subjectivities' (ibid.: 196). This feminine way is, for Fiske, imbricated within women's sexuality; in fact, the feminine stands in equivalence to a sexual essence. The referent being male, woman is defined in opposition to a supposed masculine essence. Thus, while men 'come', women:

> have no such final achievement. The emphasis on seduction and on its continuous pleasure and power is appropriate to a contemporary feminine subjectivity, for that subjectivity has necessarily been formed through a constant experience of powerlessness and subordination.
>
> (ibid.: 187–188)

Fiske's creation here of a psychosexual category is at the base of his claim for women's resistance. Just as he privileges a 'deferred' textual resolution as inherently more resistant to 'dominant ideology', women's supposed deferral of sexual climax is seen as oppositional. To risk stating the obvious, this argument is slippery at best and hopelessly heterosexist at worst.

It is also rather desperately caught up in a very limited and limiting model of textuality. Thus, Fiske's argument for feminine resistance is based on an equivalence posited between texts and subjectivities. So-called feminine texts betray the same characteristics as his fabrication of female sexual subjectivity. This articulation allows him to identify resistance with the feminine:

> Feminine genres, because they articulate the concerns of a gender whose interests are denied by the dominant ideology, must, if they are to be popular, be open enough to admit of a variety of oppositional, or, at least, resistive readings.

> (ibid.: 222)

Fiske can only make the argument that genre reflects gender by keeping within an extremely fixed notion of the feminine, not to mention a rather restricted understanding of television. At one point, he cites Mary Ellen Brown's list of 'gendered' oppositions. Among the twenty-five dualisms offered, we find that the feminine is 'passive', 'absence', 'scattered', 'imagination', 'soft', and 'night' (ibid.: 203). Constructed in these terms, the feminine offers little analytic potential. Indeed, Fiske's feminine does not even provide much conceptual reach as a simple descriptive device (just consider his description of women and sex). More importantly, Fiske implodes any semblance of distinct ontological and epistemological levels of analysis into an ontological category. In overcoding the feminine as the site of 'pleasure' and 'plentitude', 'polysemy', 'disruption', and 'deferment', Fiske loses the epistemological capacities that these terms may possess.

In making the feminine the reflection of a posited feminine text, Fiske obscures any way into an analysis of women's material negotiation of popular texts. Just as Smith cannot conceive of theorizing his body, Fiske forgets that women are embodied, historical subjects with fears, pleasures and preferences that we bring to, and involve in, our watching practices. For instance, I remember watching an episode of *Oprah Winfrey*, the American talk show named for its now (in)famous black star. This particular show dealt with a rape of a young black woman at a station in the Chicago subway system, very near to the studio where the show is taped. Before a live studio audience, and in front of us at home, this rape was simulated on video, and the rape victim was questioned by Oprah. As one can imagine, it was a harrowing experience, one that was brought home, into my home, by the insistence on the part of Oprah that the rape had happened 'here'. The mainly female studio audience was understandably moved and horrified, especially at the repeated reminders, both visual and spoken, that nobody 'here', at the subway station, had done anything to help. On the screen they moved forward, motivated through fear to a temporary movement and moment of solidarity. At home, I

moved closer to the screen as I too was caught in fear, anger and empathy.

This wasn't a moment of resistance, and the brutal facts of rape make it very clear that there is no 'redemption', no safe place, colour, class, age or sexual preference for women in the face of rape. It was, however, a moment of active articulation, the putting into play of knowledges half remembered: of statistics, of strategies of defence, of how to walk, of a sinking feeling of despair, of an anger that made me speak out loud in the isolation of my living room, of a hope that together we can do something. Of course, the show finished and the moment passed, but not before its traces were indelibly marked on my body and perhaps on others who had watched. What was clear, however, was that there was no feminine present that afternoon, no sign of 'passivity', or 'absence' and certainly no 'softness'; rather, what was in force, from what I could see and feel, was a hard female determination, a shock of recognition of being gendered in and amongst women. In short, it was a discursive and non-discursive articulation of a specific female experience; it was an all too everyday moment of violence put into discourse that reverberated into many thousands of women's lives as we watched; it may also have been the moment that articulated for some the desperate need for feminism.

It is probably quite clear by now that, as a female and as a feminist theorist, I find the feminine to be limiting in its analytic reach, limited to a metaphorical mode of describing women's place in the social. While Jardine raises the 'inevitable connotations' of the feminine, she then proceeds to ignore them. Fiske, on the other hand, supports his use of the feminine with some of those connotations: 'passivity', 'absence', 'the earth'. While, in general I find that we don't have enough words to describe our realities (does 'sexual preference' really describe what it is like to love women in the determined heterosexuality of our culture?), and while I know that we must have recourse to various tricks and tropes of language in order to get by, I also think that we need to take our theoretical languages very seriously. Moreover, as Morris states, 'meanings' are not (purely) in words: 'meaning is produced in specific contexts of discourse' (1988a: 32). Theoretical projects are 'specific contexts of discourse' and as such, one needs to be vigilant about the meanings created or reinscribed through their use. If one really wanted to use 'the feminine' as a key term within a feminist analytic project, at the very least it would have to be accompanied by an acknowledgment of its historical traces; and a conjunctural analysis of its limitations. For example, the other of the feminine that floats through its various usages that I have discussed here is that there is an original truth of woman. And this, at a time when a right-wing group like REAL Women are having some success in naming themselves as the truth of femininity. Whether or not this is intended by the authors that I have considered, discursive connotations and material effects of the feminine extend beyond individual intentions. Consider Smith's

contention that he feels alienated by feminism: 'Of course, I can be an alien only in a system which perceives itself as having some definitional integrity which can be enforced or embodied as a correctness of speech or activity' (1987: 37). While Smith may consider himself sympathetic to feminism, or even a male feminist, his words echo at a time when attacks against feminism as 'politically correct' are featured on the covers of *Newsweek* and *Time*. Of course, Smith would probably feel that I am policing the definitional with my injunctions against the feminine within a feminist context. While there is no essential integrity to words, we can, however, work to use them in ways that are integral to a larger feminist project.

Unless an analysis of 'the feminine' is implicated within its use as a critical term, the figure of the feminine obscures, when it doesn't actively block, feminist ontological and epistemological analyses of women's experiences of the social. In very simple terms I will posit that the feminine is in historical opposition to the positivity of putting experience (our own and others) to work theoretically. Moreover, this feminine rises up to haunt the tracks of the feminist writer when it is not expressly used to discount feminist work (as in the different projects of Eagleton, Smith or Fiske). The contemporary use of the feminine by literary theorists creates a situation which threatens to silence a feminist enunciative position grounded in the materiality of being a woman. In a slightly different vein, Monique Wittig reminds us that: 'the "I" (Je) who writes is alien to her own writing at every word because this "I" (Je) uses a language alien to her; this "I" (Je) experiences what is alien to her since this "I" (Je) cannot be "un" ecrivain ... "J/e" poses the ideological and historic question of feminine subjects' (cited in Morris 1988a: 31).

As Morris points out, Wittig articulates several levels of analysis: the historical, the ideological, the experiential, and even, potentially, the economic:

> Wittig is talking about the 'relationship between' the 'Je' and the 'un', between the 'I' of a woman writer and the rest of the discourse process; and in posing her split 'J/e', she connects the question of this relationship to the question of the constitution of femininity in ideology and history.
>
> (ibid.)

The potential of this argument is in the way in which 'J/e' (a feminist 'I') begins to articulate an ontological and epistemological investigation of conditions that silence or skew women speaking. At an ontological level, we can connect the 'I' and 'the relationship between a woman writer and the rest of the discourse process'. This level can be made to intersect with the epistemological question of 'the constitution of femininity in ideology and history'. Moreover, these are immediate material questions that cannot be contained within a purely textual model of signification.

While I do not want to overlook some of the problems inherent to Showalter's articulation of experience within feminism (problems that have to do with whose experience counts and who gets to speak about them), gynocriticism offers insights into the explosiveness of experience. The point is then to make the gendered experience of reading explode beyond the text. For all the limitations of Showalter's continued alliance with the text, what I find inspiring in her description of gynocriticism is the way it implicitly urges us to consider the limits of a model of gendered subjectivity captured within textual manoeuvres. Although she does not quite follow through on her insight, the depiction of women desperately reading, hoping to catch a glimpse of something else, demands that we consider the full materiality of how and where and why women read.

This is to work to situate women's reading as a practice that generates certain experiences. These experiences in turn can be made to tell us of the gendered nature of the mediation between text and individual woman, the shock of gender among women, that arises at particular moments. Against the quite obvious and banal nature of this perspective, the feminine is seductive, seemingly more sophisticated and appealing to the exigencies of critical (male) theory. However, its use, as Jardine finally recognized, threatens to silence feminists. Incarnating a reification of 'sexual' difference to the exclusion of all other differences, the feminine 'is becoming a polite code word of postfeminism, meaning "Let's not talk any more about women"' (Showalter 1986: 222). An insistence on the facticity of women's experience is not unproblematic; however, a critical use of experience must confront the central questions that the feminine elides. Not to do this, to be content with the easy pleasures of the feminine, is to lose a fundamental opportunity: an opportunity to precisely use our material experiences to map out the changing relationships between identity, ideology and gender, within the historical moment in which we live.

Chapter 3

Moving selves and stationary others
Ethnography's ontological dilemma

In her influential article, 'Notes toward a Politics of Location' (1986), Adrienne Rich mentions a girlhood game, or practice, of addressing letters to a friend which began with the street address and ended, via country, continent and hemisphere, with the postal area of the universe. As Rich describes it, you could place 'your own house as a tiny fleck on an ever-widening landscape, or as the center of it all from which the circles expanded into the infinite unknown' (1986: 212). This memory then raises the question: 'At the center of what?' (ibid.). When I read this article, many things hit home, and like many other feminists, I have been inspired to turn my gaze downward to the specificities of gendered experience. However, outside of the theoretical agenda she sets in this article, Rich's remembrance of that childhood pastime of locating oneself in relation to the universe reminded me of my rather nomadic past. As an 'army brat', and the offspring of a Canadian mother and a British father, growing up on various army bases and constantly moving, shifting friends and familiar places, I recall using this game in order to instil some sense into my movements. While I was the most unexotic of children (stolidly freckled and red-haired), the displacement from one side of the Atlantic to the other thrust upon me a slight bloom of the *unheimlich*. Following our move from Germany to Ontario I was treated as a 'Hun', only later to be regarded as a strange 'Eskimo' by my rural Welsh schoolmates. Both my sister and I became rather adept, in our separate ways, in negotiating the fine line between keeping up the difference (the seemingly constant cries of 'say something' allowed for the maintenance of a basic vocabulary of 'different' words depending on the country) and the need to appropriate enough of the local accent in order to avoid total ostracism (swear words being the preferred mode of group identification).

As a *néo-Québécoise* anglophone teaching in a francophone university, questions about where I come from continue, and although because I am white my experiences do not correspond with those of the black diaspora (nobody except rather virulent nationalists suggests that I should 'go back where I came from'), I am nonetheless marked by comings and goings.

The remembrance of rather cruel jibes as well as the simple discomfort of shifting makes it hard for me to subscribe to a current romanticization of the theorist as 'nomad'. It may be true that a certain class of academics do now increasingly travel around certain parts of the world giving papers at conferences held in lookalike Hiltons, but the pretension of homelessness strikes me as artificial. (It also overlooks the fact that the real academic vagrant is the junior or untenured professor who is forced from one small university town to another.) Baudrillard may wander across l'Amérique, but he remains a Frenchman, a Parisian, a superstar scholar, a visitor, with a firmly entrenched viewpoint as such. Indeed, the frankness with which Baudrillard describes his trip across 'America' is nearly refreshing; at least, he makes no bones about the fact that he is central to his accounts. As he bluntly states, 'For me, there is no truth of America. I only ask of Americans that they be American' (1986: 56). Strangely enough, or rather to confirm an utter disregard for local truths, the cover of *Amérique* shows a rather hazy photograph of Montréal, dominated by the Hydro Québec building which is at once the symbol of Québécois 'l'entrepreneurship' as well as the sign of white domination over native land (it also houses the office of the Liberal premier, Robert Bourassa, who is currently trying to father 'Son of James Bay' – a second massive hydro-electric complex, like the earlier one to be located on the traditional lands of the Cree). That Montréal does not figure large in his book does not bother Baudrillard, nor do the aspirations of the francophone Québécois to be and not to be American. It is not the old colonial story of France, nor the problems of 'New France' that attract him: 'Why would I decentralize myself in France, in the ethnic and the local, which are but the crumbs and vestiges of centrality? I want to ex-centre myself, to become eccentric, but in a place which is the centre of the world' (ibid.: 56).

LEAVING HOME

This tramping about the world is particularly evident as a central trope of ethnography. As Lawrence Grossberg argues:

> the travel metaphor seems quite appropriate to ethnography. To put it simply, ethnography is always about traversing the difference between the familiar and the strange. The ethnographer leaves her home (the familiar) and travels to the other home (the strange), and then returns home to make sense of it in her writing.
>
> (1989: 23)

In this chapter I want to consider the fairly recent emergence of the self within some ethnographic writing. Contrary to the 'she' that Grossberg refers to, it is, by and large, a male self that emerges here. Thus, although the history of anthropology has been marked by many notable female selves, I

will focus on the trials and tribulations of male ethnographic writers as they expose themselves in various textual forms. Given the way in which masculinity is so often constructed as the unremarkable norm, it is perhaps not surprising that even the most torrid of ethnographic self-reflexivity leaves untouched material questions about the gender, sexuality and class of those who conduct the self-reflection. Through an analysis of self-reflexivity we find a prime example of how certain disembodied masculine selves emerge as central at the expense of the materiality of others.

As Grossberg reminds us,

> Ethnography is, in the first instance, a certain kind of practice in the field, although it is not clear what sort of practice. Additionally, ethnography is a writing practice in which the other is inscribed within, and explained by, the power of the ethnographer's language.
>
> (ibid.)

The 'postmodern' ethnography of James Clifford and others is of particular interest here, caught as it is within the dilemmas of competing experiences (his or others'), discourse and representation, truth and strangeness. Generally one could say that the use of the self in ethnographic accounts and theory is motivated by the postmodern claim that science, along with other metanarratives, is no longer sufficient to the task of describing the world. This is an especially difficult blow to a discipline which was characterized by one of its forefathers as being rescued by scientific truth:

> The time when we could tolerate accounts presenting us the native as a distorted, childish caricature of a human being are gone . . . This picture is false, and like many falsehoods, it has been killed by science.
>
> (Bronislav Malinowski cited in Pratt 1986: 27)

Of course, postmodern ethnography cannot subscribe to this overwhelming belief in science. As Robert Young argues, (following Derrida) 'the constitution of anthropological knowledge, though often paraded as scientific and objective, is nonetheless governed by a problematic of which it seems unaware: the philosophic category of the center' (1990: 18). Young rearticulates this problem as the problematic of postmodernism which, he states, 'can best be defined as European culture's awareness that it is no longer the unquestioned and dominant centre of the world' (ibid.: 19). Interestingly enough, Young dates the use of the term 'postmodern' to Arnold Toynbee's *A Study of History* (1934–61), where Toynbee critiques 'a current Late Modern Western convention of identifying a parvenu and provincial Western Society's history with "History", writ large, sans phrase' (Toynbee, ibid.). This is, in Toynbee's words, 'a distorting egocentric illusion to which the children of a Western Civilisation had succumbed like the children of all other known civilisations and known

primitive societies' (ibid.). While Toynbee's widespread gesture to include all 'known' societies be they 'primitive' or 'civilized' immediately raises the question of which 'egocentric' child is now doing the knowing, his remarks are central to the matters at hand. In other words, the question is one of the position of the knower in relation to the stories that he tells. Young offers a tentative distinction between postmodernism and post-structuralism that revolves around the point of the story/teller: 'The difference would be that it [poststructuralism] does not offer a *critique* by positioning itself outside "the West", but rather uses its own alterity and duplicity in order to effect its deconstruction' (ibid.). And on the other hand, 'postmodernism itself could be said to mark not just the cultural effects of a new stage of "late" capitalism, but the sense of the loss of European history and culture as History and Culture, the loss of their unquestioned place at the centre of the world' (ibid.: 20).

Given these intellectual conditions, it is hardly surprising that there has been, of late, a great deal of interest in ethnography's 'problems' both within the discipline of anthropology and from other fields of study. Although they are not limited to ethnography, certain problematics seem to appear more pressing from its perspective, questions about the (im)possibility of representing others; the increasingly unstable con-struction of the white male as expert; the eclipse of science as a ruling metanarrative. In short, questions about where one can speak from, to whom one speaks, and why one speaks at all seem to be more immediately articulated within ethnography than elsewhere. The urgency of these dilemmas is all the more striking given the ways in which anthropological practice has historically articulated questions of the self and of the other and their respective experiences as a material object of inquiry to be scientifically studied. As Clifford Geertz puts it:

> It may be that in other realms of discourse the author (along with man, history, the self, God and other middle-class appurtenances) is in the process of dying; but he . . . she is still very much alive among anthro-pologists. In our ingenuous discipline, . . . it still very much matters who speaks.
>
> (1988: 7)

While Geertz may be sure of the fact that he is speaking, securely positioned among God, man and the rest, ethnographic writers such as James Clifford, George Marcus and Michael Fisher are busy ridding their domain of such antiquities. According to Clifford: 'ethnography is moving into areas long occupied by sociology, the novel, or avant-garde cultural critique' (1986a: 23). Ironically, just as practitioners in other disciplines seem to be drawn to ethnography because of its promise to delve into the 'concrete' (in the hopes of finding 'real' people living 'real' lives), ethnography is becoming increasingly 'textual'. Of course, the idea that

there is a real out there somewhere is a rather problematic one in itself. Nevertheless, to outsiders, ethnography seemingly offers a promise of materiality, the lure of the honest quotidian. As Radway puts it: 'anthropologists have at least aimed through ethnography to describe the ways in which day-to-day practices of socially situated individuals are always complexly overdetermined by both history and culture' (1988a: 367). Ethnography then is seen as a possible way into the personal, a potential grasping of the individual's specificity. Gail Valaskakis thus conceives of ethnography as a way of considering 'anew the significance of the relationship between personal experience and authority, accuracy and objectivity, narrative and understanding' (1988: 267–268). In these ways and others, the pull to ethnography is strong. However, in the rush to discover the reality of the self and the other, certain distinctions between ontological constructions and epistemological justifications are lost. Thus, while I am also an outsider to the field, I too am drawn to the self-reflective moment within ethnography; more voyeur than practitioner, the reason that I find myself here is to problematize the operations of the ethnographer's self. Moreover, in the give and take of disciplinary poaching that for many characterizes postmodern inquiry at the moment, some of the epistemological and ontological assumptions that underpin self-reflexive ethnography are, perforce, common to the social sciences and the humanities at large.

In fact, self-reflexivity is a rather global term used to describe quite different operations. On the one hand, self-reflexivity is used to describe a metatheoretical reflection upon the activity of writing texts. On the other, it is also employed to name a phenomenological or experiential moment of interacting with others in the field. Geertz places these types of question in the historical context of anthropology, caught between an anxiety over subjectivity and desire for empiricism.

With the emergence of self-reflexivity in ethnography, epistemological and ontological questions about subjectivity come more immediately to the fore. In simple terms, we need to ask what exactly a self-reflexive self is reflecting upon. In addition, it needs to be clear where that self is positioned and whether it is a textual or physical entity. The movement that Grossberg describes as quintessential to ethnographic 'traveling' from 'her home' to the home of 'the other' and then back home again is a physical displacement but it is also directed by the imperative of (publishing) the text. Inherent to both of these activities is the process of encountering the strange and making it familiar. Indeed Freud's term, the *unheimlich*, can be translated as the unfamiliar or the un-homelike. This going to and from various 'homes' is quite literally the process of making the *unheimlich* into the *heimlich*, or the uncanny into the known.

This movement can be seen as one of location, which as a noun designates both the process of locating as well as an established place or

situation. Imbricated in 'location' are the methods by which research sites are located, and through which knowledges come to be ordered into a certain sequences. These sequences are, as often as not, congruent with established categories of knowledge and delineate which or whose experiences are valid, scientific and true. The epistemology that underpins the possibility of location most often works to fix the other, or the subaltern, outside of the sanctified boundaries of knowledge, determining her knowledge to be peripheral and inconsequential (as not fitting in with the sequence). At another level, we can recognize that ethnographic inquiry has a vested interest in noting the inconsequential nature of the experience of others and in fitting the strange into its familiar. This then means that the onus is on the other to fit her experiences into an understandable order. In the words of Waud Kracke, 'The important thing is not so much whether (the informant) affirms or denies (an interpretation) . . . but, rather, whether he then goes on to express the idea more openly . . . or make it more understandable' (cited in Marcus and Fisher 1986: 52–53).

While the epistemological stakes involved in this 'making understandable' should be clear, the meeting of the ethnographer's self and the self of the informant is also problematic at an ontological level. Here the process of rendering her self familiar to mine is fraught with major philosophical issues. It begs the question of whether 'being is always defined as the appropriation of either difference into identity, or of identities into a greater order' (Young 1990: 13). The location of identities into consequential sequences is also their placement into a larger order of knowledge. At one extreme, Emmanuel Levinas equates this will to the same as the very principle of war. Underpinning all ontological thinking, 'it establishes an order from which no one can keep his distance' (cited ibid.). The self (or a certain self) becomes monstrous, betraying 'an egotism in which the relation with the other is accomplished through its assimilation into the self' (ibid.). Following Levinas, Young sums up the project of Western History as ordered by the principle of an all-encompassing self: 'Ontology, therefore, outwardly directed, remains always centred in an incorporating self: "this imperialism of the same"' (ibid.: 14).

While this definition of ontology differs from the sense I am giving to the ontological level of and in analysis, it is clear that the stakes are considerable. And while I do not want to burden ethnographic writers with the weight of all of Western history and its accompanying violence, I do think it important to remember, as Levinas puts it, that 'the idea of truth as a grasp on things must necessarily have a non-metaphorical sense somewhere' (cited ibid.: 13). Quite simply, ethnographic accounts depend on 'non-metaphorical' productions of self: a construction caught up in the history of actual ethnographers in the field. As Geertz argues, the duality and the materiality of the self/other and the self/text are embedded in ethnography's past and present. Simply put, both of these moments

involve material beings. The physical closeness of one self (the ethno-grapher's) to the other (the informant) is in part responsible for the difficulty of the relation of the ethnographer's self to (his) text. According to Geertz, 'The difficulty is that the oddity of constructing texts ostensibly scientific out of experiences broadly biographical, which is after all what ethnographers do, is thoroughly obscured' (1988: 10). The slippery move between biographical accounts of the other to autobiographical tales of oneself is mired in a veneer of scienticity which in turn de-materializes and disembodies the ethnographic exchange.

The difficulty of combining the intimate and scientific has led some of Geertz's colleagues to construct the problematic of the self facing the text in such a way that it overwhelms questions about facing the other. I would also add that there is something particularly 'manly' about past ethno-graphic accounts of entering into the other's world that provide the condition of possibility for the current distancing of the textual self. Raymond Firth's 1936 account of encountering 'Primitive Polynesia' is a wonderful example of the heroic white man embarrassed by the 'primitive' being he so desperately seeks. Here Firth places himself firmly in his text: 'The sullen gray day with its lowering clouds strengthened my grim impression of a solitary peak, wild and stormy, upthrust in a waste of waves' (cited in Geertz 1988: 11). This description sounds like something out of a romance novel or a scene in an old film – the crashing wave metaphor signalling male lust and conquest. And for some reason or another, the strangely thrilling tones of Firth's prose brings to my mind a poem written by John Keats as an ode to the man who translated, and thus rendered understandable, the work of Homer. Listening to the final lines of 'On First Looking into Chapman's Homer', one finds a familiar figure of the intrepid adventurer, the valiant white seeker of Knowledge:

> Yet did I never breathe its pure serene
> Till I heard Chapman speak out loud and bold:
> Then felt I like some watcher of the skies
> When a new planet swims into his ken;
> Or like stout Cortez when with eagle eyes
> He stared at the Pacific – and all his men
> Looked at each other with a wild surmise –
> Silent, upon a peak in Darien.
>
> (Keats 1977: 72)

Of course, Cortez never actually reached the Pacific, but Firth certainly found his 'crowds of naked chattering youngsters . . . [who] darted about splashing like a shoal of fish, some of them falling bodily into pools in their excitement' (cited in Geertz 1988: 12). Amongst all this exuberance and physicality, it is not surprising that Firth asked himself 'how such turbulent human material could ever be induced to submit to scientific study' (ibid.).

In an effort to calm the material 'excessiveness' of the other, ethno-graphic description turns to the problems of textuality:

> the most interesting theoretical debates . . . have shifted to the level of method, to problems of epistemology, interpretation, and discursive forms of representation themselves, employed by social thinkers. Elevated to a central concern of theoretical reflection, problems of description become problems of representation.
>
> (Marcus and Fisher 1986: 9)

Far from the 'upthrusting' waves in which grown (white) men jostle with naked boys, self-reflection (turning the critical gaze upon the self) becomes the key to Marcus and Fisher's endeavours to render 'anthropology as cultural critique', to get round the very materiality of bodies implicated in self/other relations. Along with much less exciting prose, this project is also weakened by a tendency to (ab)solve all of anthropology's problems by invoking a self-critical stance. This stance is an ironic one and for Marcus and Fisher irony is the name of the game: 'Periods of heightened irony in the means of representing social reality seem to go with heightened perceptions throughout society of living through historic moments of profound change' (ibid.: 15).

This rather large claim about society and their naming of it as ironic then serves to legitimize their proposals for 'self-conscious writing strategies' (ibid.). Here Marcus and Fisher obviously are referring to a 'postmodern' period, yet their account is solidly anchored in the West as reference point. They also seem to be taking Hayden White's 'troping of history' a little too literally. While White's (1978) account of the historiography of the West does indeed insist upon a fourfold schema of tropes as modes of fashioning history, White's project remains firmly within a meta-description of the relation between the story of history and the Piagetian story of human consciousness. Thus for White, 'self-conscious and self-critical discourse mirrors or replicates the phases through which consciousness itself must pass in *its* progress from a naive (metaphorical) to a self-critical (ironic) comprehension of itself' (1978: 19). Although White's formulation of historiography is heavily metaphorical, he does not go as far as making concrete equivalences between modes of description and actual historical moments. In other words, within White's project historical times are not automatically 'ironic' merely because irony seems to be in use. However, in their rush to elevate their discipline, Marcus and Fisher tend to lose sight of the specificity of ethnographic activity as it is situated within a certain time and place; they lose sight of the differences involved in social formations, means of representation, academic epistemologies and the materiality of their effects.

In resorting to the ironic to explain and equate various disparate cultural elements, Marcus and Fisher tend to underplay the very specificity they

argue for. Since they make no differentiation between the writing of a novel and the execution of a fieldwork report, there is little sense that who is writing what, and where, might matter. Without an epistemological critique of the conditions that allow for certain anthropological knowledges, Marcus and Fisher end up privileging a self-reflexive anthropology which posits a self-reflexive, a self-knowing ethnographic author. This, however, does not entail a critical examination of the discourses that enable the ethnographer to write 'innovatively' of the other. Cut off from an examination of how he got 'there' (in the field as well as in the text), the ethnographer's self, like Keats' Cortez, stares in 'wild surmise' at the other. But like the body of water which was not the Pacific, the other here is but an effect of the ontological construction of the ethnographer's self; the other is still a fiction of the ethnographer's own making.

WHERE DO PROBLEMS COME FROM?

In contrast to Marcus and Fisher, James Clifford begins his elaboration of the need for ethnographic self-reflexivity from an explicitly epistemological point of view. Thus Clifford asks: 'When is a gap in knowledge perceived, and by whom? Where do "problems" come from?' (1986a: 18). He finds 'a discursive partiality' in several ethnographic texts which he then equates with 'gaps in knowledge'. In *Writing Culture* (1986) Clifford expands upon two examples to illustrate this discursive partiality: 'The first involves the voices and readings of Native Americans, the second those of women' (Clifford 1986b: 15). It soon becomes clear that Clifford needs these 'marginal' voices to continue with his formulation of self-reflexivity and partial discursivity. These marginal others then allow 'writers to find diverse ways of rendering negotiated realities as multi-subjective, power-laden, and incongruent' (ibid.). While this attention to the power relations involved in describing is indeed a necessary basis from which to investigate 'gaps in knowledge', Clifford stops half-way. Despite good intentions, he does not follow through on where larger problems come from, and indeed he unwittingly adds to them himself. Thus while he lauds the Lakota ensemble of texts as opening up 'new meanings and desires in an ongoing cultural poesis' (ibid.: 16), the fact that the Lakotas' lives, myths and beliefs are authored by a dead ethnographer does not overly trouble him:

> Western texts conventionally come with authors attached. Thus it is perhaps inevitable that *Lakota Belief*, *Lakota Society*, and *Lakota Myth* should be published under [James] Walker's name.

> (ibid.: 17)

In a similar move, Clifford credits feminism for showing that a 'great many portrayals of "cultural" truths now appear to reflect male domains

of experience' (ibid.: 18). He writes that feminism 'debates the historical, political construction of identities and self/other relations, and it probes the gendered positions that make all accounts of, or by, other people inescapably partial' (ibid.: 19). The other, be she feminist or non-Western, serves to remind Clifford that

> issues of content in ethnography (the exclusion and inclusion of different experiences in the anthropological archive, the rewriting of established traditions) became directly relevant. And this is where feminist and non-Western writings have made their greatest impact.
>
> (ibid.: 21)

However, at a practical, material and even political level, this attention disappears when Clifford and Marcus exclude feminist and non-Western writers from their book (Clifford and Marcus 1986). In a by now familiar postmodernist trope, the other is sought but never materializes in the actual text. Clifford's previous question, 'where do problems come from?', begs another: 'whose self is more important?' The fact that Clifford builds his argument for 'partial discursivity' and self-reflexivity upon the example of the other, only then to ignore her has to be taken seriously; it indicates both an ethical and an epistemological weakness in Clifford's argument. In this case, problems arise when some selves are more important (invited to seminars, published and cited) than others, some selves move while others are rendered stationary.

The absence of certain voices is all the more surprising because of Clifford's insistence on the textual operations involved in ethnographic writing. However, Clifford's privileging of the textual also effectively avoids the more problematic aspects of the materiality of ethnographic practice – be it in the field or at home. For example, in his article 'On Ethnographic Allegory' (1986a), Clifford argues that 'A recognition of allegory complicates the writing and reading of ethnographies in potentially fruitful ways' (1986a: 120). In describing some ethnographies as allegories Clifford wants to stress that they are textual productions; that these are not truths. As he points out, 'Allegory prompts us to say of any cultural description not "this represents, or symbolizes, that" but rather, "this is a (morally charged) *story* about that"' (ibid.: 100). In emphasizing that allegories are stories, that they denote 'a representation that "interprets" itself' (ibid.: 99), Clifford circumvents the actual being of the ethnographic author. Thus, 'once *all* meaningful levels in a text, including theories and interpretations, are recognized as allegorical, it becomes difficult to view one of them as privileged, accounting for the rest' (ibid.:103).

While Clifford's insistence upon the allegorical nature of ethnographic accounts does deconstruct any privileging of science as arbiter, it does not solve the epistemological and ontological tensions created through

ethnographic practice. Clifford wants to argue that the 'valuing of multiple allegorical registers' allows other voices to participate in ethnographies (ibid.). Thus he states that a recognition of allegory has 'meant giving indigenous discourse a semi-independent status in the textual whole, interrupting the privileged monotone of "scientific" representation' (ibid.). Clifford's move here is admittedly an elegant one: in shifting the whole ethnographic activity to the level of writing (and ultimately, reading), he has displaced attention away from local fieldwork practices. In other words, he has turned the normal order of things upside down. Instead of the usual procedure of fieldwork research followed by the ethnographic text, the text takes prominence. While Clifford hopes that this arrangement will ensure the inclusion of other voices, it seems more likely that further emphasis will be placed on the ethnographer. The recognition that ethnographies are stories, with several levels of possible interpretations, is an important one. This recognition, however, cannot be taken as necessarily indicative of a lessening of the ethnographer's power. On the contrary, the emphasis on textual operations may further centre the researcher's self in relation to the text. Whose stories are being told to whom?

Clifford concludes his argument on allegory by setting out a relationship of writer/text/reader:

> Finally, a recognition of allegory requires that as readers and writers of ethnographies, we struggle to confront and take responsibility for our systematic constructions of others and of ourselves through others. This recognition need not ultimately lead to an ironic position – though it must contend with profound ironies. If we are condemned to tell stories we cannot control, may we not, at least, tell stories we believe to be true.
>
> (ibid.: 121)

While there is a gesture here to acknowledge the epistemological implications of ethnographies (that we should struggle over the systematic construction of others), a privileging of allegory will not get him there. Certainly, as Clifford argues, 'Allegory draws special attention to the *narrative* character of cultural representations' (ibid.: 100). This, however, merely reinforces the notion of the ethnographer as the central storyteller, who renders the 'strange' familiar for his readers back home. The ethnographer thus constructs ontological truths that can be understood in terms of a shared (Western male) perspective. As Clifford himself states, 'ethnography's narrative of specific differences presupposes, and always refers to, an abstract plane of similarity' (ibid.: 101). In the final analysis, Clifford can only say that we tell stories that we can't control; as he has stressed earlier in citing Coleridge, 'allegorical writing [works] to convey . . . either moral qualities or conceptions of the mind that are not in themselves objects of the senses, or other images, agents, fortunes, and circumstances'

(Coleridge, cited ibid.). In short, what Clifford is arguing is that ethnographers' stories present the 'fables of identity' of either the person or the culture to which he belongs. Thus, even if we cannot control them, we can describe the foreign object in familiar terms, outside of the constraints of its circumstances. If this is so, then Clifford's final remark becomes tautological; we must believe these stories to be true in that they belong and operate within our own terms. In other words, ethnographic stories are ontological constructions built around the figure of the ethnographer's being. Ultimately then, Clifford has elaborated a careful argument to prove what the marginal has known for a long time – he who pays the piper calls the tune.

BEING THERE

Against Clifford's determined move to render ethnography a purely discursive activity, constructed through the ethnographer but emptied of bodies, Geertz is quite emphatic about the actuality of the ethnographer. His *Works and Lives* (1988) places the ethnographer in his doubled setting: a physical being in the field who then writes up his experiences at home. As Geertz puts it:

> However far from the groves of academe anthropologists seek out their subjects ... It is Being Here, a scholar among scholars, that gets your anthropology read ... published, reviewed, cited, taught.
>
> (1988: 129–130)

In response to Clifford's privileging of the self/text, Geertz sees ethnography as a fairly straightforward enterprise. Thus the ethnographic account for Geertz rests upon:

> [the anthropologists'] capacity to convince us that what they say is a result of their having actually penetrated (or, if you prefer, been penetrated by) another form of life, of having, one way or another, truly 'been there'.
>
> (ibid.: 4)

This then is a clear description of the necessary ontological moment of the ethnographic endeavour. The ethnographer exists in his or her ability to convince us of another 'form of life', of the fact that their beings have been in contact with others. In turn, the ethnographic text is part and parcel of the ethnographic experience. It is the record of 'penetration', and describes 'a present – to convey in words "what it is like" to be somewhere specific in the lifeline of the world' (ibid.: 143).

This description of the ethnographic project is obviously quite different to those of Marcus and Fisher, or Clifford. Both the ontological and epistemological requirements of ethnography are summed up for Geertz

in the words of Baron Munchausen, 'Vas you dere, Sharlie?' (ibid.: 5). In other words, ethnographic knowledge depends upon the fact that the ethnographer is 'there' and that he or she then conveys that special order of reality that constitutes 'being there'. Here 'the other' is not merely on the page, or in the text; the figure of 'the other' is inherently bound up with the ethnographer's being 'over there'. 'The other' then comes to exist in the ethnographer's act of remembrance. Once again we are confronted with the contradictory requirements of ethnography – moments of being, filtered through the memory of the ethnographer, are rendered as texts and knowledges.

From Geertz's depiction of the discipline, we can say that ethnography's object of inquiry includes the lived and the experiential. Ontological moments (those 'experiences broadly biographical') are a necessary condition of possibility within ethnography. Geertz is quite clearly concerned with the ethnographer's being, over that of the other; the only way to know 'the other' is in relation to ourselves: 'We begin with our own interpretations of what our informants are up to or think they are up to, and systematize these' (Geertz cited in Rabinow 1983: 65). Thus, the informant is conceived through the figure of the ethnographer. While Geertz's own particular structural/semiotic project of interpretation then 'systematizes' what 'the informant thinks he is up to', it is obvious that the ethnographer is the nodal point here. Ethnography, then, is a 'person-specific' endeavour and needless to say, that person is the researcher. In contrast to Clifford's conclusion that we finally have to rely on a belief that some stories are truer than others, Geertz puts the onus on the ethnographer's ability to convey his 'close-in contact with far-out lives', 'we listen to some voices and ignore others' (ibid.). It is the ability to convey that special order of reality, the phenomenological reconstruction of the experience of being in the field, that will get you listened to. Thus, for Geertz, the ethnographer's self is constructed both in the field and at home in his or her texts, but s/he must have 'been there' before facing the page. As Geertz puts it, '[g]etting themselves into the text . . . may be as difficult for ethnographers as getting themselves into the culture' (ibid.: 17). Difficult as these two activities of the self may be they are, for Geertz, what ethnographers do.

Although Geertz is silent about the matter, it seems that a privileging of 'being there' would raise questions about how one actually gets there and what happens to the 'there' as the ethnographer arrives, stays and then leaves. As Edward Said has argued about Orientalism, historically the entrance is easy; the scientist, the scholar, the missionary, the trader 'or the soldier was in, or thought about the Orient because "he could be there" . . . with very little resistance on the Orient's part' (Said 1979: 7). While Said's argument proposes a deconstruction of the historical grounds that allowed for the economic and discursive appropriation of Asia, his attention to the

physicality of 'being there' is especially important here. Hence, the fact that one 'could be there' is a necessary condition for 'being there' and also stresses the 'was there'. The discursive possibility of the Orient (the ways in which it is figured as a knowable entity) is articulated with the fact that it has been physically known, visited and appropriated. Knowledges are bound up with bodies and authors with effects. As Said argues:

> if it is true that no production of knowledge in the human sciences can ever ignore or disclaim its author's involvement as a human subject in his own circumstances, then it must also be true that for a European or American studying the Orient there can be no disclaiming the main circumstances of *his* actuality.
>
> (ibid.: 11)

So one of the hidden grounds of ethnography's possibility is that ethnographers can 'be there'. Although Geertz does describe quite closely the written entrance scenes of various ethnographers, his analysis is concerned with the different textual styles they employed – 'Dickensian exuberance and Conradian fatality' (Geertz 1988: 13). Two major questions are never raised: first, what other factors were necessary (economic, historic, social, etc.) for the arrival, for getting and staying 'there'; and second, what were the 'main circumstances of the ethnographer's actuality', once 'there'. It must be emphasized that ethnography has always demanded its share of bodies, and has choreographed them in particular ways. We can, therefore, assert that there is a certain articulation of historical practices that allows for the possibility of 'person-specific' ethnographic accounts, and that those accounts are attached to real bodies which then spawn effects that are both textual and non-discursive. In addition, there are reasons other than rhetorical choices that result in some accounts being heard, while other voices are ignored.

One way to analyse this complex situation is to look at the tension and intercalation of experiential and textual levels within ethnography: 'being there' articulates ontological moments within the truth statements of ethnography. These truth statements or knowledge relations must be recognized as being organized around and through the figure and the actual experiential self of the ethnographer. Just as in Said's argument colonialism depends on the fact that the soldier, missionary or scholar could be there and actually was there, ethnography's twin conditions of possibility are the potentiality of having been there and the ability to convey this fact. Of course, the movement between these two requirements of ethnography has a wider significance. As Ian Hacking reminds us, 'although whichever propositions are true may depend on the data, the fact that they are candidates for being true is a consequence of an historical event' (cited in Rabinow 1986: 237). Thus the rendering of the field-work experience into 'data' and the ways in which some 'biographical

experiences' become 'candidates for being true' are both epistemological and ontological issues.

Before turning to a consideration of some exemplars of 'self/other' ethnographic texts, I want to be specific about the ontological and epistemological stakes that the ethnographic self brings to the fore. As I have argued, the 'new ethnographers' such as Marcus and Fisher, and Clifford, want to elevate the ethnographer and his subjects into a realm of pure discursivity. While Geertz critiques this move he avoids, without rearranging, the hierarchical ordering of knowledges that has historically operated within the discipline. So while the former advocate a 'polyphonic' text as a way of ensuring that the voices of the informant are on an equal footing with that of the ethnographer' Geertz argues that the burden of authorship cannot be displaced 'onto "method", "language", or . . . "the people themselves"' (Geertz 1988: 140). Neither of these moves, the acceptance or the deferral of ethnographic authority, comes to grips with the ontological status of the ethnographer self and the actual effects on ethnography's subjects and objects both within the text and outside – in the field or in the seminar room. As Paul Rabinow remarks, 'meta-ethnographic flattening . . . makes all the world's cultures practitioners of textuality' (1986: 250). But, of course, we all know that only some textual practitioners are heard. However, if Clifford 'is not talking primarily about relations with the other, except as mediated through his central analytic concern, discursive tropes, and strategies' (ibid.: 251), we need to ask what ethnography is reflecting upon. Rendered as a disembodied instance of language, devoid of any political import, then, 'what matters who is speaking?' To my mind, the fact that the materiality of the other is made to disappear within ethnographic self-reflection, only to reappear as a textual figure, renders it imperative that we know who is speaking. A self is speaking, and the exigencies of feminist analysis require that we make it matter that some speak and that others are merely spoken. This is not to indulge in 'rhetorical earnestness' (as Geertz characterizes the new ethnographers), but to remember that academic practices deal in real bodies and that textual selves have effects outside of their discursive homes.

DISTANT VOICES

As Radway states, 'We "know" about others because we have the power to distance them through our access to the means of representation' (1989: 4). A notable and common distancing element in self-reflexive ethnographies is the return to a field previously visited and described. This return rarely entails a physical voyage, but rather constitutes a 'second look'. If, as Geertz pointed out, one cannot go back and check the immediacy of the empirical data, it seems that nothing gets in the way of

recalling the field across the miles and years. Thus the self-reflexive move starts with a distancing of the experiencing self of the field from the 'I' who rewrites that experience. Jean-Paul Dumont's book, *The Headman and I: Ambiguity and Ambivalence in the Fieldworking Experience* (1978), comes after the fieldwork and its textual rendition, and reflects upon those previous experiences. Much like traditional autobiographies, the idea here is to re-collect the past around the figure of the self. Dumont's central question in his textual return is 'Who (or what) was I for the Panare?' (1978: 4). He describes a relation between '"I" and "they"' as a development of 'progressivo-regressive stages: a confrontation, a search for meaning, and, optimally, a recognition' (ibid.: 5). Dumont's 'anthropological reflection' constitutes the final stage (or in Dumont's terms, 'the synthesis') 'at which point the other is recognized in his/her otherness' (ibid.). Not surprisingly, the context for this recognition is Dumont himself: 'the anthropologizing subject is the occasion, the pretext, and the locus of a drama that he/she is to reflect upon' (ibid.: 12). The gaze is turned inwards because 'The studied people are not there, passively waiting for me to take their picture' (ibid.). However, the anthropologist is there and as the 'locus' of reflection poses for Dumont, 'the necessity of using myself as a discovery procedure' (ibid.). Dumont situates his work within the larger post-colonialist era, and proposes self-reflection as 'the path toward listening to what "the rest" are telling us with voices that are no longer faint, despite their progressive depletion' (ibid.: 13). With a fervour that would cause Geertz to cringe, Dumont constructs self-reflexive eth-nography as an antidote to the articulation of anthropology as imperialism. He ostensibly takes his motto from a comment by an Oglala Sioux: 'Custer died for our sins indeed, but from now on, you talk, we listen' (ibid.).

Dumont then proceeds to talk about himself. He attempts to escape or displace the burden of (ethnographic) authority through a welter of confessional statements – a moving tale of himself. As he describes his interaction with the Panare, Dumont willingly tells of his 'objective as well as objectional view of [them]' (ibid.: 131). His 'objective' stance turns 'objectional' as he is threatened by the loss of control of his self and his authority:

> When I thought that I could take advantage of the situation – that is, that I could ultimately control it – I greatly underestimated the capacity of the Panare to outfox me. I overlooked the ability of the 'objects' to remind me that they were 'subjects' indeed and that I had no manipul-ative monopoly.
>
> (ibid.)

But it is only in retrospect that Dumont relinquishes his 'manipulative monopoly'. Self-reflexivity is the mechanism that supposedly allows Dumont to recognize the otherness of his self and even the self of others. In

retelling the moment of 'confrontation', in hindsight Dumont can produce 'the recognition'; the moment when 'the other is recognized in his/her otherness' (ibid.: 5). But, of course, it is only though his self that this recognition can occur:

> My existence had finally emerged. They and I were now in a new situation, being involved in a new relation of compatibility that neither the extremes of subjectivism nor of objectivism, with the relations of dominance that they imply, could have brought forth. I had finally entered Panare culture.
>
> (ibid.: 66)

This moment of recognition, this supposedly free relationship, is Dumont's recollection of having been adopted by the Panare. What he calls his 'new and faked adoption' results in the fact that 'the whole kinship terminology of the Panare was up for grabs for the avid anthropologist' (ibid.: 65). Through this adoption Dumont finds himself within the kinship network: 'since Domingo Barrios was my "son", Marquito was my "yako", my "brother"' (ibid.). Dumont argues that this adoption was mutually beneficial to himself and to Marquito:

It was equally evident to everybody that my fictive consanguinity with him was a powerful symbol. Even though its power was limited to the duration of my fieldwork, as long as it lasted, it was manipulated as much by Marquito as by me.

> (ibid.: 130)

Dumont wants to portray his dealings with the Panare as a two-way relationship. He specifies what the Panare thought they could get out of him: 'There is no doubt that in [Domingo's] opinion I was what in the U.S. would be called a fat cat' (ibid.: 132). As such, Dumont's worth to the Panare was as a provider of goods. It is a situation that Dumont does not relish:

> His [Domingo's] constant and somewhat childish demands, always articulated in a kinship idiom, truly exasperated me . . . Trapped as I was in this situation, I stood as firm as possible, miserly as ever, but that did not discourage his requests.
>
> (ibid.)

To take Dumont at his word, one might ask what type of 'recognition' is going on here; which 'other' is being recognized in his/her 'otherness'? It is clear from Dumont's account that he is recognized as someone with something to give (and presumably his reluctance to give is also recognized by the Panare). He is not so candid about what they offer to him. In other words, the Panare have recognized Dumont in 'his otherness', but what is their 'otherness' for him? It becomes obvious through his account (the

only one of that particular encounter that we can have access to) that the Panare offer what the objects of ethnographies have traditionally offered to ethnographers: their culture, their bodies, their selves. The Panare present their 'otherness' to him in the form of (that most traditional of ethnographic prizes) their kinship network. This fairly normal ethnographic situation (the ethnographer trades some material goods for a close look at the other's being) is rendered self-reflexive in Dumont's second version of his visit. However, the self-reflexivity of this account only serves to render Dumont all the more visible (a picture of the anthropologist, warts and all). While he does move the ethnographer in the text from behind a veil of objectivity onto centre stage, this manoeuvre does not enhance the other's position.

In fact, as Dumont-the-author emerges within the text, the Panare seem to disappear. This evacuation of the other is surprising in that Dumont has critiqued this tendency. In his introduction Dumont talks about the confessional nature of unconventional ethnographies of the 1960s and finds fault with their representations of 'the other' on the grounds that 'The human group that the anthropologist studied became the pretext for his/her lyricism, and by the same token almost disappeared' (ibid.: 9). Given this critical acknowledgment of the dangers of 'self-indulgence', Dumont's own entrapment within his self is intriguing. However, the trouble stems less from Dumont's 'lyricism' than from his model of how the ethnography should proceed and what it should achieve. Dumont posits that '[t]he search for meaning corresponds to the dialectic process in which an exchange takes place, one in which they figure me out and I figure them out, so to speak' (ibid.: 5). This dialectic is based, for Dumont, on the self-reflexivity of the ethnographer as he proceeds towards a mutual 'otherness'. The problem here is that 'otherness' is constructed as an ontological moment: he posits a separate realm of reality that is contingent on the mingling of being (self/other). This attention to the self is grounded in Dumont's manoeuvre of exposing himself, yet this self is revealed to us only in his textual account. While it is possible that the Panare may later read this account of Dumont's self and realize that he had more to give than tobacco and other material objects, it is unlikely. The point here is twofold: first, self-reflexivity emerges through the textual rendition of the encounter; it comes after 'being there'; second, Dumont has more at stake in constructing his self within the otherness of the Panare than they do within his. Dumont calls this, 'I' becoming 'they', an equation which makes perfect ethnographic sense but which doesn't seem to have happened. Rather, 'they' became the stationary other that underpins Dumont's textual self.

What we can see in Dumont's *The Headman and I* is an ontologizing of the ethnographic process. His insistence on a moment of his being obscures the epistemological weakness of his proposed dialectic of

otherness. The goal of this dialectic is to produce new selves within the field, but the result is the construction of an ontological self freed from the epistemological stakes of ethnography. Paradoxically, the creation of a privileged ontological moment (the representation of 'my' being in the field with 'them') can only be achieved after the fact. Self-reflexivity enters at the point of the text, not in the field: 'The interpretation of the relationship between the Panare Indians and myself requires what I would like to call a return to the text' (ibid.). Here the 'self/other' equation meets that of the 'self/text' with a resulting emphasis on the ethnographer's self in relation to the other and the text. So Dumont uses the categories both of 'the other' and of the text to reproduce the ontological validity of his realm of being which, in turn, allows for his ethnographic accounts. In so doing he impresses upon us the fact that he indeed was 'there'. Thus the ontological imperative of ethnography is articulated with the ontological supremacy of the ethnographer's self.

Paul Rabinow's *Reflections on Fieldwork in Morocco* (1977) is another example of the new wave in self-reflexivity. Rabinow is more circumspect in his claims than Dumont; in fact, he immediately pokes fun at the grandeur associated with 'being an anthropologist': 'I left America with a sense of giddy release. I was sick of being a student, tired of the city, and felt politically impotent. I was going to Morocco to become an anthropologist' (1977: 1). This opening at once gives us a sense of Rabinow's self before he enters the field. Unlike Dumont, Rabinow does not construct his self suddenly upon entering the field, in relation to his constructed 'other'. Being in the field does not solely define Rabinow, and the field exists before Rabinow encounters/creates it. Moreover, the 'field' is also set against a 'here' (America) where Robert Kennedy has just been murdered. 'Getting there' includes 'leaving here' and arriving in Paris in June 1968 (a month too late, but meeting up with other people also fleeing the States), before finally reaching a very 'ethnographic' Morocco (ibid.: 1–10). Rabinow's self is clearly not dependent on the construction of the field as a separate ontological moment. The ethnographic experience is articulated here with other experiences, and has other dimensions. This perspective is then extended to include the other parts of his informants' lives. 'The other' does not spring to life upon meeting the ethnographer; he too is fully formed before the ethnographic encounter. As Rabinow describes it, a partial contact is all that is possible. There are no miraculous moments of ontological togetherness here:

> I could understand ben Mohammed only to the extent that he could understand me – that is to say partially. He did not live in a crystalline world of immutable Otherness any more than I did. He grew up in an historical situation which provided him with meaningful but only partially satisfactory interpretations of his world, as did I. Our Otherness

was not an ineffable essence, but rather the sum of different historical experiences.

(ibid.: 162)

Against Dumont's attempts to delineate an ethnographic self through 'otherness', Rabinow positions the goal of ethnography rather closer to earth. In clearly stating that Otherness is the necessary result of different historical experiences, he allows for the possibility of two sets of 'otherness' that one can hope to articulate only in partial ways.

For Rabinow the ethnographic process consists in jostling these two separate sets of historical experiences that constitute 'otherness'. Through this process 'naturalized' notions are challenged; as Rabinow says, 'my common-sense world was also changed' (ibid.: 38). Self-reflexivity becomes part of the ethnographic practices of 'highlighting, identification, and analysis' (ibid.). Everyday occurrences in the field demand a heightened level of awareness on the part of the ethnographer; 'they focused and dominated my consciousness' (ibid.). While this is not surprising, Rabinow also emphasizes the ways in which the informant has to go through the material process of rendering his or her familiar world into description. In the role of informant, 'the other' actively dissects his or her 'usual patterns of experience' (ibid.). Rabinow brings out the obvious but rarely stated fact that having to (or being paid to) describe his or her world to the ethnographer is a profoundly unnatural act. This is to insist upon the materiality of the process of description that the ethnographer initiates (the informant is chosen by him, spends a lot of time with him, is paid by him, etc.). As Rabinow says of one of his informants:

He was constantly being forced to reflect upon his own activities and objectify them . . . the more we engaged in such activity, the more he experienced aspects of his own life in new ways. Under my systematic questioning, Ali was taking realms of his own world and interpreting them for an outsider.

(ibid.: 38–39)

In contrast to the dictate of 'making the strange familiar' which informs much ethnography, Rabinow here concentrates on the ways in which, for the informant, the familiar is rendered strange. It is the informant's reality that is restructured in the process of telling. Instead of emphasizing the ethnographer's interpretations, Rabinow focuses on the informant, 'the other', as performing a difficult task of interpretation. This process has the effect of creating a sense of the strange in both ethnographer and informant:

he [Ali, the informant], too, was spending more time in this liminal, self-conscious world between cultures. This is a difficult and trying

experience – one could almost say that it is 'unnatural' – and not everyone will tolerate its ambiguities and strains.

(ibid.: 39)

So for Rabinow, the other's (forced) reflection upon his or her self and world is the major component of the ethnographic process. This is not Dumont's 'recognition of the other', but rather a process of de-naturalization whereby everything is rendered strange and *unheimlich*. Self-reflexivity becomes here an integral and uncomfortable process on the part of both parties, and not an object to be reified. As a practice it produces certain shared knowledges; in Rabinow's words, '[a]s time wears on, anthropologist and informant share a stock upon which they hope to rely with less self-reflection in the future' (ibid.). In this way, self-reflexivity and the jarring denaturalization of one's sense of self can be used to construct a mutual ground between the ethnographer and the informant. This mutual and momentary grounding of two material selves is then the limit of the ethnographic endeavour, a partial articulation of two sets of historical experiences. In Rabinow's words, '[t]he common understanding they construct is fragile and thin, but it is upon this shaky ground that anthropological inquiry proceeds' (ibid.).

To step back and compare Rabinow's construction of the ethnographic project with those of Marcus and Fisher, Clifford, Geertz and Dumont, we can immediately see a difference in emphasis. In spite of the differences in their projects, in contrast with Rabinow they are united in their use of ethnography as a means of constructing a fundamental similarity of the world's cultures which is firmly based in the referent of the West. For Geertz the ontological necessity of 'being there' operates to validate the truthfulness of this claim. For Clifford, it is an abstract plane of similarity. In Marcus and Fisher's words, ethnography is of interest because problems of description become problems of representation, the textual problems of how to render the different alike. This description of ethnography gets played out in Clifford's and Geertz's attention to the mechanics of writing ethnographies. Though they differ substantially, both are concerned with the hermeneutical project of 'making the strange familiar', and thus with the ways in which things (people, cultures, themselves) are re-presented in meaningful (and hence for them, similar) ways. A certain self, that of the ethnographer, is constructed in equivalence to an ontological ground which produces 'similarity'. In other words, the ethnographic project of making the strange familiar is dependent upon the articulation of the ethnographer's projected self over that of the informant. Dumont takes this to extremes as he posits the possibility of the other (e)merging in his (Dumont's) being. These projects therefore tend to reinforce the centrality of some selves over others. More importantly, self-reflexivity is fundamentally, in these textual ethnographic

projects, a practice that occurs at the moment of writing up the account, when you have returned from 'there'.

In Rabinow's account of Morocco a different sense and use of the self emerges. Here we have embodied selves involved in everyday practices:

> Most of the anthropologist's time is spent sitting around waiting for informants, doing errands, drinking tea, taking genealogies, mediating fights, being pestered for rides, and vainly attempting small talk – all in someone else's culture.
>
> (Rabinow 1977: 154)

That one may engage in these commonplace activities at home does not point to a larger plane of similarity. Rather it emphasizes the fragility of a potential but partial articulation of separate selves. For Rabinow, self-reflexivity is performed on both sides. It is a process that he calls 'intersubjectivity': 'mean[ing] literally more than one subject, but being situated neither quite here not there, the subjects do not share a common set of assumptions, experiences, or traditions' (ibid.: 155). The ground on which these separate selves meet is 'a public process' (ibid.); it is not a one-way textual recreation or representation.

MODEST SELVES

Rabinow's insistence on the partiality of the selves is a first step towards recognizing the doubled sense that Marx gave to the project of 'representation'. Remembering the distinction between *Darstellung* ('the staging of the world in representation – its scene of writing') and *Vertretung* ('representation in the political context'), Gayatri Spivak forcefully raises the twin difficulties of 'proxy and portrait' (1988: 276). And while, for historical, discursive and material reasons, the Western male self is free to roam the world, Spivak urges us to 'acknowledge that access to auto-biography, for whole groups of people, has only been possible through the dominant mediation of an investigator or fieldworker' (1986: 229). This historical fact is now joined with questions about whether 'the other' wants to tell the investigator of her world, of why indeed she should accept to be so named. As Coco Fusco states:

> the issue of 'the other' is one of power, of a dynamic between those who impute otherness to some and those who are designated as other. So the questions I ask about otherness have to do with how others or the other are spoken of, who is speaking about them, and why they have chosen to speak of the other at the given historical moment.
>
> (1990: 77)

That these problems are not confined to ethnographic practices is obvious; Fusco is talking here about 'the artworld's fetishization of "the other"'

(ibid.). My sole focus here on (only certain) ethnographers is probably unfair, yet both their discipline's historical trade in 'the other' and their current fetishization of self-reflexivity merit that they be taken at their word(s). As Fusco puts it, it seems, 'more often than not, to be a way of not talking about less appealing issues like institutional racism, and social and economic inequality among different ethnic groups' (ibid.).

One would imagine that reflexivity should, of necessity, include a questioning about issues of racism and social and economic inequalities. However, this is not the case as long as the reflexive gaze stops at its author: the self-centred self. It is not the process of being reflexive about one's research practices that is the problem; it is the conception of the self at work within this reflexivity that is at fault. This self reveals itself in its overwhelming ontological basis that draws the other, and all otherness, into its sphere; it is, as Levinas argues, 'the egotism of the preoccupation of being with itself' (cited in Young 1990: 14). It is the banal egotism which recalls to my mind what a French teacher said as he taught us about reflexive verbs: it is always 'je me brosse *les* dents' because 'why would you ever brush the teeth of someone else?' (I later learned that, of course, one can brush someone else's teeth in French, it's just no longer reflexive).

In opposition to this ontological egotism, Young formulates Levinas' proposition of 'a relation of sociality, whereby the self instead of assimi- lating the other opens itself to it through a relation with it' (ibid.). At its extreme, this is 'a movement of the same unto the other which never returns to the same' (Levinas, ibid.: 17). As a modest proposal, I want to posit the self as a theoretical movement into the text that carries with it the ontological traces of its local origins. This is to say that the self spoken invokes a particular moment of being, but that in its speaking it demands an acknowledgment of the conditions of its possibility, of its very existence. Quite simply, the sound of its 'ontologicality' must be met with an analysis of the positivity of its materiality. This is not to 'recognize the self in its otherness', but always to ask what had to be in place in order for this self to appear at all. Rather than embracing the other in a discursive relation wherein she disappears into the same, this self is an acutely self-conscious entity; her speech makes me feel strange. I should be clear here that I am not suggesting that we all remake ourselves as 'exotic', or as an undifferentiated equivalence of others among others; rather, I want to posit a self as a speaking position that entails a defamiliarization of the taken-for-granted. It is a speaking position that, in contrast to the ethnographers I have discussed, is firmly based in an epistemological questioning of how it is that I am speaking. Speaking my self thus should render me uneasy in my skin, *pas bien dans ma peau*, as it decentralizes any assurance of ontological importance.

Concretely I can rephrase my proposition as a call for a little more modesty in putting our selves forward. The self-aggrandizement of some

of the ethnographers I have cited gives flesh to Levinas' formulation of the egotism of the ontological self-same. While we cannot stop telling stories about ourselves and others, we can try to speak them from a position of some modesty, from an angle that skewers the inflation of the academic ego. While the self is integral to ethnography, the difficulties it poses cannot be solved by a move to pure discursivity. Rather than fleeing from the materiality of ethnographic selves, it might be more useful (and honest) to draw attention to the ways in which ethnographers have traditionally used their presence in the field to validate the knowledges they produce: the ontological construction of 'being there' that is necess-ary for ethnography's epistemological truth claims. However, the turn to a certain type of textual self-reflexivity cannot radically deconstruct this ontological centrality. In many cases, attention to the ethnographer's self merely serves to turn the gaze (once more) upon the researcher, as epistemology is imploded into ontological necessity. Against Levinas, I argue that this implosion is not inherent to the self (be it ethnographic or other); it is the effect of certain theoretical and textual practices. If we keep in mind the doubled sense of representation we may begin to think through ways of repositioning the relations between being a 'proxy' and producing a portrait. Simply put, ethnographic accounts are portraits, the image of the other a palimpsest through which we see ourselves. As I will argue in the next chapter, moving beyond this capturing of the other entails rethinking the very image of one's self in relation to the local, and the work this relation can be made to do as it (she and I) are put into discourse.

Chapter 4

Materializing locations
Images and selves

TO BOLDLY GO . . .

A few days ago I had the experience of lecturing about experience. To be more precise about it, I gave a talk about the category of experience within feminist cultural studies to a multidisciplinary seminar which carries the rather intriguing title of 'Les femmes devant les systèmes normatifs'. It was a puzzling experience: speaking of how my experience had informed the way in which I interpreted the theories of others made me feel like I was out on a limb with nothing beneath me. This was strange because the seminar is normally both a stimulating and comfortable place; composed of seven women professors from a range of disciplines and interested students, rigorous and even-handed intellectual give-and-take is the norm. However, the discussion following my talk *seemed* (this is, after all, my reconstruction) to revolve around the emotionality of my remarks. In my private post-mortem of the seminar, it felt as if I had gone where no woman had gone before. Before this is chalked up to delusions of grandeur, simple fatigue, or merely catchy images from *Star Trek*, I want to emphasize the irony of the situation: how could it be that raising the theoretical necessity of recognizing, of putting into words, the ways in which we read theory through experience should produce a feeling of isolation? Why should speaking something that is so common make me feel like an alien?

Coming down to earth I realized that the particularities of where we speak are as important to the signification as the content of what we are saying. The place where I was speaking hovered between the private and the public; for all its 'homey' feeling, in the final instance it was a classroom in a francophone university, an institution still touched by discursive traditions quite different from my own. Still, this does not explain why my enunciation of experience was taken as emotional, nor why that articulation bothers me.

The fact that it bothered me is perhaps, in part, due to the way in which some feminists of my generation at least are haunted by the 'touchy-feely' approach of feminism. In reaction to this, I have been guilty of the kind of

over-jargonizing (and I am not alone in this) which strives to render feminism somehow more 'scientific'. While we are quite literally based in emotions, current feminism, as a body of theories, flees emotionality. There are, of course, reasons for this as well, some of them internal to feminism. But some of them have to do with how feminism is sometimes viewed by others. As Raymond Williams puts it:

> It is understandable that people still trapped in the old consciousness really do see the new movements of our time – peace, ecology, feminism – as primarily 'emotional'. Those who have the most to lose exaggerate this to 'hysterical', but even 'emotional' is intended to make its point.
>
> (1983: 266)

While feminism is hardly a 'new' movement (new to Williams perhaps), being 'emotional' and the subsequent slide to 'hysterical' is a charge all too familiar to feminists. Being written off as 'emotional' is, as it is supposed to be, often humiliating; the idea is to attack at the level of the self. However, etymologically, being humiliated is not far from humility, that state of being humble, lowly and modest. And as Williams points out, emotions and 'emotional' movements can be characterized by their attachment to the lowliness of the everyday:

> it is in what it dismisses as 'emotional' – a direct and intransigent concern with actual people – that the old consciousness most clearly shows its bankruptcy. Emotions, it is true, do not produce commodities. Emotions don't make the accounts add up differently. Emotions don't alter the hard relations of power. But where people actually live, what is specialised as 'emotional' has an absolute and primary significance.
>
> (ibid.)

Thus, emotions point to where feminist criticism has to go; more to the point, they are also where feminism has always and already been. As Joanne Braxton says of reading black women's autobiographies, 'I read every text through my own experience, as well as the experiences of my mother and my grandmothers' (1989: 1). While experience is not necessarily emotions and emotions cannot take the place of theory, what I want to argue is that emotions can point us in certain critical directions. In this chapter I want to examine an emotional foregrounding of the self as a way of critically acknowledging the ontological and epistemological bases of knowledge formation. My interest here is in feminist uses of the auto-biographical as a tactic within the production of theory, or more precisely within the process of speaking theoretically. This is to consider uses of the self that can capture 'characteristic elements of impulse, restraint and tone; specifically affective elements of consciousness and relations: not feelings against thought, but thought as felt and feeling as thought' (Williams 1977: 132). As Joseph Bristow states, 'to try to think and feel in this way can

engage emotions which may be processed in order to redefine how stories may be historically understood' (1991: 120). Using some examples of recent feminist criticism of autobiographies I want to think through a series of questions regarding the possible construction of a specifically feminist speaking position within cultural theory. Can a feminist insistence on the autobiographical sustain a critical and political speaking position without privileging an ontological category of 'femaleness'? Is there a way of using the self that does not condense into a privileged moment of 'me'? Can stories be told through selves and through emotions without being at the expense of other stories and selves? How can we respect the local conditions that give rise to those stories and understand them without extrapolating to generalities about women's selves?

... WHERE WOMEN HAVE GONE BEFORE

Angela McRobbie's (1982a) article on feminist research was one of the first to explicitly tackle the problems inherent in feminist cultural studies research. In the years since its publication, there have, of course, been numerous feminist analyses of the politics of feminist analysis.[1] However, McRobbie's article remains notable for its attention to questions of experience and subjectivity. In examining the categories of women researchers and of women researched, she raises and problematizes the various relations among the two; along the way she also 'humanizes' ('womanizes'?) these academic problematics. In McRobbie's account we begin to realize the force of working through experience, feelings and self:

> Feminism forces us to locate our own auto-biographies and our experience inside the questions we might want to ask, so that we continually do *feel* with the women we are studying. So our own self-respect is caught up in our research relations with women and girls and also other women field-workers.
>
> (1982: 52)

This accent on the experiential is not allowed to condense into a unified or universal category: 'research is an historically-charged practice; that is it can never present more than a *partial* portrait of the phenomenon under study' (ibid.: 52). It is this emphasis on the historical nature of the relations involved in research that refutes one of liberal feminism's more enduring claims:

> feminism shouldn't be taken as a password misleading us into a false notion of 'oneness' with all women purely on the grounds of gender. No matter how much our past personal experience figures and feeds into the research programme, we can't possibly assume that it necessarily corresponds in any way to that of our research 'subjects'.
>
> (ibid.)

In arguing for the recognition of research as an historically informed

practice located in, and carrying with it, certain previously ascribed relations of power, McRobbie questions whether the fact that 'we're all women' can serve as a basis of feminist research. Both the researcher's and the researched's 'past personal experience' are rendered all the more important because they are kept distinct. The self/other relation is here a vigilant one. Moreover, there are concrete differences involved in this relation. As McRobbie stresses, the researcher is most often tied to an institution and she carries all sorts of social and cultural practices with her into the researched's sphere: '[f]unded by the state, representatives of higher education, well-spoken, self-confident and friendly as well, many women researchers might well on first impressions seem like Martians' (ibid.: 56). Moreover, 'this unequal distribution of privilege' requires us to consider whether 'women are often such good research subjects because of their willingness to talk, which is in itself an index of their power-lessness?' (ibid.); 'Is this kind of research parasitic on women's entrapment in the ghettos of gossip?' (ibid.: 57).

Faced with the extreme delicateness of dealing in and with women's experiences, one wonders whether the only avenue open to feminists is that which Rosalind Coward uses in *Female Desires*, namely 'fieldwork on myself and on my friends and family'? (Coward 1985: 14–15). The answer, I think, lies somewhere in between the vigilance advocated by McRobbie and the unproblematic way in which Coward constructs 'a field' around her friends and family. At one point in her article McRobbie raises the ways in which '[o]ur own subjectivity can often add to the force of research, just as our precise political position will inflect our argument' (McRobbie 1982a: 54). Her 'vital question of *who* we are writing for and *why*' (ibid.) has to be augmented with where we write from and how. While these questions may throw us back into an uncritical emphasis on the self, I will argue that they may also provide the conditions of possibility for constructing other paths of research, other related 'set[s] of involvements' (ibid.: 57). '

McRobbie's reminder to pay attention to the feelings of women, under-stood both as an important component of feminist research and as a common consideration, highlights the fact that nothing is as real, as necessary, and, at the same time, as necessarily abstract, as women's experiences, feelings and emotions. As such they must be incorporated into theorizations of the self as an ontological entity that we possess and as a possible speaking position. As Meaghan Morris argues, the question of putting ourselves into discourse is an immediate one:

> transforming discursive material that otherwise 'leaves a woman no place from which to speak, or nothing to say' . . . actively assume[s] that the movement of women to a position of power in discourse is a political necessity, and a *practical* problem.
>
> (Morris, 1988a: 5)

The project at hand, therefore, is simultaneously a political, practical and theoretical one. In elaborating a concept of the self I am proposing a level of analysis which engages the political and the practical; as Williams put it, 'thought as felt and feeling as thought; practical consciousness of a present kind, in a living and interrelating community' (1977: 132). The movement of women to a speaking position cannot be brought about through discourse alone, nor will simply privileging experience provide women with 'something to say'; together, however, they do give us insights into how we might say something.

While the production of a speaking position cannot be understood as the invention of 'a "personal voice" for "me"' (Morris 1988a: 7), the question of tone remains crucial. And remembering that the tone of speaking does count necessitates that we be fully aware of the very mediated nature of speaking the self; it is not a transparent self who speaks from the heart. Instead, this project recognizes that 'producing a "position" is a problem of rhetoric, of developing enunciative strategies . . . precisely in relation to the cultural and social conventions that make speaking difficult or impossible for *women*' (ibid.). This attention to the conventions that, at specific points, make it hard for women to speak discounts the possibility of an essential and pre-symbolic 'women's space'. Rhetorics and 'enunciative strategies' are always developed in reference to the historical conventions of the day. They are not tied into a primordial 'chora' (Kristeva, 1986), nor expressed in the primacy of female (bio-anatomical) difference. It is important to stress that we are talking about strategies of reference which throw us back into everyday conventions, into the materiality of how to get from here to there, from the lived to discourse.

In this way the production of a speaking position is always tied to the practices and politics bound up with daily life. And while the everyday may be boring at times, it is filled with a plethora of details and ruses that allow us to get by. The work of Michel de Certeau brings to mind the intricacies involved in 'doing' the quotidian (both researching it and speaking from it). He reminds us that our questions asked from the everyday can also rearrange its landscape, what he calls 'a geography of the possible' (1974). Simply put, there are different ways of getting around or getting by. De Certeau develops a distinction between strategies and tactics in order to clarify two very different modes of procedure:

> I will call a *strategy* the calculation (or manipulation) of power relationships that becomes possible as soon as a subject with will and power . . . can be isolated. It postulates a *place* that can be delimited as its *own* and serve as a base from which relations with an *exteriority* composed of targets and threats . . . can be managed . . . a *tactic* is a calculated action

determined by the absence of a proper locus. The space of the tactic is the space of the other . . . In short, a tactic is an art of the weak.

(de Certeau 1984: 35–38)

This distinction can help to think about the ways in which, and where, experience is spoken; the different discursive and material spaces which might encourage the articulation of selves. Given women's historical lack of institutional 'loci', it is tempting to generalize and say that all women's speaking is tactical rather than strategic. However, it maybe more accurate to say that a particular feminist use of the self may be made to work along the lines of a tactic. Moreover, tactics are not immediately 'nicer' than strategies (both terms are, after all, impregnated with connotations of war). In his discussion of tactics and everyday life, Roger Silverstone argues that tactics are not acquiescent; rather, 'they are the expression of an opportunistic logic: the rhetoric, the conceits, the tricks of the everyday' (1989b: 82). Moreover, he makes clear that tactics 'are social life' (ibid.); they indicate the materiality of the speaker (ibid.: 83). We can therefore talk of an active voice, one that is actively implicated in and spoken out of gendered everyday practices and places. Spoken out of practices that tend to be constantly shifting and places that are not often constituted as a legitimized and stable, these voices take on a tactical rather than strategic edge. As Silverstone states, 'the tactical rhetorics of everyday life' are to be found

[i]n the occasions and locations when talk, of the past or the future, of commitments or interests, of self and other, is legitimated or required: in homes, canteens, pubs, at parties, family gatherings, political meetings.

(Silverstone 1989b)

The concept of the tactic gives us another way of theorizing feminist utterings of selves in common places; a mode of speaking that engages with the taken-for-granted and underestimated ways in which women express themselves at home and in the family – the places where emotions are allowed. As with tactics, they 'can be both self-consciously political and unselfconsciously apolitical' (ibid.: 82). We can take the concept of tactical rhetoric to shed light on women's sometimes hidden uses of the self, to think about how the self is 'legitimated and required' in some situations and locations. From there, we can elaborate ways of tactically speaking in strategic loci where the sound of the self is unexpected. This is, therefore, to begin to consider the self as a 'language in action, mobilising both thought and feeling' (ibid.).

What I want to develop out of this discussion of tactics is a way of looking at certain articulations of the self. My concern here is to reveal the self as both the possession of experience and emotion, and as a way of conceptualizing the effectivity of that possession. I contend that the self

operates ontologically as an instance of being brought forth in certain locations: among friends, in certain gendered spaces, in some writing practices, and in theoretical contexts. The identification and insertion of one's self in differing contexts brings with it different orders of effects. One need only consider how an academic audience reacts to personal revelations contained within a theoretical context, or how the speaker feels if she does this. While some might argue that an academic context is not 'the place' for revealing the self, this precisely reaffirms that the self can bring forth other consequences which don't 'fit' the location. Used tactically, the self may operate ontologically as it testifies to a separate order of affectivity: the shocking immediacy of its emotionality. This of course does not exhaust the possibilities of the self and indeed, in academic contexts, it is more generally used at an epistemological level. Here the self is used as a construct through which the historicity of the discourses and structures of the social formation can be analysed. For example, Foucault's (1980b) analysis of the French nineteenth-century hermaphrodite, Herculine Barbin, is concerned with the ways in which 'she' was named and constructed as a social category by the juridico-medical discourses of the day. The affectivity of her situation, of her tortured self, is left untouched by Foucault, although others have sought to bring it out.[2]

However, I do not need to judge which level of analysis is the 'correct' one. I am arguing for a practice of the self that operates at both the ontological and epistemological levels. Moreover, against a logic which insists that emotions are a private matter and knowledge a public affair, which seeks to divide the self in two, I want to argue that speaking the self, of necessity, blurs the distinction between private or public, inside or outside. As Gilles Deleuze argues, rather than the one or the other, we need to think in terms of the double: 'the double is never a projection of the interior, it is on the contrary an interiorization of the outside' (Deleuze 1986: 105). Folded upon each other (I discuss Deleuze's concept of 'le pli' at more length in the following chapters), the question becomes how to constitute 'an inside co-present with an outside, applicable to the outside?' (Deleuze 1990: 153). For the moment we can simply state that once it is spoken, the self is out there, and its discursive effects attest to its materiality. As it speaks of how it got there, it is both ontological *and* epistemological.

IMAGING SELVES

As a description of the tension between the ontological and the epistemo-logical, and as an analytic tool to investigate the affectivity that this produces, the self works within a certain 'operative reasoning', to use Michèle Le Doeuff's term. As Morris states, 'the question [Le Doeuff] poses

of possible places for speech, places other than those prescribed by the Outside/Inside alternative, is an operational question for feminism' (Morris 1988b: 76). Le Doeuff's notion of 'operative reasoning' cuts through the discursive and non-discursive arenas without privileging either. Hence it is not the 'Outside/Inside' model of discourse and ideology, or the liberal public/private dichotomy that interests Le Doeuff. Rather, 'Le Doeuff passes from a concept of images as "located" in relation to a given discourse (as *lodged* "outside", "at home", "elsewhere") to a functional analysis of what they do – the "faire" of images in discourse' (ibid.: 83). What we have here is a mode of conceptualizing the ways in which an image or a concept works in relation to a set of discourses within one particular system as well as what that image or concept tries to do outside of the system in which it is enunciated (what meanings it allows or discounts). This is what Le Doeuff calls the 'work' ('le faire') of an image. In order to reconstruct the work of the self we must analyse it in relation to a given discourse (that of the individual, the Author, the masculine Subject of civilization) but we are also impelled to analyse it 'functionally', to consider how the concept of the self allows for and discounts ways of experiencing the self (e.g., how its 'faire' is 'lodged' within us). This is to draw 'attention to the importance of asking how philosophical discourses can *work* in particular contexts, rather than debating their (imagined) worth' (Morris 1988b: 83). This is also to pay careful attention to the specificity of each level and to recognize that the work of an image in its discursive context may be quite different to how it is lodged in 'the real', and vice versa. As Louise Marcil-Lacoste has argued about the relation of reason to violence,

> it would seem that the only possible level of identification of reason and violence lies in the kind of broad statements on their 'total' nature, which have the unfortunate effect of slipping from the absence of any recognized connection between reason and violence to the diffuse presence of a relationship everywhere. From a methodological point of view, this transition leads us back again, all too often, to the starting point, to nowhere.
>
> (1982: 170)

Against an implosion of levels ('all philosophy is sexist and does harm to women'), this is to use 'specificity as a heuristic device' (ibid.). This then entails a method of reading which is clear in Le Doeuff's essay on Simone de Beauvoir, 'Operative Philosophy' (1979). Here Le Doeuff reads de Beauvoir's philosophy as 'transforming the existentialist problematic – transposing it from the status of a system to that of *a point of view* oriented to a theoretical intent by being trained on *a* determinate and partial field of experience' (Morris 1988b: 101). Le Doeuff is less interested in whether de Beauvoir's existentialism is right (and in any case right to whom? Sartre?) and more concerned to consider her philosophic project as constituting 'a

point of view'. As she states, '[m]y object here will be to show how the ethic of authenticity functions as a specific theoretical level, an operative viewpoint for exposing the character of women's oppression' (Le Doeuff 1979: 48). Le Doeuff starts her analysis of de Beauvoir's *The Second Sex* with a pertinent question: 'in what respect, if any, is the choice of this or that philosophical reference-point a decisive factor in feminist studies?' (ibid.). She then moves through de Beauvoir's text to argue that de Beauvoir's 'viewpoint' of existentialism allows for an understanding of women's oppression that is unthinkable within Sartrianism:

> But in strict orthodoxy, it would have been necessary to conclude that this oppression did not exist – unless in the bad faith of certain women . . . Simone de Beauvoir does not draw this conclusion, and I see in this the proof of a primacy of involvement in the real over the reference-point in philosophy.
>
> (ibid.: 55)

The conclusions reached from that viewpoint have ramifications beyond a particular philosophical system. While Le Doeuff sees problems in existentialism, the fact remains that 'Simone de Beauvoir made existentialism work "beyond its means" because she got more out of it than might have been expected' (ibid.). The trick is to articulate 'an involvement in the real' with the reference-point of a certain philosophical project. Thus, one can argue that de Beauvoir viewed existentialism from a very localized point, and that this point of view changed the parameters of what she saw. The image is bent, or refracted, by being tied to the primacy of an involvement in the real. The discursive image is thus 'worked over' by the very materiality that it describes.

The point here is not that de Beauvoir somehow ignored the limitations of a particular epistemology although, as Le Doeuff sees it, she could have done with 'another problematic than that of the subject, and another perspective than that of morality' (ibid.: 56–57). Rather, what merits attention is the way in which de Beauvoir reworks the status of philo-sophical system to that of a point of view. Thus, images within the system are taken not as guaranteeing the system's validity; rather, they act 'as a pertinent theoretical level, an operative viewpoint' (ibid.: 48). For example, de Beauvoir took the concept of authenticity (a concept within existentialism which serves to deny the oppression of women) and trained it on the oppression of women. Authenticity as an 'image' is shifted from its position within the philosophical system to where it ultimately 'lodges': within 'the terrifying relation of men with women's bodies . . . [in the] ontological-carnal hierarchy of "the masculine" and "the feminine"' (ibid.). Again, it is not that de Beauvoir rejected the image and the system, but that she used it as 'a viewpoint'; she fractured its sight line, bending its reach in order to be able to touch the 'faire' of the image within the

'ontological-carnal relations' between men and women. In this way, the image is taken from its place within discourse and used, as a theoretical lever, to reveal its 'faire', its work within social relations. The image then becomes 'a point of view' focused on 'a determinant' ground. The image is articulated with 'a point of view' located in 'the real'. This exemplifies what Le Doeuff calls elsewhere, 'the process by which a localized discovery can overthrow the philosopher's palace of ideas' (1981–82: 62).

In her analysis of the seventeenth-century philosopher, Pierre Roussel, Le Doeuff draws out 'the drafts of specular objects in which the writer thinks himself, and thinks his relation to the Other' (cited in Morris 1988b: 84). In testing the limits of Roussel's system, Le Doeuff concludes that:

if no regional knowledge can found a global world-view, a philosophy in the classical sense, regional knowledges are on the other hand quite capable of producing disabling arguments *against* such philosophies.

(1981–82: 62)

The local citing of images can ultimately 'disable' a given philosophical system. In the case of Roussel, it is his use of 'woman' as image which supports his 'globalizing theory' and finally, in Le Doeuff's hands, proves to undo his system. In his image, 'Roussel genitalizes the whole body, but degenitalizes sex' (ibid.: 45). Le Doeuff uses the rhetorical term of the 'chiasmas' to explain the functioning of this logic: 'the denial of a quality "x" to an object or place which common sense holds it to actually possess, with the compensating attribution of that same quality to everything but that object or place'. Thus sex is denied its 'proper' place and displaced elsewhere. The power of the image is here augmented by the way in which it refers to other images outside its own ken. As Morris explains, 'The procedure of tacitly quoting an image already invested by a previous philosophy is what Le Doeuff calls "winking"' (1988b: 85).

This is again to emphasize the work of the image. As Le Doeuff notes, images 'are not, properly speaking, "what I think", but rather "what I think with", or again "that by which what I think is able to define itself"' (cited ibid.: 83). At one level, the image is a fundamental epistemo-logical vector, embedded in and allowing the production of knowledge; we can follow its lines as it winks at, and mobilizes, other knowledges. The image is that 'in which the writer thinks himself and thinks his relation to the Other'. At another level, however, the image is 'lodged' in 'the real' and in local situations. Quite simply, women live with the image; popular knowledges continue to circulate the image of woman as pan-genitalized. Yet because the image is also precisely lodged in a primacy of the real, it can be bent from its location in a discursive system; it can be contested. The localized image reveals 'regional knowledges' that then disrupt and 'produce disabling arguments' against the system in which the image discursively operates.

So the image loses its stability within the discursive system and is made to move. A feminist analysis can chart and sometimes encourage the image to move tactically, away from its place in any given philosophical system. In following the work of the image we can raise the ways it nods to other knowledges and destabilize their previous articulations. This type of analysis therefore brings together an epistemological examination of how knowledges can be stitched together through an image and an ontological investigation of the ways the image is anchored elsewhere. This then doubly disturbs the image's discursive placement as it allows us to see otherwise hidden configurations both within the system and in the real. As Le Doeuff puts it: 'oppression always also exists at points where it is least expected and where there is a danger that it will not even be noticed' (1979: 47). Far from erecting oppression as an evident starting point, this points to the different ways in which oppression may be hidden by the operations of images in philosophical systems as well as how and where oppression lodges in the everyday. The point, therefore, is to analyse the image in both its epistemological and ontological functions and to realize other mobilizations of the image. It is to put the image to work in other ways, always remembering that images can be folded upon themselves in order to reveal the ground that gave rise to them. As such the image becomes a point of view into its own work as an articulation of the real and the discursive.

Re-figuring the self as an image, we can begin to locate feminist speaking positions within a tactical use of images as points of view. In this way, the self works at a discursive level, operating epistemologically within various systems of thought. The self is made to designate and allow for certain configurations of knowledge to proceed, and concurrently to function at (but not necessarily indicating a correspondence to) an ontological level. What we need to do is to formulate certain articulations between these two levels. The self as an image is 'that with which what I think is able to define itself'. At the same time, as a lived moment, the self can be used to 'disable', or disrupt the smooth articulation of discursive systems. A possible speaking position emerges in articulating these two levels; spoken, the image of the self articulates a position that is informed by, but does not reify, the epistemological and the ontological.

AUTOBIOGRAPHICAL SCRIPTS

To investigate the possibilities of the self as an active articulation of the discursive and the lived, I'll turn now to some exemplars of feminist discourse on the self and the autobiographical, and then to an instance of a feminist folding of the image of the self within a theoretical text. Much feminist literary criticism has, understandably enough, been concerned with constructing a distinctly feminist discourse of the female reader.

Faced with the legacy of New Criticism's privileging of the text, or with the assumption of a universal (and male) 'reader', feminist critics have sought to reveal the gendered specificity of women's reading and writing. Often this works to reveal the embodied nature of texts; to disturb the neutrality of the text. And as I argue in Chapter 2, a textual selfhood is central in feminist criticism. But however important it may be, the material operations of the self tend to be overlooked as the text gets read.

Judith Gardiner starts her investigation 'On Female Identity and Writing by Women' with the statement, '[a] central question of feminist literary criticism is, Who is there when a woman says "I am"?' (1981: 348). She goes on to define 'female selves' based on her reading of Nancy Chodorow:

Thus I picture female identity as typically less fixed, less unitary and more flexible than male individuality, both in its primary core and in the entire maturational complex developed from this core. These traits have far-reaching consequences for the distinctive nature of writing by women.

(ibid.: 353)

Hence, for Gardiner, 'female identity is a process' which then partly explains women's approaches to writing: 'One reflection of this fluidity is that women's writing often does not conform to the generic prescriptions of the male canon' (ibid.: 355). Thus the roving female identity cannot be captured within one genre:

Women's novels are often called autobiographical, women's autobiographies, novelistic . . . Because of the continual crossing of self and other, women's writing may blur public and private and defy completion.

(ibid.)

While Gardiner's assumption of a strict equivalence between a psychological model of feminine identity and women's forms of writing is especially blatant here, it is a fairly common trait among some feminist literary critics. The move is to identify women's psychological being and then to apply it to a general process of reading or writing. However, when social conditions are collapsed within a psychological rendition of 'woman', some rather large generalizations are bound to occur. Thus, Judith Fetterley posits a universal and transhistorical condition for women which then agrees with how women read: women suffer,

not simply the powerlessness which derives from not seeing one's experience articulated, clarified, and legitimated in art, but more significantly, the powerlessness which results from the endless division of self against self, the consequence of the invocation to identify as male while being reminded that to be male – to be universal . . . is to be *not* female.

(Fetterley cited in Schweickart 1986: 42)

Conceived in a pervasive 'powerlessness', in the face of the male women's selves come to be united. The absence of women's experiences in the text then leaves the woman reader nowhere. While this is a salient point, I'm not sure if it leads to what Patrocinio Schweickart posits as the efficacy of androcentric literature: 'it does not allow the woman to seek refuge in her difference. Instead, it draws her into a process that uses her against herself' (Schweickart 1986: 42). Powerlessness becomes a key image within this particular system, yet its work is not explored; it is merely assumed. Indeed, the image of powerlessness becomes cut off from where it lodges in the real, and as such it loses the capacity to provide a point of view into the complexity of women not having power. It operates at the level of the text but does not open up into its involvement in the real.

Some recent perspectives on women's autobiography within literary criticism expand upon the correlation of woman within the text and woman as writer of the text. For Sidonie Smith the genre of autobiography is especially interesting because of its 'maleness': 'Autobiography is itself one of the forms of selfhood constituting the idea of man and in turn promoting that idea' (S. Smith 1987: 50). Smith describes women's struggles against the dictates of the autobiographical canon.[3] 'I am' becomes, for Smith, an impossible statement for women writers. As she argues:

> Since the ideology of gender makes of woman's life script a nonstory, a silent space, a gap in patriarchal culture, the ideal woman is self-effacing rather than self-promoting, and her 'natural' story shapes itself not around the public, heroic life but around the fluid, circumstantial, contingent responsiveness to others that, according to patriarchal ideology, characterizes the life of woman but not of autobiography.
>
> (ibid.)

Thus women's stories of their lives are cancelled out by the larger narrative of gender. 'Self-effacing' and 'self-promoting' become the two poles around which gender is articulated. There is, however, little movement here as women's lives are described as a state of being and not the stuff of art. Hence for Smith, patriarchy pre-empts any self-representation on the part of women; their 'meaning' is already assigned. This description functions as an ontological sentencing of women, based in the primacy of their posited being. The image of powerlessness is again fundamental here and Smith goes on to characterize women's writing as 'impossible':

> [If] she conforms totally to that ideal script, she remains bound (her book, her 'self') always in her relationships to men (and their progeny) and defined always in relationship to a life cycle tied to biological phenomena and the social uses to which those phenomena are put: birth, menarche, marriage, childbirth, menopause, widowhood.
>
> (ibid.: 54)

While Smith clearly puts the blame for women's condition on 'patriarchal ideology', she also holds onto a psycho-sexual model strongly influenced by Chodorow. She has no problem assigning certain qualities to women ('fluidity', 'contingent responsiveness to others'); the trouble is that patriarchy doesn't appreciate these virtues. The life cycle is what allows for these feminine attributes but, 'her life story is like every other female life story' (ibid.). This then is the only story women can write and one that no one (no man) wants to hear. Women (as historical subjects) therefore disappear into an ontological argument about their being. The very pervasiveness of the image of powerlessness flattens out any possible epistemological or ontological distinctions. Smith's landscape of equivalences ('book', 'self', 'life cycle') makes it difficult to conceive of any position from which a woman might speak. The problem with Smith's argument is that there is no 'point of view' other than the silence of the flip side of patriarchy. Rather than making the image of oppression work for women by locating its 'faire', its work within the social, Smith paints woman into a corner leaving her no place to speak from. The pall of powerlessness is all we have as Smith brings forth a final silencing figure of the castrated mother:

> the authority to speak as 'representative' man and 'representative' woman derives from the erasure of female sexuality; for the male-identified fiction commands the repression of the mother, and the 'good woman' fiction commands the repression of female eroticism.
>
> (ibid.: 55)

For Smith then, women can only speak as a woman masquerading as a man (and repressing the mother) or into the silence of a patriarchal script (repressing the female). Thus the only speaking position for women is when 'phallogocentric discourse has permitted women powerful life scripts'. And these scripts depend upon the writer having 'successfully escaped the drag of the body, the contaminations of female sexuality' (ibid.). To state the obvious, this doesn't leave one a great deal of room. In a move reminiscent of early psychoanalytic film theory, woman cannot initiate the 'gaze', she *is* the image.[4] In Smith's argument, woman is her 'life script/cycle'; there can be no distance between her self and her representation as women's existence is written by her historical and biological fate.

Her characterization of autobiography is understandably grounded in an ontological split

> privileging the autonomous or metaphysical self as the agent of its own achievement and in frequently situating that self in an adversarial stance toward the world, 'autobiography' promotes a conception of the human being that valorizes individual integrity and separateness and devalues personal and communal interdependency.
>
> (ibid.: 39)

Smith here performs a double articulation of genre and gender: auto-biography necessitates a unique self; the masculine self is grounded in 'separateness'; women's gender is constituted in 'interdependency'; a woman's self is excluded on the grounds of gender from this genre. Woman's very 'femaleness', her ontological state of being, excludes her from speaking. The problem is not that women's writing may be historically more 'personal' and involved in a community; it is rather that this situation is described under the sign of powerlessness instead of epistemological circumstance. In other words, Smith's argument is ultimately uninterested in the grounds that allow for some women to speak in certain circumscribed ways. She has insisted on the lack of women's enunciative endeavours as an adjunct of their state of powerlessness. This psycho-sexual model of women is therefore seen both as evidence of and the basis for women's inability to speak. This mode of analysis closes down any avenue of investigation; various 'facts' may be inserted into this reasoning, but as a line of inquiry it cannot itself raise new questions. The effects of women's uses of the self are known in advance.

In contrast to this approach which confines itself to analysing the system in which the self is caught, there are other possibilities of the self, understood as 'a point of view', which open up questions about the formation of knowledges and their relation to the lived nature of the image. Again, as Le Doeuff characterizes this approach:

> The 'point of view' is not concerned with creating that which it is trained on; of course, it allows for the construction of questions and modes for analyzing the scrap of reality that is under its consideration, it does so in such a way as to allow these questions to meet up with the facts: one can only say, therefore, that it produces things.
>
> (1989: 105–106)

Thus the 'point of view' doesn't create that which it describes; it has to construct questions from the level of the reality that it is trained upon. It produces or provokes connections; this is to realize the self's doubled locations.

In her article, '"Not Just a Personal Story": Women's *Testimonios* and the Plural Self' (1988), Doris Sommer 'shifts the focus from the portrait produced to the productive trope of self-reference' (1988: 119). Here the self is to be used to provoke connections and produce new articulations. Sommer is particularly concerned with the operations of Latin American women's *testimonios* (accounts of the self). She describes the use of the self in these accounts: 'the singular represents the plural not because it replaces or subsumes the group but because the speaker is a distinguishable part of the whole' (ibid.: 108). Sommer identifies two different spheres of the self's operations:

> In rhetorical terms, whose political consequences should be evident in what follows, there is a fundamental difference here between the *metaphor* of autobiography and heroic narrative in general ... and *metonymy*, a lateral identification through relationship, which acknowledges the possible differences among 'us' as components of the whole.
>
> (ibid.)

This analytic perspective on the uses of the self is obviously very different from Smith's, for whom the self is 'indistinguishable and always replaceable' (S. Smith 1987: 54). In contrast to the latter's construction of a biologically based self-same story, Sommer's emphasis on metonymy allows the self lateral movement. Remembering Jakobson's (1972) distinction between metaphor as paradigmatic and metonymy as syntagmatic, we can see that certain uses of the self may move away from a logic of substitution. However, while this may be an improvement on Smith's closing down of the self, Sommer's concentration on the metonymical ultimately undermines her insights about the *testimonios*. In this particular case, the self has more to do with the materiality of the reality that it is describing than with any metonymic movement to create an 'us'. Sommer is after all talking about texts that speak of actual suffering and that are often written in dangerous circumstances. These circumstances bring forth particular styles of writing; as Sommer says, 'these intensely lived testimonial narratives are strikingly impersonal' (1988: 109).

The 'strikingly impersonal' nature of these uses of the self may in fact have more to do with the concrete situations in which they are written than with linguistic notions of metonymy. Sommer's depiction of the testimonies of these Latin American women readily recalls de Certeau's sense of 'tactics'. The self cannot operate from a position of stability or strength. As Sommer tells us, these stories speak of immediate and terrifying situations: 'raped countless times by Somoza's National Guardsmen ... her mother's torture at the hands of the Guatemalan army ... the baby kicked out of her during torture in a Bolivian prison ...' (ibid.: 120); as Sommer says, these accounts of the self question the 'academic pause we take in considering how delayed or artificial ... reality is' (ibid.). Given the danger of where they speak from, these voices constitute calculated actions determined by the absence of a proper locus. The abstraction of one's experiences into writing is a practical and a political necessity. These women need to tell of themselves (to help others) as they need to avoid making that self into a locus (thus inviting retaliations against themselves). The self here, because of specific historical reasons, takes on the tactical logic of guerrilla warfare. As Sommer says of the movements required:

> As working-class or peasant women involved in political, often armed, struggle, the subjects of these narratives move about in a largely

unmapped space. Or it is a space on which competing maps are superimposed, where no single code of behavior can be authoritative?

(1988: 120–121)

These women then cannot afford the luxury of a stable and singular self. Working in this complex situation, they are simultaneously 'a mother, a worker, a Catholic, a Communist, an indigenist, and a nationalist' (ibid.: 121). While one could say that their location demands several contradictory 'subject positions', I think that it goes deeper than this. When Domitilia, a woman tortured in a Bolivian prison, is given the 'choice' of naming fellow revolutionaries or losing her children, her cell-mate tells her: 'You shouldn't think only as a mother, you've got to think as a leader' (ibid.). It is not that Domitilia is positioned both as mother and leader, but that she must (for her mental and physical survival) 'think her self' as mother *and* leader. These two points of view are not allowed to be exclusionary; they must be used together in order to provoke ways of thinking through the situation, a way of producing knowledge about what to do.

I do not want to extrapolate from this particular situation to render some universal model of the self and its relation to textuality. To do so would be the height of intellectual insensitivity. We can nonetheless take from these instances ways of looking at the self that emphasize the levels at which the self actively works in given situations. The very situated responses of these women must deny a reduction of their selves into a psychological model of 'woman'. These *testimonios* cannot be seen as just another replaying of woman's 'life script' or as merely a reconstruction of the self within an endlessly repeated psycho-biological story. Against such abstractions, we need to see that the projections of various selves are ways of 'expressing ourselves' for individual women in specific situations; as a Guatemalan woman states, there is no one 'immutable way' (cited ibid.). These very local uses of the self situate their locations at a conjuncture. In writing they produce a document that places both the writers' selves and the situation in relief. Such use of the self is an act (and entails others) which arises from the situation as it comments upon it. It is in this sense that we can understand the self as image:

it produces things, in the sense that it is quite an art, and an act, to make something apparent, to produce an object that will be considered as a document, to bring out of the shadows and to put forward 'facts' that, in the final instance, are never given.

(Le Doeuff 1989: 106)

So the image of the self in the case of these Latin American women's testimonies produces something, makes something appear, which can be considered a conjunctural document of the self and of the times. The self

comes out of 'the shadows' to put forward 'the facts', facts which are never officially given. This movement brings to mind an image of the Argentine 'mothers of the disappeared' who, in the face of official disavowal, used their bodies and selves in an effort to bring the facts of torture and murder out into the open. Their pictures of their 'lost' daughters and sons were documents of facts that were not given. These examples could be said to demonstrate a sense of the self which moves metonymically to articulate experience, location and history without reifying an ontology of being.

Metonymy, however, has an unfortunate way of sliding, which becomes obvious when Sommer imprints the trope of metonymy on the creation of community.

> Another part of the strategy is to pry open the process of subject formation, to rehearse it with the reader in a way that invites her to hook into the lateral network of relationships that assumes a community of particular shared objectives rather than interchangeability among its members.
>
> (Sommer 1988: 109)

Sommer's point is that 'the intentional difference in the writing goes far beyond a possible fallacy on the reader's part' (ibid.: 110). While she is quite right to insist on the 'intentional difference' involved in these writings, her emphasis on metonymy tends to push these 'documents of the self' to a level of abstraction where 'a community' can be constructed. To my mind, the importance of these writings lies in their powerful articulation of their very local and concrete circumstances, not in any claim to 'rehearse subject formation'. These are women writing for immediate reasons, and it is precisely the immediacy of their selves that emerges from Sommer's frame of interpretation. As conjunctural texts these testimonies place versions of the self within a precise time and place. These images of selves articulate other knowledges, knowledges that as women we are aware of. However, the images are tied to a particular specificity; it is not rape in general, it is being raped by Somoza's soldiers. The images do not float off into a generalized sense of women's condition. In placing too much emphasis on Western liberal feminist notions of community we may lose that conjunctural moment. While it is of course tempting to find 'communities' of women wherever we look, it is essential not to impose our longing for oneness and female solidarity in instances where, for concrete historical and geopolitical reasons, it does not exist (or at least not in our ideal vision). As Joanne Braxton writes of historical autobiographical writing by black women (notably in this instance of those of Zora Neale Hurston and Era Bell Thompson), 'their texts reveal a growing sense of displacement that is geographic, cultural, and social' (1989: 144). The point is to respect this material displacement, even if it does not fit within what we would like to recreate. Indeed, Braxton

formulates a challenge to feminist critics: 'The critic who is *not* black must simply work harder to see the black woman at the center of her own (written) experience' (ibid.: 6). This injunction serves us well in dealing with any use of the self that is written and spoken in the urgency of its own moment and not ours.

Susan Stanford Friedman, for example, constructs a frame for reading women's autobiographies which is destined to lose the local importance of writing the self:

> Autobiography is possible when the individual does not feel *herself* to exist outside of others . . . but very much *with* others in an interdependent existence that asserts its rhythms everywhere in the community . . . [where] lives are so thoroughly entangled that each of them has its center everywhere and its circumference nowhere.
>
> (Friedman 1988: 38)

The testimonies of individual women tortured and raped deeply challenge any notion of extrapolation to a global women's community. As Gloria Anzaldua writes of 'illegal' Mexican women, 'la mujer indocumentada . . . leaves the familiar and safe homeground to venture into unknown and possibly dangerous terrain. This is her home/this thin edge of/barbwire' (1987: 12–13). Anzaldua's image reminds us forcefully of the material reality of living at, and perhaps speaking from, that thin line – a line which cannot be moved metonymically beyond the concrete locality of its construction. Thus, while the selves in those writings may indeed reach other women, and touch us, they remain committed to their social and historical locations. As Biddy Martin says of the specificity of lesbian autobiographies:

> the feminist dream of a new world of women simply reproduces the demand that women of color (and women more generally) abandon their histories, the histories of their communities, their complex locations and selves, in the name of a unity that barely masks its white, middle-class cultural reference/referent.
>
> (Martin 1988a: 93)

Instead of the image of powerlessness that circulates in Smith's model of autobiography, or even Sommer's image of a generalized community, Martin emphasizes the conjunctural moment in constructing local selves: 'The invocation of the sights, smells, sounds and meanings of "the street" works to locate the author concretely in geographic, demographic, architectural spaces' (ibid.: 95). It is then in the 'sights and smells' of 'complex locations' that the images for speaking the self emerge. These images, taken from an everyday reality, can be refracted as a point of view into the lived, bent back into the smell and the sounds from which it is taken. This point of view works against what Martin calls 'the

assumptions that there are no differences within the "lesbian self" and that lesbian authors, autobiographical subjects, readers, and critics can be conflated' (ibid.: 83). In order to be analytically useful the self cannot be conflated with ontological notions based in a primacy of 'femaleness'. Moreover, as Martin points out, women marginalized through sexual preference or colour must seek out their difference and refuse to be generalized in the name of a globalizing image.

THIS THING WHICH IS A SELF

In recognizing constructions of the self as specific points of view both derived from very local configurations and trained back onto a particular ground, we can begin to open up the analytic possibilities of the self beyond the literary problematic of autobiography as a unifying discourse. In moving away from autobiography as the object of inquiry, I now want to consider using the autobiographical as a means of inquiry within the analysis of social formations. As Carolyn Steedman states in her study of a nineteenth-century soldier's memoir, *The Radical Soldier's Tale* (1988):

> the point of analysing a document like that of John Pearman's 'Memoire' is that it allows the reader to follow the ebb and flow of a *mind*, to see an intellect engaged with theoretical problems that connect directly with lived experience.
>
> (1988: 21)

In locating the image of the self that is put forward in a document (or as a document), we can begin to analyse and articulate the specificities of the relation of 'theoretical problems' to 'lived experience'. This is not to reify individual selves nor to extrapolate from them into generalities; rather, it is to conceive of moments of the self as points of view that allow insight into the construction of particular conjunctural social moments.

In *Landscape for a Good Woman* (1987), Steedman takes a feeling that may be common to many women, that 'no one gives you anything', and reframes it as, 'if no one will write my story, then I shall have to go out and write it myself' (1987: 23). It is a story about herself and her mother and 'the places where we rework what has already happened to give current events meaning' as Steedman insists upon the 'social specificity' of our stories about ourselves (ibid.: 5). It is

> a book about *things* (objects, entities, relationships, people), and the way in which we talk and write about them: about the difficulties of metaphor. Above all, it is about people wanting those things, and the structures of political thought that have labelled this wanting as wrong.
>
> (ibid.: 23)

The very 'thinginess', the materiality, of the things can be seen as images that bridge systems of discourse and the hopes and disappointments – the

emotions – of very real individuals. One of the central images that emerges and articulates several layers of Steedman's story of 'two lives' is that of her mother wearing the 'New Look, a coat of beige gabardine which fell in two swaying, graceful pleats from her waist at the back' (ibid.: 28). This is obviously a very literal 'image' of her mother; it is very present in Steedman's text as a real thing, although it sometimes reappears as a 'New Look' dress or an image in a dream (it is the thing of dreams). As a double image, Steedman's mother in her New Look performs wider functions in the text. Thus on one level, '[t]he connection between women and clothes surfaces often . . . in the unacknowledged testimony of many nineteenth- and twentieth-century women and girls' (ibid.: 24). Here the image is used as a bridge in history between the material means and the aspirations of women at certain epochs. It reveals an historical structure of feeling. On another level, 'it was with the image of a New Look coat that, in 1950, I made my first attempt to understand and symbolize the content of my mother's desire' (ibid.). Here the image connects the desires of the mother with the quite different desire of the daughter. It portrays a personal structure of feeling.

Analysed as a point of view, the image of her mother in the New Look coat can be used to raise questions about the constitution of the social and the materiality of wishes and emotions caught up in its formation. Recalling Le Doeuff's qualification of the point of view, the image provides a point of view which allows for the construction of modes of analysis about the reality from which it is taken. The image of the coat is a cultural and social product; and, according to Le Doeuff, 'regard[ing] an imaginary as a cultural product certainly involves looking for varia- tions and differences as between epochs, social categories, and fields of knowledge' (Le Doeuff cited in Morris, 1988b: 89). In taking up everyday images we 'reflect on scraps of the imaginary that do work in places where, in principle, the imaginary is not supposed to reside' (Le Doeuff, ibid.). One doesn't perhaps immediately connect coats with the imaginary but of course (as any young girl can tell you) they are profoundly articulated through each other. It is important here to remember that these images must maintain their specific identity because 'to collapse them back to the status of illustration . . . [is] to deny that they do work' (Morris ibid.: 84).

Images should not be seen as part of a system: they are not examples that prove a larger theoretical truth. Contrary to 'normal science' the image is not the proof but rather provides a point of view: 'it is about exploring a patch (or scrap) of social and intersubjective reality, and not about constructing a system' (Le Doeuff, 1989: 105). A particular image allows for a point of view which is focused on and explores a very specific patch of social reality. Particular images allow us to raise questions as we inevitably run into 'facts' that have been hidden or never constituted as

such. In other words, the image as a point of view can be used to analyse facts that it has in itself brought forward.

In Steedman's book the image of her mother in the New Look articulates an historical fact that '[t]he post-War years were full of women longing for a full skirt and unable to make it' (Steedman 1987: 32). The texture of the image articulates Steedman's mother's break with a general economic trend of 'girls in working class families north of Rochdale [who] would automatically go into the mill – usually into the weaving shed – when they left school' (Liddington and Norris cited ibid.: 103). The image of the coat brings forward biographical, emotional and material 'scraps' of knowledge: for instance, Steedman's mother came 'from a cotton town . . . [and] had a heightened awareness of fabric and weave' (Steedman, 1985: 108). The pride and knowledge of a working class woman become clear through the point of view of an image of clothing. 'My mother's black waisted coat with the astrakhan collar' serves to show the internal movements between class discourses and distinctions. Stitched into this image are points of view that are thrown back into the realities of work, economics, and a changing social formation:

> From her job, supported by the magazines she brought home, and from her older skill of tailoring and dressmaking, we learned how the goods of the earth might be appropriated, with a certain voice, the cut and fall of a skirt, a good winter coat; with leather shoes too, but above all by clothes.
>
> (ibid.: 112–13)

The 'cut and fall of a skirt' is used as an image which constructs a point of view through which the limited mobility of lower middle-class women can be seen, measured and felt. At the same time, this point of view brings out the immeasurably large gap between the fact that 'a girl can get ahead dressed right' and the actuality out of which this image is taken. In other words, the importance of the very 'thinginess' of the image is not lost. It brings out the knowledge of the mother as it reveals the daughter caught within a reality wherein 'dresses needing twenty yards for a skirt were items as expensive as children' (Steedman 1987: 29). Here the image clearly nods to a very present reality:

> We believed we were poor because children were expensive items, and all the arrangements had been made for us. 'If it wasn't for you two,' my mother told us, 'I could be off somewhere else'.
>
> (Steedman 1985: 113)

Finally, another dress can be used to recall the articulation that is Steedman's mother, her past and her present: '[w]hen I want to find myself in the dream of the New Look, I have to reconstruct the picture, look down at my sandals and the hem of my dress' (1987: 142). As an

image and as a cultural product (in Le Doeuff's sense) the dress articulates several 'scraps' of reality. As a point of view it can be used to delve into the past and the present to pose some rather fundamental questions. These are questions that potentially disable certain systems of thought, including certain tenets of feminist thinking. In using the dress as an image instead of the more taken-for-granted figure of 'the mother' unsettling aspects of the real are brought forward: for example, the mother–daughter relationship is disarticulated from its textually romanticized position, and in a similar fashion, childhood is placed firmly within a discourse of economic calculations. Instead of painting women into the ontological position of 'nurturers', Steedman draws out 'the social specificity of wanting and not wanting children in the first place, and wanting and not wanting them once they exist' (ibid.: 90). Children can be evaluated in terms of dresses and a mother's freedom 'to be off somewhere else'. The dress as an image then is used by Steedman as a point of view and articulates both Steedman as 'an expensive child' and Steedman the theorist looking back. The self here is not given an ontological primacy but emerges as a point of view in the articulation of several discourses. This point of view is therefore enabled not in direct reference to 'a self' caught in time; rather it is 'produced' through the use of images taken from specific moments.

The image of the New Look dress and the point of view that it enables move from the actuality of the ground to be described and then interrogate that ground and the description. We know that there is a dress (a photograph of her mother wearing one appears in the text) and we begin to know these selves of Steedman and her mother as they are depicted through the discourses of class, of gender, of the historical times, but most clearly through the longing bound up in the image of the dress. Steedman describes talking with her sister after having visited her mother for the last time:

> she insisted that the feeling of being absent in my mother's presence was nothing to do with the illness, was the emotional underpinning of our childhood. We were truly *illegitimate*, our selves *not there*.
>
> (1985: 121)

The point of view of the dress also raises this absence, this feeling of being 'not there'. Further on, Steedman remarks upon the 'feminisms, soft and sentimental, that would have my mother returned to me, and make us sisters in adversity' (ibid.: 125). However, in the use of the image of the New Look dress, separate selves emerge that a 'sentimental' image could not conceive of. The image of the dress is therefore located in relation to a given discourse (of the family, of gender) as it is deployed for its 'faire'.

It is quite clear that Steedman does indeed have a reference-point in a feminist system (just not a 'soft' one). However her description of the various articulations that held her mother and her together derive from

images that testify to 'a primacy of involvement in the real'. The relation-
ship between the image, a point of view and 'an involvement in the real'
then problematizes any simple tale of the self. Giving a primacy to the real
does not in any way cancel out the project of making images work; rather
it fuels the efforts to make them work, to insert them ever more deeply into
the real, revealing the structures and knowledges of the real. In the
introduction to Steedman's stories of her mother and her self, Steedman
describes a moment when a health visitor chastised her mother. Steed-
man's response is: 'I will do everything and anything until the end of my
days to stop anyone ever talking to me like that woman talked to my
mother' (1987: 2). Under the image of the well-cut dress lies a reality
brought forward through the remembrance and use of that image:

> I read a book, meet such a woman at a party (a woman now, like me)
> and think quite deliberately as we talk; we are divided: a hundred years
> ago I'd have been cleaning your shoes. I know this and you don't.
>
> (ibid.)

Steedman thus expresses her self in images of things and emotions that
articulate the present and the past. Whether it is a dress and a coat, a
memory of feeling 'illegitimate', the image of her mother being chastised,
or the embodied flash of material and social difference, Steedman uses
these moments to bring forward a self grounded in the specificities of
gender and class. These images articulate an 'involvement in the real' and
a reference-point within a larger system: they 'raise central questions
about gender as well as class, and the development of gender in particular
social and class circumstances' (ibid.: 7). They are found interwoven
throughout the historical, economic and affective discourses that inform
the book. Steedman's often painful memories of her mother's and her own
personal past ensure an involvement in reality; and they are painful
precisely because they are bound up in emotions and things. These
registers within the story are articulated to allow for the self: in Steed-
man's words, '[c]lass and gender, and their articulations, are the bits and
pieces from which psychological selfhood is made' (ibid.). However, I
think that we can take from this account more than its construction of a
'selfhood'. What emerges from the articulation of reference-point, image,
things and the real is a way of using the self, of putting the self to work in
order to 'cut into the real'. The self here is both an object of inquiry and the
means of analysing where and how the self is lodged within the social
formation.

EMOTIONS AND IMAGES

Responding to the problematic of a feminist speaking position, we can say
that certain uses of the self work to figure the local sites and conjunctural

moments necessary to the development of a feminist enunciative practice. This project involves transforming discursive material to allow women 'a place from which to speak and something to say'. Neither of these requisites can be taken lightly: considering the places, we remember McRobbie's hesitations about entering into research practices that only allow certain women to speak. Thinking of certain feminist practices of globalizing the local should remind us that this too can take away the place from which other women speak. Formulating women's selves as monolithic and impossible structures obviously leaves one little room and not much to say. What I have argued here is that we need an 'operative reasoning', an operative speaking, which both figures a place and enables a point of view into the social construction of that place. The operation of images taken from that place can be seen as points of view that may disable and transform discursive practices that silence women.

At the beginning of this chapter I spoke of the difficulty of speaking, of an image of being stranded out on a limb with nowhere to go and nothing below, as the spectre of emotionality haunted and taunted me. Both the feeling of speaking into a void – that no one can hear you – and the feeling that what one is saying is merely emotional drivel – that you are saying nothing (new) – are obvious impediments to speaking as a woman. No one wants to consciously fall into a personal abyss. However, what I am suggesting is that there are rhetorical tactics that can rework how the personal is put into discourse. Rather than throwing us into a discursive darkness, certain images of the self may rearrange where we speak from as well as the spaces in which 'we' are spoken.

In positing the self as an analytic level in the construction of a con-junctural site, I do not want to reify local sites. It is important to remember de Certeau's use of the tactic. If the self as a way of figuring different relations in the social formation is to be analytically useful, it cannot be condensed into a 'proper locus'. As I have argued, the self cannot be seen as an entity that binds women together in the face of racial, sexual, national, and other differences. The self must therefore be seen as a theoretical manoeuvring, not as a unifying principle. The self can be made to work to articulate an epistemological critique of the discursive ordering of the social and to affirm an ontological recognition of the affectivity of emotions and things. Instead of speaking the self as an endless repetition of women's ontological being as a script, the self as an image and images of the self can comment on the conjuncture of discourses and everyday commonplaces. Speaking the self does not necessarily imply any trium-phant move; rather as a theoretical level, the self may simply and quietly enable yet more questions, yet more theoretical work. As Morris states: '[f]or the lovers of high-speed iconoclasm, the lowly labour of listening carefully to a text connotes the fussiness of housewives' psychosis' (1988b: 95–96). This is not to say that a feminist speaking position is comparable to

housework; it is to say that the work of formulating enunciative practices that can speak certain unasked questions may be equally never-ending.

NOTES

1 In the last several years there has been a veritable explosion of feminist work around issues raised by and in feminist research. While it would be impossible to cite the entire range of feminist analyses in this area, within the social sciences the key references include Sandra Harding (1986), Dorothy Smith (1987) and edited collections such as Micheline R. Malson et al. (1989), Marianne Hirsch and Evelyn Fox Keller (1990). The question of the power relations inherent in research have been most powerfully raised by feminists of colour from the work of bell hooks (1984) and Cherri Moraga and Gloria Anzaldua (1981) to Michele Wallace (1990, 1992) and Gayatri Spivak (1988). Questions of exclusion have been forced on a sometimes reluctant feminism by these writers and more and also increasingly from lesbian theorists – from Monique Wittig (1980) to Diana Fuss (1991). The meeting of postmodernism and feminism has also raised epistemological and methodological issues; see Linda J. Nicholson (1990). For a detailed account of feminists entering into research see Nicole Laurin et al. (1991).

2 In contrast to Foucault's use of Herculine Barbin as a body upon which the discourses of the Church, the education system, and those of the medical and legal institutions are inscribed, René Feret's (1985) film Le Mystère d'Alexina takes up Herculine Barbin's life. Supposedly based on the memoirs that are contained in Foucault's (1980b) analysis, Feret's rendition of the life of Barbin focuses on the individual, albeit in a rather 'soft porn' way. He portrays her as both a tormented 'soul' and as a sexually obsessed young man, rendering Barbin and her lover as thwarted heterosexual couple. Foucault includes in his volume a rather baroque short story ostensibly based on Barbin's life called 'A Scandal at the Convent' by Oscar Panizza, first published in 1893. What these representations of Barbin show is that an attention to the individual does not necessarily reveal a self. See Butler (1990) for a close feminist analysis of Herculine and a critique of Foucault's positioning of her.

3 I will not enter into the debate over what constitutes autobiography as a genre. It is, however, a rather heated one with most of the recent feminist theorizations of autobiography insisting upon the 'forefathers' of autobiography in order to point out women's exclusion from this genre. While it is, of course, important to raise the ways in which women are silenced in these accounts, the critiques tend to be repetitions of the larger 'canon debate' within literary criticism. For examples of this, see S. Smith (1987) as well as Gunn (1982), Jelinek (1986), and Dodd (1986).

4 Mulvey's (1975) article is the one that is most often cited as the 'seminal' formulation of the problematic of 'woman as image'. Doane's (1982) article takes up Joan Rivière's (1986/1929) concept of the masquerade and applies it to female spectators.

Chapter 5

Technologizing the self
Foucault and 'le souci du soi'

WHO OR WHAT ARE WE?

As a girl it always fascinated and bothered me when my mother talked about how she would have preferred to live in another era. As an educated woman caught up (or tied down) in the petty politics of army-wifedom, she dreamed of presiding over a 'salon littéraire' along with other 'précieuses'. Along with the fact that I couldn't figure out where I might be in her historical scheme, I was also rather prickly about the specificities of economics and gender that seemed to be assuring a rather limited future for my sister and me. 'How do you know that you wouldn't have been a servant?', I would ask. Looking back on it, I suppose that I was most worried about where my self was if hers was partially constructed in another time and space, outside of the dour pressures of the present.

The question of selves, and how they are positioned in the historical present, continues to preoccupy me. Michel Foucault's comments about a small newspaper article written by Kant articulate past questions in a very present way. As Foucault interprets it:

> When in 1784 Kant asked, Was heisst Aufklärung?, he meant, What's going on just now? What's happening to us? What is this, this period, this precise moment in which we are living? Or in other words: What are we? . . . Compare this with the Cartesian question: Who am I? I, as a unique but universal and unhistorical subject? I, for Descartes, is everyone, anywhere at any moment?
>
> (1984b: 423)

While we could usefully put Kant to work in order to calm some of the current postmodernist *fin-de-siècle* frenzy, I want to use Foucault's remarks about 'Was heisst Aufklärung' to raise some hopefully timely hesitations of my own. What, indeed, is going on and what are we at this present moment? Foucault's last writings before his death turned on these questions, as had his entire life's work, investigating what he termed 'the technologies of the self'. In this chapter I will follow Foucault's wonderful

leap into the self and consider the ways in which we can technologize gendered selves and put them to work within a theoretical and critical agenda.

Amongst other things, this is to rethink the necessity of an 'attitude' in contemporary feminist theory. Along with Foucault, by 'attitude' I mean:

> a mode of relating to contemporary reality; a voluntary choice made by certain people; in the end, a way of thinking and feeling; a way, too, of acting and behaving that at the one and the same time marks a relation of belonging and marks itself as a task.
>
> (1984b: 39)

To think the self with attitude is to think in a doubled way; the question of 'what are we?' marks the exigencies of acting and behaving and belonging within the present as it problematizes the task of contemporary cultural criticism. Indeed, questions about what we are abound in the present moment, as they reverberate with questions of who we are. For instance, at the end of 'Landscape for a Good Woman' Carolyn Steedman says:

> I want a politics that will take all of this, all those secret and impossible stories, recognise what has been made out on the margins, and then, recognising it, refuse to celebrate it; a politics that will, watching that past say: 'so what'; and abandon it to the dark.
>
> (1985: 126)

Steedman's is a call thrown up from the specificities of place and background (or class and gender), a call for a project that may recognize the conjunctural exigencies of the self even as it refuses to celebrate that self as 'resistant', or even very special.

It is quite clear that in Steedman's call for 'another' politics, feminism remains central. However, there is also a recognizable yearning for something more. Beyond the one-dimensionality of an entrenched position, there is the hope for a politics which can include and work with lived complexities. As Sheila Rowbotham puts it: 'Feminism is a given – but I want more than the political outline. I want a culture that you can tug and shape with complexity' (1985: 211). What we can take from these calls is an idea of a political and analytic project grounded in a more complex theoretical articulation of gender-, class-, race- and sexually marked practices. This desire for a tangible and nuanced programme is necessarily beyond the stability of a humanist identity. It is, however, grounded in a politics marked by selves and it is inspired and engaged with the subjectivities emeshed within our everyday lives.

This in turn raises questions about where we speak from when we ask what we are. In her early article, 'Feminism, Criticism, and Foucault', Biddy Martin uses Foucault to think through a position, her position, for feminist critics:

The point from which Foucault deconstructs is off-center, out of line, apparently unaligned. It is not the point of an imagined absolute otherness, but an 'alterity' that understands itself as an internal exclusion. From that perspective, it is possible to grasp and restructure the organization of our bodies, psyches, and lives through discourse.

(1988b: 10)

As certain 'hard line' theories (e.g., Althusserian marxism, certain articulations of feminist psychoanalytic theory, or hardened forms of Baudrillardian postmodernism) pass out of favour, the possibility emerges for unruly and critical questioning about the relation of individuals to the social formation, as well as about the very differing ways that we construct selves for ourselves in relation to other selves. Here the question of who and what is she is not a directive or a duty but rather an inspiration. The possibility of going beyond the singular formulation of 'who am I?' emerges in the specification of the local nature of the mediations involved in this relation of the self to self. In her book, *Essentially Speaking*, Diana Fuss enriches poststructuralist reasoning by articulating it with/in the project of Afro-American literary criticism. The need to think about and beyond the injunction against 'essentialism', all the while using post-structuralist concepts as tools, encourages her to ask: 'How is black subjectivity constituted? ... is the relationship of Afro-American sub-jectivity to social text fundamentally the same or different from Anglo-American subjectivity?' (1989: 95). Her line of questioning is thus based on the assumption that Afro-American subjectivity is constructed in specific ways as a self is positioned (and felt) in relation to social texts and other selves.

Outside and alongside of the guiding paradigms of the last decades and centuries, current questions about the self, subjectivity and inhabited and actual selves and subjectivities take various forms as they insist upon the necessity for theories of the particularity of historical subjectivity. As Fuss argues, 'Developing these "alternative and different notions [of subject-ivity]" to question current ethnocentric theories of the subject may well be one of the most important and urgent tasks facing the critic of Afro-American literature today' (ibid.: 96). The breaking down of the centre unleashes questions and subjects previously taken as unthinkable. To my mind, these alternative subjects include questions like 'What kind of sociology would take dreams as "data"?' (Hebdige, 1987a: 48), and 'what dream, what future, what here, what now?' (Walkerdine, 1985: 76). These 'subjective voices' provide simple anecdotal evidence of people trying to make sense of the world, of what is going on right now, in relation to certain theoretical levels of abstraction. These questions express an unease with established political and critical agendas as well as the need to theoretically formulate ways of getting on with the everyday activities of working, thinking, writing and dreaming.

These critical voices can also be seen as telling instances of what Foucault describes as an experimental 'historico-critical attitude':

> I mean that this work done at the limits of ourselves must, on the one hand, open up a realm of historical inquiry and, on the other, put itself to the test of reality, of contemporary reality, both to grasp the points where change is possible and desirable, and to determine the precise form this change should take.
>
> (1984b: 46)

This is then to act within an awareness of the historical present. Moreover, if I am to be true to this awareness, I must also be vigilant to the fact that even as I put forward the importance of using the self with attitude, these subjective voices could also be seen as evidence of an undesirable individualism. Put simply, there is a distinct possibility that the self could become lost within an individualistic agenda. As François Ewald argues in 'L'individualisme, le grand retour': 'in the 1980s, the landscape suddenly changes. Structures fade away, the system is no longer mobilized. We are present at the return of the actor, the subject, the individual' (1989: 16). These events are located within a larger configuration of discourses and historical actualities. However, within this discursive rearrangement there seems to be a theoretical shift taking place, evidence of which can be seen in the increasing demands for some type of agency, and in the ambiguous currency of the individual in some critical writing. What is unsure is whether this points us to the Right (the more traditional home of the individual) or to a new and progressive recombination of politics and social sentiments.

As Ewald says, the topography of the social is changing, and with it, or within it, so too is cultural criticism. For me, the trick, at the present moment, is to think and use the self – to follow lines of subjectification – without falling into a humanist and universal individualism. As a quiet proposition, I think that we can use Foucault in performing this operation, in order to get there. If this seems overly teleological, let me state that the 'there' is here; if this sounds like a proposition to slavishly follow the great man, let me say that, at the very least, Foucault reminds us of the stakes involved in elaborating a critical position in the present. The self must therefore be thought in tandem with a 'limit-attitude', as a stance that may ensure

> that criticism is no longer going to be practiced in the search for formal structures with universal value, but rather as a historical investigation into the events that have led us to constitute ourselves and to recognize ourselves as subjects of what we are doing, thinking, saying.
>
> (Foucault 1984b: 45–46)

Here is a useful horizon, one that reminds us to bend our gazes away from reconstructing an overarching individual, be it incarnated in our thoughts

about ourselves or projected outward in attempts to speak of others. Quite simply, this is to think about the task of criticism both in its full scope and in its quiet necessity. Beyond the egoism of the supposedly self-sufficient individual, this is to to remember that selves always work with other selves within discursive events; as Gilles Deleuze puts it: 'We belong to apparatuses, and we act within them' (1990: 190). However, Deleuze also raises the excitement of this work as he distinguishes what it means to work within a new 'dispositif':

> The novelty of an apparatus in relation to previous ones, we call its actuality, our actuality. The actual is not what we are, but rather what we become, what we are in the midst of becoming, in other words, it is the Other, our becoming-other.

> (ibid.: 190–191)

WOMEN IN FOUCAULT: FOUCAULT AND FEMINISM

One of Foucault's more beautiful and cryptic passages is clearly marked with the excitement of the actuality of moving from one apparatus to another:

> As the archaeology of our thought easily shows, man is an invention of recent date. And one perhaps nearing its end. If those arrangements were to disappear as they appeared, if some event of which we can at the moment do no more than sense the possibility – without knowing either what its form will be or what it promises – were to cause them to crumble, as the ground of Classical thought did, at the end of the eighteenth-century, then one can certainly wager that man would be erased, like a face drawn in sand at the edge of the sea.

> (Foucault 1973: 387)

While I am unable to read this passage without feeling slight *frissons* of pleasure and anticipation (what are we in the midst of becoming?), this is hardly a corroboration of Elaine Showalter's hope that 'in the critical histories of the future, these years will be remembered ... as the Age of Feminism ... we have all been living in women's time' (Showalter 1987a: 42). Nonetheless, the erasure of the face of man is very a compelling image. What are we if man is effaced? If indeed man disappears as an apparatus, the question of what and where I am is radically shifted. It could be argued that, as a feminist, I am already working at the edge of this apparatus; however, as a feminist, I have also invested more time and energy in trying to deconstruct the apparatus 'man' than those for whom man retains a convenient invisible superiority. And if man were indeed to fade, instead of having to work around, through and under 'him', feminists would have a lot more time to do other kinds of analysis. New

and exciting 'lines of actualization' could be followed, lines that 'require another mode of enunciation' (Deleuze 1990: 192–193). The crumbling of man would also accord with what Deleuze calls Foucault's 'history of what we are slowly stopping to be' (ibid.: 191). Might the disappearance of man allow 'A new light, new (modes) of enunciation, a new power, new forms of subjectification?' (ibid.: 191).

However, even as I write these words, as I use Deleuze and Foucault to glimpse beyond man, I hear the strongly voiced objections from some feminists. Perhaps the loudest of these is the one that says, 'But there are only men in Foucault, there are no women'. Not out of duty, but out of respect for the apparatus that has given me voice, I hope to show here some of the creative possibilities that Foucault may hold out to feminist theory. This is also to remember that over the years there have been many 'women in Foucault'. We can be inspired by their critiques and appropriations of Foucault. It is, of course, hardly news that there is precious little feminism in Foucault, or that the alliance between Foucault and feminism has been a rather fraught one. As Meaghan Morris succinctly puts it: 'any feminists drawn in to sending Love Letters to Foucault would be in no danger of reciprocation. Foucault's work is not the work of a ladies' man' (1988a: 55). Perhaps more than any other contemporary figure, Foucault has come to epitomize the pleasures and dangers that a certain understanding of poststructuralism poses to a certain understanding of feminism. And it is either dangerous or pleasurable according to the relation that is posed between feminism and humanism. For instance, Tania Modleski seems to equate Foucault and poststructuralism and sees both as threatening to feminism:

> thinkers like Foucault and Lacan have provided the analytical tools by which we may begin the arduous task of unbecoming women. However, as feminists are increasingly pointing out, the once exhilarating proposition that there is no 'essential' female nature has been elaborated to the point where it is now often used to scare 'women' away from making *any* generalizations about or political claims on behalf of a group called 'women'.
>
> (1991: 15)

While one is free to read Foucault in every which way, Modleski's slide from 'unbecoming women' to Foucauldean theory as scare tactic is accomplished through some rather large generalizations and by glossing over complex issues both in Foucault and in feminism. It is, of course, possible to translate Foucault's preoccupation with showing 'that things "weren't as necessary as all that"' (1981: 6), into 'unbecoming women'. However, as an unbecoming woman and as a feminist, I find that Foucault's staunch anti-humanism provides a theoretical impetus to political action.

While Modleski's remarks may be short-sighted, they can be used to rehearse some of the problems that some feminists have with Foucauldean analysis. Briefly, the major source of tension inherent in one articulation of the 'Foucault and feminism' question is Foucault's radical anti-humanism. Thus while Foucault seems to offer an analysis of power and resistance, he does so without giving anything that would resemble an image of individuals resisting. To be very blunt about it, it is not people that interest Foucault; it is our profound 'logophobia': 'this sort of deaf fear of these events, this mass of things said, the surging up of all these statements (énoncés)' (1971: 52). As in *Les mots et les choses* (1966), it is the deep disjuncture between 'words' and 'things' that must be analysed, as well as our fear of being caught between them, overwhelmed by the roaring sound of 'things said':

> And if one wants – I won't say to efface this fear – to analyse it in its conditions, its game and its effects, I think that we must come to three decisions to which contemporary thought is rather resistant and which corresponds to three groups of functions that I have just raised: to question yet again our wish for truth; to restore to discourse its character of event; to lift once and for all the sovereignty of the signifier.
>
> (Foucault 1971: 53)

So it doesn't seem to matter who is speaking, or whether they are male or female. What does matter is that things are said, and that in the rush of words we still seek a truth; that we hide from the singularity of discourse as we indulge in 'a temptation to invoke a historical constant, an immediate anthropological trait, or an obviousness which itself poses uniformity on all' (Foucault 1981: 6). While Foucault never raised these points in relation to feminism, they do nonetheless describe a certain tendency to pose, for example, the oppression of women as an obvious and uniform truth. Some feminist criticism of Foucault then turns on the fact that he is presumed to have authorized

> the 'end of women' without consulting her. What matter who's speaking? I would answer that it matters, for example, to women who have lost and still routinely lose their proper name in marriage and whose signature . . . has not been worth the paper it was written on; women for whom signature – by virtue of its power in the world of circulation – is *not* immaterial. Only those who have it can play with not having it.
>
> (Miller cited in Modleski 1991: 33)

The tone of Nancy Miller's remarks is understandable enough, and I heartily agree that it does matter who or what is speaking. However, I am not sure that sovereign signifiers such as 'woman' or 'oppression' do not equally get in the way of allowing women to speak; they get in the way of hearing the specificity of what she is saying. Moreover, we can use

Foucault's comments to remind ourselves that the yearning for truth does have deleterious effects, both at a theoretical level and at a practical one.

There are, of course, other feminist uses of Foucault that do not founder on truth. For instance, Jana Sawicki divides feminist appropriations of Foucault into two camps:

> namely, those who use his analysis of disciplining power to isolate disciplinary technologies of women's bodies that are dominating and hence difficult to resist, and those who acknowledge domination but center on cultures of resistance to hegemonic power/knowledge formations and how individuals who are targets of this power can play a role in its constitution *and* its demise.
>
> (1991: 14)

However, while Sawicki's distinction is useful, in order to divide the two camps she establishes 'discipline' as the main term of reference in Foucault and as the limit of his interest to feminists. Indeed, the title of her book, *Disciplining Foucault*, seems to suggest that Foucault has to be disciplined and that his work must be whipped into shape before it is of use to feminism. I do not want to underestimate the role that resistance and discipline have had in some feminist thought, nor deny the work of these concepts. However, what I want to argue here is that there are other Foucauldean lines that may be more helpful to feminism at this particular conjuncture. Indeed, there are other ways of considering discipline and resistance; I want to suggest that we can think of them, along with other Foucauldean notions, as lines of analysis that can be bent in directions other than those Foucault himself laid out.

What happens when the exteriority of discipline is bent upon itself, when the 'dehors' becomes the 'dedans'? What happens when we move from an analysis of women as object disciplined to one which privileges gendered processes of subjectification? Turning to the question of our actuality, to the movement between what we are and what we as women are becoming, requires some attitude; it is to leave the relative security of one mode of established analysis and forge a way of thinking and feeling, of articulating the end of one apparatus and the possible beginning of another. And in setting out in this direction I will use some of Foucault's propositions as vague indications of what might lie ahead, or at least of why it may be worth the trip. At one point, Foucault gives us this sign of where he was going and why he needed to do so:

> Perhaps I've insisted too much on the technology of domination and power. I am more and more interested in the interaction between oneself and others and in the technologies of individual domination, the history of how an individual acts upon himself, in the technology of the self.
>
> (1988a: 19)

Without disarming the validity of using Foucault to theorize how women have been dominated, my argument here will turn on his theorizations on the self. The accent will be on the theoretical and practical modes of various selves, all the while remembering that these selves are the stuff of life. In focusing on volumes 2 and 3 of *The History of Sexuality* (*The Use of Pleasure* [1986] and *The Care of the Self* [1988b]) I will draw an epistemological map of the self's effectivity in order to elaborate some of the theoretical uses of the self's affectivity (its ontological appeal). This is to think about the self in terms of what it is (a point of articulation) and where it may allow us to go (a way of speaking and communicating a gendered actuality).

In sketching out a path that is in part inspired by Foucault yet does not retrace his steps exactly, I must also take to heart Teresa de Lauretis' critique of Foucault:

> to think of gender as the product and the process of a number of social technologies, of techno-social or bio-medical apparati, is to have already gone beyond Foucault, for his critical understanding of the technology of sex did not take into account the different solicitation of male and female subjects, and by ignoring the conflicting investments of men and women in the discourses and practices of sexuality, Foucault's theory, in fact, excludes, though it doesn't preclude, the consideration of gender.
>
> (1987: 3)

While de Lauretis is quite right that Foucault does not take into account the different solicitation of men and women into the discourses of sexuality, I think that in taking up Foucault's turn to the technologies of self we may find other perspectives on theoretical levels at which we can sex the self. While, as Jeffrey Weeks states: 'We are not under any obligation to accept all his positions' (1991: 158), we may be able to find, in Foucault's last work, modes of conceptualizing gender and subjectification outside of an apparatus of truth and individuality. Moreover, and most importantly, this is to begin to think about gendering selves outside of the dictates of obligation; at a conceptual level as well as at a lived one, the aim is to put some joy back in the processes that constitute what we are. Thus, when Foucault states 'I have sought to study – in my current work – the way a human being turns himself into a subject. For example, I have chosen the domain of sexuality – how men have learned to recognize themselves as "subjects" of sexuality' (1984a: 417) we hear the theoretical import of 'turning into subjects', but we can also catch the deep affective imperative of so doing. It is, of course, telling that it should *for example* be men that Foucault studies, but we should also not lose sight of what Weeks raises as central:

Far from denying the possibility of sexual change, Foucault beckons us

to think about it in different ways: not as a point of transcendence to power, not as a mythic moment of liberation, but as a possibility for inflecting the dominant codes, undermining the truth claims of the arbiters of desire, and making new relationships.

(1991: 166)

This is, then, to emphasize the work of the technologies of the self and to articulate that work from our personal experiences into our theories, and back again into our lives:

We have to understand that with our desires, through our desires, go new forms of relationships, new forms of love, new forms of creation. Sex is not a fatality; it's a possibility for creative life.

(Foucault, cited ibid.)

'FESSING UP A SELF

Since I began this chapter with an evocation of my self in relation to my mother, I want to inscribe the continued actuality of my self in relation to hers, in relation to what I am writing – selves in theory. While I was writing the thesis version of this argument, my mother died, abruptly, accidentally and unfairly. In the midst of the pain of shattered bits of self that followed her death, I wondered where to turn. The need to keep on going is evident; less evident are the ways in which one can 'keep on theorizing' while caught in the primacy of grief. In this case, in my case but in others too, there is no line of demarcation between an academic self and a personal one. Thus, especially at this time, thinking and theorizing and feeling the various movements of selves is as Foucault said, 'une forme de vie', 'a way of life' (1989a: 150). I see these forms and uses of the self as responses to some of the fears and changes in the current social formation and in my own life. Sometimes the personal is both a practical and political mode of interpretation; however it is in the modalities of its enunciation that we can begin to figure (in) new or different paths for cultural analysis. In simple terms, this is to think about how we can speak a self in relation to other selves, in such a way as to open up the possibility of a creative life: in such a way as to bring the joy and pain to bear upon the exigencies of analyzing the present.

John Berger, who has long studied the historical present in a personal and personable way, notes that

The present tense of the verb 'to be' refers only to the present; but nevertheless, with the first person singular in front of it, it absorbs the past which is inseparable from the pronoun. 'I am' includes all that has made me so. It is more than a statement of immediate fact: it is already an explanation, a justification, a demand – it is already autobiographical.

(Berger 1980: 47)

This description of the 'I' plays on the theoretical centrality of the construction of an 'I' in language even as it departs from a post-structuralist privileging of an 'I' only in language. While Berger's remarks may be understood as emphasizing the historical conjuncture which formulates a specific identity, they can also be taken as a justification of autobiographical explanations. Indeed, the use of the past to show what is bound into 'I am' has become a fairly common trope. For instance, in Valerie Walkerdine's article, 'Video Replay', the past wells up into the present: '[t]he film brought me up against such memories of pain and struggle and class that it made me cry' (1986: 169). Hebdige's article, 'Some Sons and their Fathers', tells of times when '[t]here was no "I" to do the knowing' (1985: 37). While these remarks obviously do go beyond 'statements of immediate facts', one needs to question Berger's qualification of the autobiographical as 'the explanation, the justification, the demand'. Berger's omission of a direct object to accompany these acts raises the question of what is demanded, explained and justified through the use of the autobiographical voice. We need, therefore, to consider the conditions of possibility that can allow for an articulation of the personal, and thence the self, as performed within the tensions between 'a justification' and 'a demand'.

The most obvious historical example that coincides with Berger's emphasis on the demanding nature of the autobiographical is that of the confession. As Foucault states: 'The obligation to confess is now relayed through so many different points, is so deeply ingrained in us . . . it seems to us that truth, lodged in our most secret nature, "demands" only to surface' (1980a: 60). To speak the self is to enter into certain relations and expectations: 'we have . . . become a singularly confessing society . . . Western man has become a confessing animal' (1980a: 59). In the first volume of *The History of Sexuality*, Foucault identifies confession as inherent to '*scientia sexualis*' and as the procedure 'for telling the truth of sex geared to a form of knowledge-power' (ibid.). What is not so clear is how statements like the following work within a theoretical discourse: 'Trying, crying, gaining, winning and, of course, ever present the barely whispered fear that I might not be good *enough* to avoid and evade failure and loss' (Walkerdine 1985: 71).

While these remarks are certainly confessional in tone, the effects entailed by this emphasis on the self are not quite contained by Foucault's formulation of confession as an instrument of power. This is not to say that the self here is not inscribed within relations of power, but as Foucault realized, the model of confession does not quite capture the wider productions of the self. The next two volumes of *The History of Sexuality* therefore turned to the question of 'the ingrained [or instituted] modes of knowing the self' (Foucault 1989a: 133). While there has been a rather surprising silence about Foucault's last writings (as Meaghan Morris says,

quoting a prospective publisher, 'Ah Foucault ... I'm very sorry, but there's no boom' [1988a: 5]), I will suggest that the projects of early, middle and late Foucault are deeply interconnected. More immediately, I see his theorization of the self as an alternative vector to the 'boom' that 'individualism' is now re-experiencing.

GETTING TO THE SELF

Roughly speaking, the problem is how to get to the self without going though the individual. And it is here that Foucault can most be of use. Given Foucault's deep abhorrence of any notion of a transcendental subject and his lack of interest in individuals, his move to the self may at first seem slightly strange. As the Italian historian, Carlo Ginzberg, says of Foucault, 'what interests [him] primarily are the act and the criteria of exclusion, the excluded a little less so' (1982: xviii). While Ginzberg is perfectly correct in his emphasis on the centrality of the 'acts and criteria of exclusion', there is a widespread notion that Foucault is uninterested in those bodies upon which the acts of exclusion are inscribed. For example, in *Herculine Barbin* (1980b), the ways in which the figure of the hermaphrodite is named and excluded are more important than the individual her/himself. In *I, Pierre Rivière* (1975), the case of a young nineteenth-century man who killed his mother, sister and brother and then painstakingly wrote about it, Foucault again surrounds and overwhelms the individual with evidence of the legal documents of the time. As with *Herculine Barbin*, Foucault leaves Rivière's memoir untouched, uninterpreted. While one could say that this serves to illustrate his indifference to the historical individual, it can also be seen as testimony to the power of Barbin's and Rivière's own statements about themselves. In other words, to have interpreted the memoir would have been to impose another individuality and authority upon these historical figures. As Foucault later said of Rivière:

> I believe that Rivière's own discourse on his act so dominates, or in any case so escapes every possible handle, that there is nothing to be said about this central point.
>
> (1989b: 132)

Rivière's own discourse about himself and his crime is left to stand alone without any detracting commentary. As Foucault puts it: 'I have said nothing about Rivière's crime itself, and once more, I don't believe anyone can say anything about it' (ibid.). While Foucault's method should not be romanticized as 'letting the individual speak', part of his procedure is aimed at showing the limitations of the professional discourses in interpreting the individual. By 'professional discourses', I mean, of course, psychology and psychiatry, two of Foucault's *bêtes noires*. Thus he explains that part of the reason for publishing *I, Pierre Rivière* was

for me a way of saying to the shrinks in general (psychiatrists, psycho-analysts, psychologists): well, you've been around for 150 years, and here's a case contemporary with your birth. What do you have to say about it? Are you better prepared to discuss it than your 19th century colleagues?

(ibid.: 131)

As it turned out, none of them actually did venture to 'discuss the case of Rivière in their usual insipid language' (ibid.: 132). 'Except for one fool, a psychoanalyst, who claimed that Rivière was an illustration of paranoia as defined by Lacan' they were 'literally reduced to silence' (ibid.).

Foucault's antipathy to 'the science of the unconscious self' (psych-ology/-oanalysis/-iatry) is readily apparent here, but the way in which he accords a certain dignity to historical figures should also be noted. Indeed the indignity of speaking for others combines with his concern with the historical possibility of certain types of subjectivity. Judith Butler presents an interesting hypothesis that in talking around Herculine Barbin, Foucault is performing a rather personal move:

In other words, Foucault, who gave only one interview on homo-sexuality and has always resisted the confessional moment in his own work, nevertheless presents Herculine's confession to us in an un-abashedly didactic mode. Is this a displaced confession that presumes a continuity or parallel between his life and hers?

(1990: 101)

While this may or may not be so (though the articulation of selves across centuries and pages of historical documents is appealing), clearly, in the cases of Barbin and Rivière, and in that of Foucault himself, we do not find examples of constituent subjects whose 'truth' can be analysed at the level of individuality. What can be studied, however, is the historical frame-work, and the fact that by putting themselves into discourse by writing their memoirs, they transformed themselves in print. As Butler says of Herculine Barbin's 'narrative self-exposition', it is 'itself a kind of confes-sional production of the self' (1990: 99). Here the gaze is internalized, the line of power is turned inward but, unlike techniques of surveillance, it may yield more enjoyable results. Thus, one can analyse

techniques which permit individuals to affect, by their own means, a certain number of operations on their own bodies, their own souls, their own thought, their own conduct, and this in a manner so as to transform themselves, modify themselves.

(Foucault cited ibid.: 367)

Barbin and Rivière were obviously documented and punished objects of the knowledges of the time. One can also say that through their memoirs

they 'affected an operation' upon their bodies and thought. We can therefore see here a 'double conditioning' requiring that we 'examine the relations between "local sites" and "transformation schemas" on the one hand, and larger strategies with their global effects on the other' (Morris 1982: 265).

This is then to articulate the techniques of domination with those of the self; to bend the line upon itself. In volumes 2 and 3 of *The History of Sexuality*, Foucault moves from the workings of the confession as a key instrument in producing the truth through domination to an emphasis on the constitution and transformation of the self: 'What to do with oneself? What work can be effected upon oneself?' (1989a: 134). If Foucault's first step in *The History of Sexuality* (volume 1) had been to deconstruct the 'repressive hypothesis' and to show exactly how sexuality was controlled not by repression but through the regulating effects of an overabundance of discourse, the next step was to shift from the attention to the 'techniques of domination' still evident in his first analysis. Thus if the first step concerned 'a history of the experience of sexuality, where experience is understood as the correlation between fields of knowledge, types of normativity, and forms of subjectivity' (Foucault 1986: 4), the next was to consider how individuals recognized themselves within this correlation: 'the relation of self with self and the forming of oneself as a subject' (ibid.: 6). 'What can we do with one's self? How can we work over this self?' (1989a: 134).

This preoccupation is not totally new; even in *Discipline and Punish* (1979), Foucault argued for the materiality of what he then termed 'the soul':

> It would be wrong to say that the soul is an illusion, or an ideological effect. On the contrary, it exists, it has a reality, it is produced permanently around, on, within, the body by the functioning of a power that is exercised on those who are punished.
>
> (cited in Butler 1990: 135)

The soul here is produced in what one might call the negative operations of power (in order to avoid the repressive epistemology, perhaps we should just say that the soul produced here is the result of some not very nice operations). However, in the turn to the term of the self, we find a signpost signalling a shift in the conception of power. The focus is now on

> the practices by which individuals were led to focus their attention on themselves, to decipher, to recognize, and acknowledge themselves as subjects of desire, bringing into play between themselves a certain relationship that allows them to discover, in desire, the truth of their being.
>
> (Foucault 1986: 5)

This is not to remake the self into a simple proposition; in fact, there are two interrelated levels, both of which have to be confronted in order to understand how self-constitution comes about:

> it was a matter of analyzing ... the *problematizations* through which being offers itself to be, necessarily, thought – and the *practices* on the basis of which these problematizations are formed.
>
> (ibid.: 11)

In turning to the philosophical arguments of Antiquity, Foucault seeks to elaborate a 'hermeneutics of the self' which would be concerned with the self, 'not only in its theoretical formulations; but also to analyze it in relation to an ensemble of practices' (1989a: 145). This hermeneutic would be situated at the point where theoretical formulations and practices intersect, or can be made to intersect. We can therefore begin to see here a double usage and performance of the self. Luther Martin explains that the attraction of the Greeks lies in the ways in which they articulated a theory and a practice of the self:

> two differently situated technologies of the Hellenistic self may be identified. The first, which is characteristic of the Western ethical tradition, might be termed an epistemological technology of self. This tradition emphasizes the activity of self-disclosure always in terms of an other ... The second, exemplified by the Eastern Thomist tradition, might be termed an ontological technology of self. This tradition emphasizes the discernment or disciphering of what the self already is.
>
> (L. Martin 1988: 60)

In Foucault's terms, we can contrast these two modes by characterizing the first as 'knowing thyself' and the second as 'taking care of the self', in other words, an epistemological technology of the self with an ontological one. As Foucault points out, '"Know thyself" has obscured "Take care of yourself" because our morality, a morality of asceticism, insists that the self is that which one can reject' (1988b: 22). In Martin's distinction, the epistemological and Western self is revealed in 'self-disclosure' and emerges in the activity of confession ('in terms of an other'), whereas we can say that the ontological self concerns a self already there ('take care of the self').

Although these distinctions may be valid, what is more important in Foucault's analysis of the Hellenistic conceptions of the self is the way in which he draws out a certain articulation of theory and experience through the figure of the self:

> how has the experience of the self and the knowledge of the self, and the knowledge that gets formed around the self, been organized in relation to certain schema? How are these schemas denied, valorized, requested, imposed?
>
> (Foucault 1989a: 133)

The questions that Foucault raises here are of a fundamental epistemo-logical nature: how do the experience and knowledges of oneself, and the knowledge that resides in the relationship between experience and knowl-edges, come to be organized? It is therefore not the Greeks *per se* that draw Foucault; it is the intricate formulation that he sees at work in their intercalation of theory and practice. It is the possibility of the self as an articulation of a way of life, a set of technologies, and a theoretical project that Foucault takes from Antiquity and brings to the present. As Wilhelm Schmid states: 'certainly, it is about a practice taken from Antiquity. However, Michel Foucault conceives its actualization as the opening of a perspective: the Self as possibility' (1989: 55). Thus the Greek concept of the self is 'actualized' and brought to light as a condition of possibility for the emergence of other knowledges, for the construction of strategic knowledges about ourselves.

A SOCIOLOGY OF DREAMS

One of the ways in which Foucault's project of the self 'opens up a new perspective' can be seen in his description and epistemological inter-pretation of a text by Artemidorous, a second century AD 'oneirocritic', an interpreter of dreams:

> [Artemidorous] undertook to write a work of method, and this in two senses: it was meant to be a manual for use in daily practice; it was also meant to be a theoretical treatise on the validity of interpretive pro-cedures.
>
> (Foucault 1988b: 4)

The emphasis in Artemidorous' text, *The Interpretation of Dreams*, is on the quotidian nature and need to interpret one's own dreams: '[o]ne should bear in mind that the analysis of dreams was one of the techniques of existence' (ibid.: 5). The point then was not to look for extraordinary dreams and their sources but for ways in which the dreams intersected with the real, to offer a 'handbook-for-daily-living' (ibid.: 6). Thus one could say that Artemidorous' book was aimed at making dreams 'work' in the everyday: '[a]lmost entirely centered not on the prophetic marvels of dreams but on the *techne* that enables one to make them speak correctly, the work is addressed to several types of readers ... to "ordinary" individual[s]' (ibid.: 6–7). In more contemporary terms, this analysis of dreams can be seen as focusing upon levels of mediation between (ordinary) individuals and their lived reality. The trick then is to learn 'the techne' of matching up the dreams with the real. It is in this task that the 'general reader ... needs basic instruction ... a manual for living' (ibid.: 6).

Included in Artemidorous' work is a validation of his mode of

procedure. First there is the 'ethnographic' collection of data: 'in the different cities of Greece . . . in Asia, in Italy and in the largest and most populous of the islands, I have patiently listened to old dreams and their consequences' (Artemidorous cited ibid.: 8). Then these data are tested and 'verified':

> he will submit it to 'experience' (*peira*), which is for him the 'guiding principle' and 'witness' of everything he says. What he means by this is that he will verify the information by matching it against other sources, by comparing it with his own practice, and by subjecting it to argument and demonstration.
>
> (ibid.)

In this way Artemidorous draws up a detailed text which 'presents in connection with dreams a catalog of different possible acts and relations' (ibid.: 9). The dreams are divided into two broad categories: '*enypnion*, those that speak of the individual; and *oneiros*, dreams that speak of events in the world' (ibid.: 10). Artemidorous is not concerned with the morality of the acts but with the relations to be formed between the dream and the waking world. The dream is intimately connected with a 'mode of being' but not with a normative evaluation of that being:

> the dream 'tells what is real' . . . the dream tells the event, the good fortune or misfortune, the prosperity or sorrow, that will characterize the subject's mode of being in reality, and it tells it through a relationship of analogy with the mode of being . . . of the subject as an actor on the sexual stage of the dream.
>
> (ibid.: 16)

Thus the self can be made to work upon itself: ordinary people take up their dreams and interpret them through a theoretical and practical manual, and they are then, through analogy, equated with modes of being. These modes are not ranked according to a set of moral principles but rather are linked to ways of stylizing oneself, to an art of existence. In drawing upon the work of Artemidorous as an exemplar of the period, Foucault wants to establish that the self is constituted through practices; it is not a given: 'It isn't given but is to be created . . . it's not a substance but a form' (Foucault cited in Schmid 1989: 55).

One can therefore see various changes in the formation of the self. In a key example of these changes and the fundamental shifts entailed by them, Foucault works through the Greek debate over the love of boys versus that of women. Remembering that Artemidorous founds his interpretation of dreams on the establishment of analogies to sexual states and positions, it becomes clear that the forms of 'aphrodisia' (lust, erotics) play an important part in the transforming of the self. Following the intricate debates of Plutarch and Pseudo-Lucian, Foucault raises the ways

in which the debate over women versus boys is not 'the conflict of two forms of sexual desire . . . It is the confrontation of two forms of life, two ways of stylizing one's pleasure, and of the two philosophical discourses that accompany these choices' (1988a: 218). So the shift in sexual ethics that at this time began to formulate a self in relation to a monistic and conjugal form of love is intimately tied to the self:

> It is not the accentuation of forms of prohibition that is behind these modifications in sexual ethics. It is the development of an art of existence that revolves around the question of the self, of its dependence and independence, of its universal form and of the connection it can and should establish with others, of the procedures by which it exerts its control over itself, and of the way in which it can establish a complete supremacy over itself.
>
> (ibid.: 238–239)

Here Foucault is quite definite that the shift from the love of boys to the heterosexual conjugal containment of love and sex was not prompted by repression or 'forms of prohibition'. It is, rather, that the modifications in sexual ethics were intricately tied into a particular articulation of the 'art of existence' and forms of the self. Foucault's project then in *The Pleasures of the Self* and *The Care of the Self* is to specify the ways in which a new sexual ethics arose through a particular conception of the self. In other words, how were the relations between selves changed as they were positioned differently in regard to a new horizon of sexual ethics? In Foucault's own terms, we could say that the self as formulated in the discourse of Plutarch and others provided the conditions of possibility for this new priority of heterosexual and conjugal love. Thus the Greek 'dilemma of passivity' (ibid.: 207) had long defined possible relations among men – it was the key factor in relation to which any stylistics of the self could be formed. What we see in the discursive emergence of a heterosexual and monistic love was that passivity could be avoided in 'the double activity of loving, by husband and wife' (ibid.: 208). Hence, Plutarch's 'new stylistics of love' was founded in the need to avoid passive relations among selves, resulting in the fact that '[t]here can no longer be a place for [boys] in this great unitary and integrative chain in which love is revitalized by the reciprocity of pleasure' (ibid.: 210).

While it might be tempting to see in this moment the birth of our homophobic society, this would be precipitous. In tracing through the modifications of the self and its relations to sexual ethics, Foucault does not propose a causality of events resulting in the present: 'some precepts emerge that seem to be rather similar to those that will be formulated in the later moral systems. But one should not be misled by the analogy' (ibid.: 239). What we do see is the establishment of analogies between the self and sexual behaviour which will then play out in:

other modalities of the relation to self: a characterization of the ethical
substance based on finitude, the Fall, and evil; a mode of subjection to a
personal god; a type of work upon oneself that implies a decipherment
of the soul and a purificatory hermeneutics of the desires . . . a different
way of constituting oneself as the ethical subject of one's sexual
behavior.

(ibid.: 239–240)

The questions Foucault raises should not be seen as a break with his
previous methods and mode of inquiry; they are rather a deepening of his
concerns with apparatuses which produce the possibility of various
'subjectivities', of various 'truths' about ourselves. These 'truths' are not
discrete but are the resulting positivities of multiple discourses and
practices:

[i]t's not a matter of locating everything on one level, that of the event,
but of realising that there are actually a whole order of levels of different
types of events differing in amplitude, chronological breadth, and
capacity to produce effects.

(1980c: 114)

His technologies of the self must, therefore, be seen as precisely designating
'a whole order of levels of different types of events'. This is a complex
economy of events that operates at different levels and that produces a
wide-ranging calculus of effects. Thus he reminds us of another method of
interpreting dreams that specifies analogies with sexual practice: the
interdiction of passivity seen in the types of sexual practices that allow a
male citizen to stylize his pleasures with boys without 'losing face'; the
debates over boys versus women which at first equate the love of women
with natural (animal) needs and then rearticulate the meaning of 'natural';
and the establishment of the truth of conjugal love at the expense of the
love of boys. These events all have to do with the self but they are not
located on one level, nor are they of equal weight and 'chronological
breadth'.

Artemidorous' interpretation of dreams has left little historical trace,
whereas we can find in the shift to monistic and conjugal love a condition
of possibility for the establishment of the Western heterosexual contract.
This possibility may be seen in Plutarch's rhetorical move as he 'transposes
to the married couple the traits that had long been reserved for the *philia* of
lovers of the same sex' (Foucault 1988b: 205). We also see the possibility of
the nineteenth-century naming of homosexuality as 'deviant' and 'inverse'
in Plutarch's formulation of 'pederasty' as 'consented to by an individual
who, because of his "softness", his "femininity", "enjoys being passive"
. . . which is a "shameful", "unnatural" thing' (quoted ibid.: 206). What is
important here is not a strict equation of an ancient discourse with a

present state of affairs, but the way in which this statement of Plutarch enters into a discursive field which previously held the love of boys to be of a higher order than that of women. To repeat what Foucault said in *Power/Knowledge*, 'it is a question of what *governs* statements, and the way in which they *govern* each other' (1980c: 112). The shift here from boys to women is not 'a distant mirror' of our present society, but the effects of these changed discourses will be felt in the possibility of other statements. One also clearly sees here that the shift away from boys has evident effects in the constitution of women's place within marriage. Thus the events involved in the care of the self, in the formulation of an art of existence, differ in their amplitude. Nonetheless, their intricate articulations enable other discourses concerning the relations of selves to each other, of selves to the discursive production of gender, and of gendered selves in relation to social institutions.

We can see in Foucault's technologies of the self the extension of his previous epistemological analyses. The self is a figure which designates a particular conjuncture of practice and theory. Beyond the historical interest of Foucault's description of the Greeks, his use of the technologies of the self implements a double analytic movement. As Foucault frames this analysis:

> a history of the 'care of the self' understood as experience and but then also as a technique that elaborates and transforms that experience. Such a project is at the intersection of two themes previously dealt with: a history of sexuality and an analysis of the forms of governmentality.
>
> (1989a: 134)

The 'care of the self' is therefore to be understood both as 'experience' and as a technique to elaborate upon and transform that experience. Fundamental to the concept of the self are the practices that individuals engage in. These practices (which in *The Care of the Self* are shown to revolve around different forms of sexuality) then serve as the basis on which to form 'problematizations through which being offers itself to be, necessarily, thought' (1988b: 11). Thus the theory, practice and use of the self are neatly interwoven, and they allow for other modalities of being. While 'practices [are] the basis [on] which problematizations are formed' (ibid.), these resulting problematizations allow for other practices. Here we can see that no single state of being is offered; states of being are always in tension with the practices of being. Taking from Foucault, we can begin to envision a self produced in the articulation of problematization and practice: operating at an epistemological level to reveal the problematization of a ground, which at another level is constituted in the very practices and engagements of the self. To be sure, this self is not a universal guarantee; it is the combination of several levels implied by the self that allows for specific analyses. This conceptualizing of the self is not only an

historical description of the self but also offers a mode of analysis that can 'locate the connections and extensions of power, to build little by little a strategic knowledge' (Foucault 1980c: 145).

In other words, the self should be used congruent with Foucault's notion of how theory in general proceeds:

> (i) The theory to be constructed is not a system but an instrument, a *logic* of the specificity of power relations and the struggles around them; (ii) That this investigation can only be carried out step by step on the basis of reflection (which will necessarily be historical in some of its aspects) on given situations.
>
> (ibid.)

Conceived of as a 'tool kit', the self both expresses the specificities of local power relations and allows us to figure them in ways that can be analysed. In that the self is seen as both practice and the problematization of practices, the investigation of power struggles and relations is undertaken through the self, thus ensuring that the analysis is both historical and reflective of the given situation. It is a self conceived of as within the force of a critical attitude.

I now want to consider how Foucault's elaboration of the self may help us in the formulation of an enunciative position within feminist cultural studies. From Foucault, it is clear that the self is not an entity that can be represented; rather it is in the articulation of problematizations and practices that certain modalities of the self historically emerge. These modalities are ways in which 'being offers itself to be thought'. The ontological pull of the self is checked by the social techniques that 'elaborate and transform' the experience of the self. No one aspect of the self can therefore be represented metonymically; no one practice can stand in for a whole.

FOLDS IN THE SELF

The 'care of the self' is 'always a real activity' (Foucault 1988b: 24). These real activities performed on the self and through the self emphasize that the self cannot be seen as a stable ontological entity; rather, the self is a line of analysis that articulates the epistemological and the ontological. Deleuze's reading of Foucault and his metaphor of 'le pli' (the 'pleat', the 'fold', the 'doubling up') further insists upon the pliable nature of the self as form and not substance. As Deleuze notes, the idea of the *pli* can be found throughout Foucault's work, but it becomes more evident in his last work; it is here in the technologies of the self that we find *le pli* 'as the operation of the art of living (subjectification)' (Deleuze 1990: 151). Arguing that Foucault's notion of *le pli* is akin to that of Michaux, Deleuze cites Michaux's rather lovely idea that

A child is born with twenty-two pleats (*plis*). It is a question then of unpleating them. Life is then complete. In this form the person dies. There are no more pleats to undo. It is rare that one dies without having a few more pleats to undo. But it has happened.

(Michaux cited ibid.:152)

In Foucault we find only four pleats, which are modes of articulating the 'outside' and the 'inside' ('le dehors et le dedans'). Here we can see the distinction again of the line of power that remains outside (pressed against the body) against a conceptualization of the ways in which the line meets up with the inside. Simply put, one is to be found in the techniques of objectification and the other in the processes of subjectification. The act of 'pleating' or 'folding' ('la pliure') is thus the doubling-up, the refolding, the bending-onto-itself of the line of the outside in order to constitute the inside/outside – the modes of the self.

What we can take from these descriptions and metaphors is a way of conceptualizing modes of creating and using selves which cannot condense into a unified Individual or Subject. The example of the Greeks is used to show that there was (is) a moment when 'it is not sufficient that force is exercised against other forces, or that it takes on the effect of other forces, it also has to be exercised on the self, itself' (Deleuze 1990: 153). Thus the line of the outside is folded, and refolded against the inside along a series of 'optional' practices involved in the relation of self to self and to selves. As Deleuze argues, 'This is subjectification: to bend the line so that it comes back upon oneself' (ibid.: 154). The production of subjectification then allows us to envisage ways of living with ourselves and with others. This is both a practical question and a theoretical one. It is, for Deleuze, the question of poetry-philosophy:

up to what point can we unfold the line without falling into an unbreathable void, into death, and how to fold it without nonetheless losing contact with it, in order to constitute it as an inside co-present with an outside, applicable to the outside?

(ibid.: 153)

In simple terms, this is to acknowledge that we need to push our selves and feel our selves moving. At the same time, it is not an instruction to throw our selves over the brink into madness. The self has to be stretched but not broken, folded but not rendered schizophrenic. We need to manipulate and bend our selves but this is not inward action conducted in the hallucinations of self-supremacy. The task is one of folding the outside and the inside together so that we can better intervene in the outside. The point is not to include the outside with the inside in such a way that overwhelming pain renders us only able to inhabit the inside. Folding the line reconstitutes us in another form of subjectification; it does not annul us.

The different ways in which the outside is folded with the inside provide us with a model of individuation without an individual: 'Subject-ification as process is personal or collective individuation, in relation to one or to many' (ibid.: 156). For Deleuze, there is a distinction between two types of individuation to be found in Foucault's care of the self:

> one is love, by people, the other is by intensity, as if people are founded in passion, not in an indifferentiated way, but in a field of variable intensities . . . a field of intensities that individuate without a subject.
>
> (ibid.: 157)

The processes of subjectification thus are individuated ways of producing subjectivities that do not coalesce into a fixed subject. The bending and folding of the line of the self is always an individuated construction of the inside and the outside, although the line is also articulated in public ways. In fact, the concept of folding the self scrambles any dichotomy of interior self and exterior social. The practices of the self are bound up in and carried over to the political realm: '[b]eing occupied with oneself and political activities are linked' (Foucault 1988b: 26). 'Taking care of the self', as opposed to 'knowing thyself', involves practices which construct a self. These practices are sexual, political and practical. It is in analogy with sexual practices that selves can be known in the waking world; one takes care of the self through caring for the community, 'the activity of a farmer tending his fields, his cattle, and his house, or to the job of the king in taking care of his city and his citizens' (ibid.: 24–25). One way of extending the care of the self is to write about the self: '[t]aking care of oneself became linked to a constant writing activity. The self is something to write about, a theme or object (subject) of writing activity' (ibid.: 27); 'the self is an object of care, an element for reflection' (Foucault 1984b: 30). What we can take from these descriptions is a model of the self which operates at both ontological and epistemological levels in order to construct various modalities of the self.

Against a model of organicism, we can see here a self that is not posited before the community to represent them on the basis of 'authentic origins'; it is a self that is in part allowed to be thought through the articulation of sexuality, care for the community, and as an object of writing and reflection, a substance to be stylized. Thus the work ('le faire') of the technologies of the self is precisely to emphasize the different operations and levels of the self. To clarify this, I'll consider more closely the enunciative position which emerges through 'the care of the self'.

Key to Foucault's last writings is the intersection of the self and sexuality. The Greek male self in all his permutations must maintain a position of activity both in regard to sexual practices and in wider political dealings. Thus in Artemidorous' interpretation of dreams, signs of weak-ness in sexual encounters are correlated with the reality of losing face in

everyday dealings. 'To place oneself "beneath" one's servant in a dream, thus overturning the social hierarchy, is ominous; it is a sign that one will suffer' (Foucault 1988b: 19). It was the interdiction against passivity that led the way to a reformulation of acceptable sexual practices. The equation of self and sex is in turn governed by this interdiction against passivity. 'Concern for the self always refers to an active and erotic state' (ibid.: 24). The love of boys occupied a precarious legitimation, sanctioned if conducted with young boys who allowed the male citizen to be 'masterful'. As, in turn, these young boys grow up, in order to be 'masters' themselves they had to dominate others; they could no longer politically maintain a position of passivity.

So the 'new sexual ethics' which begins to emerge with Plutarch was founded in a situation which precluded passive male citizens. The way out of this dilemma of passive masculinity was to elide boys altogether in favour of the 'naturally passive' sex: women. Thus the techniques of the self took place within a discursive field marked by a dichotomy of passive/masterful. The 'faire' of this image of passivity was what caused a turn to heterosexuality from which the West has yet to recover. As a third term, homosexuality 'disappears' within the formulation of technologies of the self ruled by the image of mastery and the interdiction of passivity. In this way, the technologies of the self that are in place before Christianity constitute an 'elegant solution' to the problematic encounter of same-sex selves. The love of boys is thus elided within the apparatus of 'the economy of pleasures, conjugal fidelity, and relations between men' (Foucault 1988b: 240). These manoeuvres must also be conceived of as technologies of gender – social and discursive operations that produced two genders and aligned them with a binary definition of sex and sexuality. So to say that there is no gender in Foucault's conception is wrong. That he does not critique the position of women either in Antiquity or in the present does not obviate the fact that he does describe one of the conditions of possibility for modern articulations of sex/gender. Thus, while his articulation of the self does not explicitly touch the ways in which women may have experienced their actual discursive exclusion and then inclusion in the practices of sexuality and care for the self, Foucault's theorizing of the self nonetheless holds out feminist possibilities.

In an interview conducted in 1982, Foucault remarked that '[e]ach of my works is a part of my own biography. For one or another reason I had the occasion to live and feel those things' (in R. Martin 1988: 11). Without overly privileging these remarks, I think that we can see Foucault's formulation of the self as an attempt to think through the necessary groundwork for the formulation of a possible enunciative position. This position is grounded in its relation to all those discourses elided in the establishment of the heterosexual contract. Thus the self has to be thought in the positivity of discourse: that which is said or not said as well as that

which is said against certain forms of self. How does one speak when your self is ruled (out) by an image of interdiction? As Foucault puts it, rearticulating Weber's renunciation of certain parts of the self, '[h]ow have certain kinds of interdictions required the price of certain kinds of knowledge about oneself?' (ibid.: 17). Knowledge of the self, and the uses of the self, exist in relation to certain kinds of interdictions. However, these interdictions along with modes of the self are not fixed or stable. The question then becomes an operative one of how we can fold ('plier') these interdictions upon themselves? Is there a way of bending the line which weighs upon women and others so that we actually see and are seen differently? This is to insist upon the fact that we are used to seeing our selves in a certain way and in a certain relation to others and to the social. As Foucault argues, there are good reasons for this but these reasons themselves must be questioned and folded onto themselves:

> [t]he political and social processes by which the Western European societies were put in order are not very apparent, have been forgotten, or have become habitual . . . It is one of my targets to show people that a lot of things that are part of their landscape – that people think are universal – are the result of very precise historical changes . . . and show which space of freedom we can still enjoy and how many changes can still be made.
>
> (ibid.)

Here we can see a very concise statement of Foucault's historical project: to allow people to see that the ways in which they live, the concepts by which they organize their thoughts and feelings, the 'habitual order that they enjoy or suffer under – that all of these things are the results of 'very precise historical changes'. In other words, the relations that individuals maintain in society, and the interdictions that hold us, can be 'de-naturalized', their historicity shown. Furthermore, in so doing we may be able to approach those small 'spaces of freedom' and begin to think of the historical possibilities of change. Using the technologies of the self as a way of analysing the self's different levels and its work in the historical arrangement of the present adds an important and essential critical perspective to this overall project. What emerges from this concern with the self is a way of formulating an enunciative position in the interstices of self/social relations.

Indeed, *The Care of the Self* demonstrates that enunciative positions may be mobilized in diverse ways; that they emerge in different and localized articulations of practices and problematizations. Foucault's last writings demonstrate clearly the historical shift away from a society that privileged homosexuality and the integration of sexual practices in concepts of caring for the self. He therefore provides us with a theoretical framework that demonstrates the fallacy of universal heterosexuality. Within the

concept of caring for the self, Foucault provides a basis for an enunciative practice that integrates sexuality with other political articulations of selves.

An example of this type of investment in the modalities of the self can be seen in Dick Hebdige's article 'Some Sons and their Fathers.'[1]. There Hebdige moves from his breakdown to the actual historical situation in Britain, to the death of a friend, to the public mourning of Diana Dors, to his own father. As he explains: '[b]y trying to speak in more than one dimension – by using different voices and images – I am trying to explore certain possibilities which a more straight-forward approach would, I think, ignore' (1985: 31). Hebdige's point is not the construction of a picture of fragmented subjectivities, but the ways in which selves struggle with themselves in order to say something. In Hebdige's description this is to try to find ways to speak in different voices, to put forward different modalities of the self without falling apart, to develop other relationships – with others and with oneself. As he puts it:

> It is so difficult to resist our own construction, to build constructively on what's already there. It is so difficult to peel back the shifting layers of images and words through which we have been made and within which we go on making and remaking ourselves so that we can stand up and say this is who I am and this is where I come from.
>
> (ibid.: 34)

The process that Hebdige describes can also be taken as a depiction of the work of the technologies of the self: a continual process in which the self is practised and problematized. It is in and through these struggles that an enunciative position, a place to speak from, emerges: 'we want to own ourselves at last. To own our own voices' (ibid.).

Hebdige's use of self illustrates a double articulation of the self: on the one hand, to speak of and to one's self thereby transforming the self; and on the other, to put forward voices and selves in relation to a theoretical and actual horizon, thereby transforming the practices which constrict selves as well as the horizon itself. As instances of caring for the self, these selves and their movement articulate the practical business of getting on with life, the social relations in which one lives, and the sexual practices and definitions of gender that seek to define us. In his conclusion, Hebdige restates these levels as

> what counts now as always is collective action ... finding ways of linking with and expressing emergent and residual forms of masculine identity, [and] tracing out how these forms are related to and shaped by institutional pressures and broader social and economic forces.
>
> (ibid.:38)

The possibility of articulating these levels lies in the construction of

different modalities of the self. Lodged in specific situations and conditions, the self must be used epistemologically to reveal the nature of the articulation, and ontologically to acknowledge the affectivity of the articulation. 'We have to go on making connections, to *bear* our witness and to *feel* the times we're living through' (ibid.: 39).

WHAT IS GOING ON JUST NOW?

This statement by Hebdige is echoed by Deleuze's summation of Foucault's project: 'What new modes of subjectification can we see emerging today that are certainly neither Greek nor Christian?' (1989a: 192). But this question begs another one, one that we all confront be it in our research or from students, the question that waits for us at the end of the day. How can we untangle the lines of the apparatus in which we live, sleep and think? What are we bearing witness to? How do we see new modes of subjectification emerging when we are formed in the old? Possible answers to these questions can be glimpsed only if we radically reconstruct what we are. For Foucault, the possibility of diagnosing the present entails that

> The diagnosis be understood as not establishing the constant of our identity through a play of distinctions. It establishes that we are difference, that our reason is the difference of discourses, our history the difference of time, our I the difference of masks.
>
> (cited in Deleuze 1989a: 192)

This means that the question of who are we must be replaced by that of what are we, and that the self be understood as a moving line that takes us towards the 'becoming other at which we are arriving' (Deleuze, ibid.: 191). While rather mystical in tone, this injunction is far from a utopian appeal to discard the brutal evidence of what we are now in the hopes of becoming something better. Rather, these lines of analysis 'have their theoretical coherence in the definition of the historically unique forms in which the generalities of our relations to things, to others, to ourselves, have been problematized' (Foucault 1984a: 50).

With the concept of Foucault's self in mind, and the question of what we are, we can begin to situate the use of the self in theoretical writings as moving somewhere between an apparatus of the individual and the processes of subjectification. In charting the movements of the auto-biographical voice we see two poles (re)emerging within cultural criticism which need to be problematized, and worked against. The first is a tendency to use the autobiographical as a guarantee of authenticity, a reworking of the self in the face of the acknowledged difficulties of representing 'the other'. This theoretical pull can be historically located in the aftermath of Baudrillardian arguments about the impossibility of

(representing) the masses (Baudrillard 1980; 1983; Lipovetsky 1983). Here the theorist's self is free to roam, to turn back to itself. As Baudrillard puts it: 'tout à découvrir, tout à effacer' (Baudrillard 1986: 25). In a mood of 'discovering everything, effacing everything' the self becomes an end in itself. The uses of the self that gravitate towards this pole can be said to work primarily on an ontological level; the use of the self guarantees a special order of reality located in a personal 'truth'.

The second tendency is towards a return to the individual. This move can be seen as a loosely articulated response to the centrality of a disembodied subject within poststructuralism. As the 'subjectivity' debates wear thin, there is a decided turn away from 'the subject' in theory to an individual self. It would seem that the influence of Althusserian formulation of the interpellated subject is such that it leaves little room to rethink subjectivity without having recourse to equally limited notions of the individual.

However, I am arguing for a way of understanding the self and subjectivity outside of either an apparatus of truth and individuality or one of interpellation and ideology. It is not enough merely to state that 'lived "experience" is not a *given*, given by a pure "reality"', but the spontaneous "lived experience" of ideology in its particular relationship to the real' (Althusser cited in Fuss 1989: 114). Without falling back into the real individual, we can nonetheless go beyond the flat terms of the subject. Using Deleuze's description of the folds and pleats of the self, we can begin to examine modes of subjectification that neither pass through the individual nor stop dead at the subject. On the one hand, it is hard to imagine speaking positions that arise from Althusser's conception of the subject. And on the other, we are all too familiar with the types of enunciations that emanate from the individual when, for instance, REAL Women take hold of the sovereignty of the signifier woman.

In bringing together the practices that we live and the problematizations of those practices, the self can provide a place to speak from. We can think of the 'work' of the self; grounded in 'the primacy of the real' the self must also be made to move analytically, revealing the character of the mediations between individuals and social formations. The work of the technologies of the self both describes the location of the self in everyday practices and the capacity of the self as a theoretical articulation, as an analytic tool, to 'cut into that real'. This double articulation of the self then provides the necessary basis for, and the beginning of an elaboration of, an enunciative practice in cultural studies. This means that one cannot simply 'speak out' and cry from the heart; without a theoretical model of that speaking there is no ground for an enunciative position. While we cannot always guarantee the politics of individual voices, we can work to elaborate a speaking position that is formulated through and stitched into the larger political articulations of feminism and socialism. In speaking

from there and in speaking our individual selves, we begin to see the ways in which we can 'bear witness' to ourselves as theorists and to the times in which we live.

The self that is uttered from a theorized speaking position is not an ontological moment (though it may contain it); rather, it works at an epistemological level to analyze its own *mise-en-abyme*. This then allows us to conceptualize and rethink the relations involved in the self: the relationships of the self to self as well as those brought together when the self bends the line of the exterior – when the self is reflected upon and spoken in the community. While we can't go back – nor would we want to – to an idealized time when the self played out differently, we can conceptualize the self as caught in the tensions of two statements; between 'knowing thyself' and 'taking care of the self'. We can work to articulate an epistemological technology of the self with an ontological one. This would be to recognize and analyse the epistemological productions of the self as played out in statements, interdictions and knowledges. Yet at the same time the ontological operations of the self reveal the ways in which the processes of subjectification, the relations of ourselves to ourselves and to others, always problematize any set knowledge of the self. As a theoretical position this means taking the implications of our attitudes seriously; that as feminist critics we must consciously work with and through ourselves, that the theoretical uses of the self constitute a mode of relating to our actuality – of what we are becoming. To recall Foucault's words, this is a mode of theorizing, 'of acting and behaving that at the one and the same time marks a relation of belonging and marks itself as a task' (1984b: 39).

This task is to put oneself into the cultural landscape in order to throw it into relief and to allow new vectors and relationships to be seen, to be created. As 'man' fades away, the face of this discursive and affective landscape changes radically. Seen from the position of an alternative conception of the self, the self as an enunciative and theoretical strategy, this new landscape contains the possibility of ways of living within the social, of new sexual and gender ethics, of constructing theoretical accounts, and of experiencing oneself in relation to others in the historical present of oneself.

In less heroic terms, Foucault's care of the self allows me to consider a way of speaking and of theorizing that proceeds from 'me' without reifying me as the subject of my speaking. This opens the way to considering a mode of theory that is not organized around individuals but that with force offers us a space where we can take seriously how we are individuated. From this point I can begin to envision ways of thinking that can fold the line between us, and thus bring together the question of 'who and what is she?' and 'who and what am I?'

NOTE

1 While the tone of this article is particularly striking, Hebdige's writing in general is remarkable for the way in which he interveaves fragments of self, place and space; see Hebdige (1989, 1987a and 1987b).

Chapter 6

'Without *her* I'm nothing'
Feminisms with attitude

While Madonna's numerous charms for feminism have been variously lauded, I think that her song *Vogue* most aptly captured a certain mood, pose and attitude for feminists in the 1990s.[1] However, if Madonna can sing that it makes no difference if you're black or white, if you're a girl or a boy, in this chapter I want to examine feminist theories that insist on those differences (it does make a difference if you're black, if you're a girl, if you're a lesbian). More specifically, I will argue for a certain feminist use of attitude that articulates these differences in imaginative enunciations of feminist selves. At the moment, instances of the tone that I wish to explore can be most clearly heard in certain critiques of representation elaborated by Black feminist cultural criticism and by lesbian feminists. For instance, against all the logics, theoretical and institutional that want to oppose her 'as "Other" to whiteness, as difference personified, feared, repressed, and (so) oppressed', Jackie Goldsby responds with attitude: 'But yo: there's more to life than objectification. There's subjectivity in "race": *I* can speak first, out of the primacy of my existence; I can speak first, out of the richness of my blackness: *I* think, therefore I is' (1991: 218). While we can't all imitate her, we can, nonetheless, turn for inspiration to '"the virile girl", the butch baby, full of attitude but not of scorn, lots of street smarts and a bit of muscle' (Golding 1991: 200–202).

BUT *WHO* IS SHE?

While the questions of 'who am I? and who is she?' have served as my horizon for many of the arguments presented so far, it seems that the focus keeps on falling on the first part of this equation. My problem is that speaking the self seems to revolve around speaking myself. This is not really what I set out to do and so it troubles me although it may not be a problem for others. For instance, Barbara Christian argues that critics need to 'let go of their distanced and false stance of objectivity and . . . expose their own point of view – the tangle of background, influences, political

perspectives, training, situations that helped form and inform their interpretations' (1989: 67). From Christian's point of view I may not have sufficiently exposed myself; whatever the extent of my self-disclosure, I want to argue that the point is not to stop there. And in any case, Christian's argument is directed at white feminists in the hope that they will let go of a certain articulation of centrality and privilege, and not that I as a white woman should actively claim more space. In Gayatri Spivak's words, 'what we are asking for is that the hegemonic discourses, the holders of hegemonic discourse should de-hegemonize their positions and themselves learn how to occupy the subject position of the other' (cited in hooks 1992: 346).

In problematizing my position as a white feminist as well as the concept of positionality, I want to slightly shift Spivak's demand and turn it in a hopefully more productive direction. It is not that I disagree fundamentally with the idea of 'positionality'; I am not quite sure how one goes about 'doing' positionality in theory or in practice. Rather than building on a logic where the one becomes the other I want to re-pose a problematic wherein women may speak within the tensions of 'herself' and 'myself'. Instead of switching positions (the postmodern ploy where 'I' can decide to be 'other'), this is to work in an anaclitic mode privileging identities, differences, difficulties, desires and wishes without silencing what she wants or what I want. Outside of a logic of binary opposition, an anaclitic model of identity would gently fold expressions of difference upon themselves so that like acetate transparencies one can no longer tell which one was first. If this sounds utopian, let me stress that as a theoretical and practical project it may be more realizable than Spivak's demand. This mode of analysis also foregrounds the fact that it is very rare for one individual to 'hold' hegemonic discourse. While there may be times that I as a white woman hold more power than a black woman or a woman of colour, there are probably times when Spivak finds herself in a hegemonic position. Beyond this, it seems to me that we need to instil some sense that being articulated with the 'other' may be a pleasurable experience. The point is to work within the desire that I have of being with her and not a programme based on guilt and self-denigration.

In arguing for feminism with attitude, I want to elaborate an enunciative practice based in the positivity of 'who is she and who am I'. Of course, this involves more than just simply 'striking a pose'. It entails a doubled project; as Foucault has argued, attitude necessitates that an analysis of complex relations must be augmented with 'a more positive content to what may be a philosophical ethos consisting in a critique of what we are saying, thinking, and doing, through a historical ontology of ourselves' (1984b: 45). While Foucault's conception of attitude certainly differs from that of Madonna, it too can point us in the right direction:

This philosophical ethos may be characterized as a *limit-attitude*. We are not talking about a gesture of rejection. We have to move beyond the outside–inside alternative; we have to be at the frontiers. Criticism indeed consists of analyzing and reflecting upon limits . . . The point, in brief, is to transform the critique conducted in the form of necessary limitation into a practical critique that takes the form of transgression.

(ibid.)

Thus, a limit-attitude stipulates that we work at the frontiers of ourselves, not looking back on what we know, but rather that we look forward to what we do not know, that we transgress on what we do not know. In the context of feminist debates on identity and difference we can use Foucault's limit-attitude to think about ways to construct a more positive critique. So in addition to analysis aimed at revealing the material conditions of sexual or race difference, we need to elaborate modes of enunciating difference that would go beyond the limits of our individual selves. Far from negating difference, this analysis is fuelled by a 'historical ontology' of what we are. Enriched by that ontology, the point is then to push beyond an 'outside–inside alternative' to a place where we can think the two together: this is to refuse a logic of either 'me' or 'she' and move to a mode of theory that allows us to think difference together, outside of a binary logic, at the same time that the material and ontological conditions of difference are privileged. This is then to speak in difference and to elaborate a mode of enunciation that transgresses the limits of difference. It is to speak with attitude; an ethical and caring mode of saying, thinking and doing, inspired by a historical ontology of what and who we are and what and who we hope to become.

There is at the moment a small explosion of writers exploring their selves. As a theoretical practice, this is particularly evident within American feminist literary criticism. As a self-conscious strategy, what Nancy K. Miller calls autobiographical or personal criticism 'entails an explicitly autobiographical performance within the act of criticism . . . [it is] a deliberate move toward self-figuration' (Miller 1991: 1). And as a mode of interpretation within literary studies, the self is figured before a literary text. Or, in Mary Ann Caws' description, the self mingles in with the text: 'the crucial element of this act involves the mixing of text and critic, and the marking of that interaction in voice, tone, and attitude' (cited ibid.: 27). Attention to herself is also central to Rachel Blau DuPlessis' project, where 'elements of guarded yet frank autobiography, textual analysis, and revisionary myth-making suddenly fused into a demanding voice, with a mix of estatic power over cultural materials and mourning for the place of the female in culture' (DuPlessis cited ibid.: 27). These articulations of a personal mode of criticism turn on the conviction that 'somewhere in the

self-fiction of the personal voice is a belief that the writing is worth the risk' (ibid.: 24).

Although these are compelling arguments, the critical voice that speaks from the frontiers of the self seems to be looking back in the direction from which it came. In other words, I'm not sure if the articulation of 'who is she' doesn't get lost 'somewhere in the fiction of the personal voice'. Moreover, it is not a generic 'personal voice' that is at play but very specific voices within the canon of feminist literary criticism. I wonder whether the emphasis on risk doesn't efface distinctions about who is writing and who is risking what, and why. After all, taking a risk means that you actively expose yourself to possible loss, injury or danger. Simply put, if it's worth the risk there must be something that you are conscious of not wanting to lose. And unless you are foolhardy (which is not the same thing as having attitude) you don't go about embracing danger for the sheer thrill of it.

Yet the invocation of risk often seems to stand on its own without any explanation of why it is necessary. For instance, in Rosi Braidotti's formulation risk takes on epic and abstract proportions:

> one aspect of contemporary feminist reflection which I find particularly striking is the element of risk that those thinkers introduce into intellectual activity ... Veritable adventuresses into the field of theory ... they reveal remarkable acrobatic talents as they trace mental routes across the void, without falling victim to gravity.
>
> (1991: 280)

While this image is heroic, one has no sense of why these nameless women are flinging themselves into the void. This is not to say that there are not many feminists who do indeed put their jobs and status on the line by coming out against institutional racism or sexism or by coming out as lesbians. Many feminists do speak out and take risks for good reasons. They may do it in hope or in rage, but hardly just for the thrill of it. While Braidotti probably does not intend to vaunt risk for its own sake, her celebratory discourse reproduces the type of statement that we are used to hearing from tenured liberal males (the ones that say they'll back us up when we risk our non-tenured jobs for causes they espouse in abstract, and then disappear).

In an interesting turn, risk seems to have replaced the emphasis on rage that Teresa de Lauretis succinctly articulated several years ago as the impetus in feminist theorizing: 'The real difficulty, but also the most exciting, original project of feminist theory remains precisely this – how to theorize that experience, which is at once social and political, and how to construct the female subject from that political and intellectual rage' (1984: 166). As one of the acrobats that Braidotti does identify, de Lauretis forges a feminist theory of subjectivity and experience that could disquiet some

versions of feminism. And theorizing the female feminist subject does involve something akin to a balancing act as one tries to hold together, without subsuming, the analyses of diverse experiences. Conscious of the ways in which individual feminist writers navigate the abyss that seems to gape between distinct experiences, identities and subjectivities, de Lauretis argues for

> the concept of a multiple, shifting, and often self-contradictory identity, a subject that is not divided in, but rather at odds with, language; an identity made up of heterogeneous and heteronomous representations of gender, race, and class, and often indeed across languages and cultures; an identity that one decides to reclaim from a history of multiple assimilations, and that one insists upon as strategy.
>
> (1986: 9)

The importance of specificity cannot be doubted, but how to do justice to all its instances is far from evident. Even less obvious is the passage from difference of experience to putting difference into and at the core of a workable theoretical language. Merely stating that difference exists is not not enough; we need to conceive of ways of rendering specificity into theoretical tools. As a small instance of ambivalence, de Lauretis' use of 'assimilation' strikes me as odd. In my own discursive context, assimilation designates the process whereby immigrants are to throw off their cultural differences in order to become good néo-Québécois. This meaning of assimilation (of becoming the same) is created discursively in the con-juncture of several discourses that announce a Québécois claim that historically they have been assimilated by English-speaking Canada and that therefore their francophone difference must be protected. Here the 'assimilation' of one group (immigrants) is made to make sense by the invocation of another group's right to enshrine in law and common sense their difference.[2] The argument that identity can and should be reclaimed from 'a history of multiple assimilations' suggests to me either a rather simplistic logic whereby semiotic and political questions are put aside in the name of equality, or an essentialist logic wherein it is simply obvious whose difference should count more. If we truly work at the limits of ourselves in a conviction of attitude, it is hard to predict and place the weight of difference beforehand.

In another example of this slippery scale of difference, as the editor of *Feminist Studies/Critical Studies* (1986), de Lauretis uses the metaphors of mask and masquerade to sum up the differences between the representa-tions of black feminist identities and those of white feminists. She argues that the black feminist writers in the anthology tended to use the term 'mask' rather than 'masquerade':

> the former is there to represent a burden, imposed, constraining the

expression of one's real identity; the latter is flaunted, or, if not, at least put on like a new dress which, even when required, does give some pleasure to the wearer . . . Verisimilitude, realism, positive images are demands that women of color make of their own writing as critical and political practice; white women demand instead simulation, textual performances, double displacements.

(ibid.: 17)

As de Lauretis further points out, 'That – considering that the political, the personal, and the tension between them are foregrounded by each and all of the critics in question – is difference indeed' (ibid.). Important as de Lauretis' naming of these differences is, dividing them along these metaphorical lines runs the risk of lumping together and solidifying difference. On the one hand we have the figure of the mask to represent the oppression of all black women, and on the other, masquerade translates into a generalized demand for pleasure and simulation; somehow the one is more real and immediate while the other just wants and can afford to be playful. It is fairly certain that de Lauretis does not mean to etch this articulation of difference in stone and, indeed, it may have merely been a momentary categorization, a useful heuristic device to organize the meeting of certain writers and critics, at a specific conference, in a particular place. Nonetheless, this example does raise the necessity of being specific in our choices of metaphors that are used to signify specificity. It also emphasizes the difficulty of speaking carefully, without being diffident, about differences. The point of attitude is to recognize and put into play in differentiated ways what Miller calls 'the affect and effects of self-display, and the spectacle of gender' (1991: 22).

First and foremost, I want to examine how we might speak within the tensions of a problematic of differences. In part, this necessitates moving beyond 'personal criticism' (the question of who am I?) in order to ask whether speaking the self can be made to work at an epistemological level in order to examine the terrain of the question of 'who is she?' Attitude cannot be expressed by looking back at myself; speaking with attitude means being thrown forward onto a terrain of other selves. This terrain holds both my self and her self but we remain distinct; we are spoken in compatible registers but we do not collapse into an amorphous and indifferent state. This attitude must be grounded in the profound recognition of the deep structure of difference.

I am not putting forward a naive hope, but a proposal for a complex theoretical project which proceeds on several levels. In his quest to excavate the ground underlying the question of 'who speaks, and to whom?', Michel de Certeau gives an idea of the scope of such a project. His approach is a doubled one which combines two analytic trajectories:

The first seeks to elucidate what one cannot eliminate . . . in other

words, it seeks to render explicit the conditions *without which* the range of problems to be resolved would be feeble, fallacious or already out of date. In practice, this means opening up hypotheses, breaking down interdictions, omissions or ignorance, to make flexible or to overturn objectives which present themselves, at first glance, as 'evident'. The second seeks to supply *concrete localizations* for problems considered to be the most important, to map pertinent points of contact, to project concrete hypotheses onto the soil of social life, and, in this way, to construct a geography of the possible.

(1973: 270)

De Certeau's argument raises with some force the questions that have to be asked before we can envision articulating the questions of 'who is she and who am I'. 'Disclosing and critiquing closures' and 'creating and rendering precise openings' are the twinned conditions of possibility of a doubled mapping of the ground that lies between her identity and mine. I want to use de Certeau's project of a 'geography of the possible' to render graphic the necessity of simultaneously working at two levels. De Certeau is very clear that intellectuals speak from a particular place ('lieu') which he defines as 'an ensemble of determinations'. In turn, 'we can never efface nor surmount the alterity which is maintained, before and outside of us, in our relation to the experiences and observations anchored elsewhere, in *other* places'(ibid.: 268).

Any critical project that forgets this is doomed to reproduce problematics that are already 'feeble, fallacious or expired'. Thus one strain is aimed at deconstructing these already 'evident' formulations. This line of procedure could be carried out and in many cases continues to be carried out, at an abstract level; for instance, in abstractions about 'the other'. However, for de Certeau, the direction of this line of analysis is towards its ultimate destination within 'concrete localizations'. Rather than an endless deferment, deconstruction becomes positivity as the line of argument is made to meet up with 'pertinent points of impact'. Employing a visual imagination, we could say that a map of the geography of the possible would consist of multiple transparencies which, without any one taking precedence, would allow us to see points of possible contact.

To my mind, 'personal criticism' does not get beyond the projection of one map. While in some cases it does this very well and gives us an in-depth view of what the social looks like from one place, including the determinations of that 'lieu', its logic stops there. As much as I like and appreciate Miller's form of 'personal criticism' (whenever I get blue from the frustration of teaching and working in another language and culture I cheer myself up by recalling her hilarious stories in her essay 'The French Mistake' [1991]), at an epistemological level she never quite gets beyond

herself. And comforting as it is to know that she has been humiliated by her French mistake, I am not convinced by her argument that this humiliation would necessarily make her empathetic to my own political, cultural and linguistic terrors. In other words, her text cannot reach into my context. Of course, in many ways the richness of Miller's work comes from the erudite fashion in which she precisely recounts her own context, her past and present 'as a feminist'. And to be perfectly fair, she may not wish to go beyond the limits of speaking within her self.

But in distinction to Miller's emphasis on her own autobiography ('the risk of a limited personalism': 1991: xiv), I want to run the risk of speaking within the space between my self and another's self. This then entails working within a 'limit-attitude', speaking with attitude, as I attempt to elaborate ways in which we can transform limitation ('I' am not 'she') into practical critique. The risk involved here is that I will transgress sensibilities as well as the limits of my own capacities; that I will either reproduce the condition for, or actively commit, epistemic violence; that I might make a fool of myself (with all the material consequences that entails). However (and this is not to fall back on 'good intentions' as a caveat) my transgressions are aimed at transforming the representation of the relations of alterity; my limit-attitude can be characterized as the rejection of a binary construction of identity as horizon. This is then to move away from an either/or, 'she' or 'me' logic. As I say this, I also recognize that not only is it impossible for anybody to speak in anybody else's voice; to imagine that I could do so would be, in Wallace's words, 'to further consolidate the lethal global presupposition (which is unconscious) in the dominant discourse that women of color or black women generally are incapable of describing, much less analyzing the world themselves, or their place within the world' (1992: 661). Thus, as a feminist practice, speaking the self can neither privilege 'me' nor can it presume to speak for her. As Hazel Carby clearly puts it, 'The herstory of black women is interwoven with that of white women but this does not mean that they are the same story. Nor do we need white feminists to write our herstory for us, we can and are doing it for ourselves' (1982: 223).

Without speaking for her, a problematic of enunciative practices located within the absence and presence of her identity and mine must recognize that racism continues to be, as Carby says, 'a structuring feature of our relationships with white women' (ibid.: 213–214). The fact that racism is structural and not an epiphenomenon of other structures is something that feminism has been loath to confront. In part, this can be understood because it undermines clear-cut equivalences of various degrees of oppression. In part, it is also because drawing attention to the ways in which racism structures relationships forces us to admit its overwhelming pervasiveness. Simply put, racism is implicated in our very sense of ourselves. For black women this is not news. In celebrating

the more widespread availability of black women's literature, Toni Morrison argues that this allows 'us to choose to examine centers of the self and to have the opportunity to compare these centers with the "raceless" one with which we are, all of us, most familiar' (cited in Wall, 1989: 1).

It also has to be said that over the past few years, thanks to the publication of books like *This Bridge Called My Back* (Moraga and Anzaldua 1981) and *Yours in Struggle* (Bulkin, Pratt and Smith 1984), white feminists have become increasingly aware of this (our) racism. That this has been slow and long in coming is obvious; that we don't quite know how to speak about it is also evident. Unfortunately, the recent discussions about how black women, women of colour and white women might address racism together are often marked by a liberal bandying about of the standard metaphors of 'voice', 'conversation', 'dialogue' and 'listening'. All too often, this produces a situation wherein problems are articulated in such way that they are already closed down, or in de Certeau's words, they are rendered 'feeble'. Of course, it would be wrong-headed of me to suggest that these metaphors can never produce wanted effects. At times they do capture and convey meaning in heartfelt ways. For instance, when black feminists like Barbara Christian ask whether 'By the year 2000 will our voices sound like women's voices, black women's voices to anyone?' (1989: 74), the metaphor of voice expresses a complex relationship between the institutionalization of black studies, the place of black women within that process, and the awful possibility that black women's representations of themselves will in the future belong to anyone but themselves.

At best, metaphors can accomplish this type of connection, they can evoke and encourage movement; at worst, they stifle and render abstract that which is immediate, or that which needs to be contextualized in the density of the immediate; they tame the impulse of attitude. While it may just be my idiosyncrasies, 'conversation' is a prime example of the way in which some uses of metaphors can cloud the stakes. It always conjures up for me that white middle-aged American liberal phrase of 'I hear you', which usually means that the speaker has not understood (or heard me), nor does he want to. The idea that we could solve structural problems in free and equal conversing goes against the requisite that we proceed from an acknowledgment of the ensemble of determinants that limit the ways in which we can encounter others. Given that racism and homophobia are among the structuring elements of women's relationships with each other, I suggest we drop the pretence of liberal dialogue. This does not mean that we give up; it does mean that we should get on with imagining other ways in which we can realize alternative relations of alterity, a geography of the possible in which our lines of analysis, of thought, of difference may be made to connect.

USE YOUR IMAGINATION

With some trepidation, I want to put forward the idea that we use our imaginations (that *is* what they're for); not as a metaphor but more in the spirit of a perlocutionary act. Appropriating for the moment Austin's term, I'll use Oswald Ducrot and Tzvetan Todorov's definition to recall that perlocutionary enunciations project necessarily long-term goals. As they state, 'in questioning someone, one can have the goal of doing her a service, kissing her, making her believe that her opinion is valued' (1972: 429). Thus, the statement, 'use your imagination' can entertain the immediate as it also points us to the long-term necessity of generating and entering into the movement amongst identities. Against the very unimaginative mantra of conversation/dialogue, our imaginations and the practice of using them may allow for new spaces in the theorization and experience of difference.

The figure of imagination has, of late, appeared in several articles by bell hooks. Given that hooks has never sought to mitigate the concrete realities of how white women's historical racism actually hurts black women, her turn to the lyrical and political possibilities evoked by imagination may seem at first unusual for her. However, she uses the term to draw lines connecting her own experiences of racism with those of other black women as she redresses the map of black and white relationships. Describing how her love of reading led to writing, hooks states that, in 'Reading, I could vicariously experience, dare to know and feel, without threat of repression, retaliation, silencing' (1991: 54). As a locus that allows for other places and spaces to emerge, she writes that books

> were the places where I could bring the broken bits and pieces of myself and put them together again, the places where I could dream about alternative realities, possible futures. They let me know firsthand that if the mind was to be the site of resistance, only imagination could make it so.
>
> (ibid.: 54–55)

Her description of imagination captures the absolute necessity of being able to place oneself elsewhere; as a child the ravages of racism meant that in order to survive she had to use her imagination to piece the bits into some semblance of self. Children who live in these circumstances know, just as children who, across race and class, are emotionally and physically battered also know, that imagination is not a luxury but a lifeline. In very concrete ways, 'To imagine, then, was a way to begin the process of transforming reality. All that we cannot imagine will never come into being' (ibid.: 55).

hooks' argument is, above all, about the ways in which the black colonized mind must use imagination as a tool to cut into the real, as 'a

liberatory gesture' (ibid.). Wrought in pain and cruelty, it must be used with care because it can just as easily slice into you, leaving you fragmented within bloody memories. Thus, if at first sight imagination conjures up a saccharine mission (and it is hard to think about imaginations without hearing the strains of John Lennon's 'Imagine'), it can propel other connections just as it can precipitate a spiral into an unending personal hell. The ability to imagine is not necessarily couched in pain; remembering personal experience is, however, a precondition for the capacity to articulate rhizomatic lines that touch and connect with the aspirations of others. As hooks argues, in this way we can use our imaginations in order to forge 'a conscious gesture of solidarity' (ibid.: 57). Based in the limitations of our everyday lives, using our imaginations is crucial to being able to empathize – to participate in the feelings and ideas of others. Moreover, as a critical strategy, empathy does not allow for a hierarchization of my experiences or yours. What I want to argue for is a conception of an alternative critical practice that would be set in motion by imagination, sustained through empathy, and that seeks the articulation of new spaces in the movement between 'who is she? and who am I?'

At an epistemological level, empathetic practices of imagination can be used to foreground the fact that we do indeed piece together knowledges in various ways. According to hooks, entering the imagination of others requires that

> the reader shift her paradigms ... This may indeed require them to relinquish privilege and their acceptance of dominant ways of knowing as preparation for hearing different voices. The ability to be empathetic is rooted in our capacity to imagine. Imagination can enable us to understand fictive realities that in no way resemble where we are coming from ... to enter realms of the unknown with no will to colonize or possess.
>
> (hooks 1991: 57–58)

Against a common reaction of total despair and anger on the part of black feminists and women of colour, and of guilt and despair on the part of white feminists, emphasizing empathy as a set of practices may inspire us to envisage structural change; using our imagination may propel us to the point where we catch glimpses of structures changing. Indeed, continuing to insist upon guilt is a precise example of what we could call, after de Certeau, the enfeeblement of problematics. It is to turn around a problem that has been constructed socially and historically and say, with a sigh, that all is hopeless. At the same time, the simple proposition that we use our imagination to imagine our way into the feelings of others entails an enormous political commitment as well as a ferocious vigilance. This is not empathy without epistemology; empathy is understood here as an operation within the overall apparatus of the technologies of the self.

While empathy cannot exist without an initial ontological experiencing of individuated conditions, it cannot attain the level of a critical practice if it is not put to work to examine the conditions of possibility of those experiences. In simple terms, I cannot be empathetic in a purely altruistic way. My self is selfishly involved, I have an investment in the concerns of others.

To take a small example, I am in a classroom situation where a feminist lecturer proceeds at an abstract level to enumerate the ways in which violence is perpetuated against women according to class, race, and even, she says, age. While abstract, this lecture brings home the material conditions of violence against women in general. However, I catch the eye of a lesbian student across the table, and seemingly in empathy we silently acknowledge the effacement of the street violence that is increasingly happening to lesbian women. That moment, which could be roughly called an ontological recognition on both of our parts, becomes empathetic in a critical sense when it forces me to rethink the ways in which I may silence, through omission, the experiences of others. While 'epistemological' may sound a grand word for this line of thought, propelled from an instance of mutual recognition I am compelled to think differently. I literally see things differently as I confront the face of the black woman student whose experiences have been abstracted into Race, the lesbian student whose self is subsumed by the category of Sexuality, or all of my students whose experiences are somehow on a lower level than my own. The epistemological project that emerges from this situation can be formulated as a question: how can we connect the lines that emanate from the immediacy of individual experiences so that they will at times interconnect, so that we can posit local manifestations of problems? Obviously, neither 'good intentions' nor globalizing rhetoric is enough. The first is divorced from an involvement in my own self, and the second consists of a movement that empties empathy and transforms it into disinterested abstraction. While the possibility to imagine may be initiated by a general description of the material conditions, attitude takes the description further and lodges us in the particular. Without denying one level of abstraction, we must then mobilize our imaginations in order to reach those of the specificities of others, the specific pain, needs and joys of other selves that we can only reach through imagination.

In the face of the nearly deafening and silencing complexities of these propositions, I want now to turn to a very small instance, to a representation of desire and difference. I want to use a recent film, *Without You I'm Nothing*, to consider what happens when one looks at the structuring of relationships between white women and women of colour from another angle. My use or analysis is consciously 'informal', and works within what could be called a low theory. My interest in the film is in its widely scattered lines and erratic connections. I do not want to render these lines

into a coherent whole so that I can pronounce upon its intentions or its political direction. To be blunt, I am not overly interested in the text *per se*, at least understood as either a coherent or incoherent entity. What draws me to the film is the way it articulates a messy entanglement of emotions and experiences. It is not the attraction of one representation of experience nor is it solely because of my experiences (although they are what pull me in); rather, as Laura Kipnis argues, 'the focus on conscious experience is provisional, part of a provisional strategy for a provisional postmodernist cultural politics of "refunctioning"' (1986: 34).

I want to try to 'read' *Without You I'm Nothing* in an imaginative way. My reading borrows from some aspects of black feminist cultural criticism and attempts to look through their theorizing to use the film in order to see issues of difference differently. With the help of these theories – theories elaborated through and in conditions that do not resemble my own – I want to try to 'enter realms of the unknown with no will to colonize and possess' (hooks 1991: 58). However, I should also emphasize that this is not an attempt to imitate what a black feminist reading of this film might be; to my mind, this would be both futile and condescending. In the euphoria of talking about the possibilities of empathy it cannot be forgotten that I imagine from my own experiences, wishes and intellectual and emotional background. And at an epistemological level I try to bend my imagination in order to see differently. Using my imagination with attitude I do not forget my self, but at the limits of this self I try to understand in an unprepossessing way how these images might make her feel. I am not concerned with necessarily making those significations my own, or setting them up as somehow compensating for my significations. Knowing what these images mean to me, I want to stretch my self to the limit in the hopes of reaching what and how these images signify to another self. Thus, putting imagination to work as a critical stance entails a shifting of paradigms and not an imposition of one onto another. The movement involved in shifting paradigms could, in turn, be called a 'paradigm of *transition* – the indeterminate space opened up by such a break' (Kipnis, 1986: 17). In that space, certainties about what something means to her and what it means to me are, at least temporarily, suspended. Simply put, in order to be able to envision other articulations of 'who am I and who is she' we need to let go of the presupposition that we know the answers in advance.

REPRESENTING LONGING

To foreground the fact that I do not intend to efface my presence, let me state clearly that when I first saw Sandra Bernhard's film, *Without You I'm Nothing* (1990), I was completely entranced. From the opening scene I was invited in, as Sandra tells me, "I'm so glad that you can see how truly

beautiful I am right now". Seeing it again, I began to realize how truly strange this film is. In an at times obnoxious manner it works over several of the social discourses that have centred on identity, race and sexuality in various forms within the American scene over the past two decades; all this while Sandra continually teeters between political (in)correctness and outrageous bad taste. For those unfamiliar with Sandra Bernhard, she can be most simply described as a performance artist/stand-up comic who achieved notoriety with Madonna as they teased us with the idea that they were lovers. In actual fact, while Madonna has never come out, Sandra repeatedly does so in various ways that don't quite conform to the dictates of gay and lesbian pride: as a bi-sexual, as involved with a man, as sleeping with different women, etc.

Moreover, it is the way in which the film is organized around Sandra's desire for one black woman that is particularly striking and most problematic. This woman is unnamed throughout the entire film, although the credits finally do name her as 'Roxanne' played by Cynthia Bailey. In keeping with the way in which her namelessness is a crucial structuring element throughout the film, I will also describe and nominate her as 'the black woman'. The film opens with this black woman playing Mozart and ends with the return of Mozart on the soundtrack as she writes in lipstick, 'Fuck Sandra Bernhard'. She then walks through a doorway filled with light as the screen literally fades her to white. Structurally, the film moves from skit to skit all performed in a black nightclub in Los Angeles and linked together by a black emcee (played by Ken Foree) who repeatedly presents Sandra to the predominantly black audience. The first skit has Sandra as a black singer dressed in African clothing with her face blackened. The camera moves amongst the audience members, who are laughing in disgust or bemusement at Sandra who gyrates and sings: 'My skin is black, my arms are long, my hair is woolly, my back is strong . . . What do they call me, they call me Aunt Sarah, yes Aunt Sarah." From there the sketches deal with race, class or sexuality, or more often, a mixture of all three: from Israeli folk songs to a monologue about growing up in Flint, Michigan where the greatest thrill is when the next-door neighbour is carted away to an asylum, to being 'caught up in the romance of belonging in a middle-class Gentile family' ('being a big sexy blonde called Babe'). One of the more memorable moves is when Sandra 'becomes' a black lounge singer who recounts her affair with a woman as she sings 'Me and *Mrs, Mrs* Jones' ('we've got a thing going on'), and ends the sketch with the triumphant cry: 'The sisters are doin' it for themselves.'

The question this immediately raises is whether some of the sisters would want Sandra doing it with them. An easy and limited answer would be no. One can imagine negative critiques of this film from several fronts: black and white feminists, Afro-Americanists and general leftists can all find something to attack here (as, of course, could the Right).

Beyond predictable attacks, Michèle Wallace offers a more challenging set of questions that I want to apply to this film. She calls for three fluid horizons to be mobilized in thinking through feminist minority identity politics which are categorized as: 'equality, difference, and the deconstruction and demystification of the dichotomizing of equality and difference' (1991: 141). In trying to make sense of the multiple articulations of difference that is at play in this film, Wallace's horizons can be used to foreground the fact that no one element can be privileged. In other words, working simultaneously on several fronts means that no one aspect can be valorized and another despised; it is the continual movement between the representation of equality and difference that counts. This necessity of analysing the multiple articulations of difference to equality is, for Wallace, 'best indicated by recognizing the fact that the basic assumptions of equality and difference are constantly being challenged and eroded in the dominant discourse and on the left' (ibid.). This stipulation requires that we be careful about either assigning a film like *Without You I'm Nothing* to the now emptied category of politically correct (emptied that is by a fierce neo-conservative rhetoric), or that we too quickly write it off as a negative representation (of women, of blacks, of gays). At the same time, Wallace's levels of analysis cannot be allowed to implode into mere relativism. Thus, equality is the basis upon which the other two horizons can be constructed. It may be that we can only hold this equality in our imaginations, but equality must be accepted as the fundamental demand before difference can be recognized and 'celebrated for its own sake and on its own terms . . . as a process rather than as a *fait accompli*' (ibid.). Wallace's third horizon turns our attention to 'the deconstruction of the binary opposition of equality versus difference'. Here 'we call the language we speak into question' (ibid.: 142).

In other words, the language of critique is not a stable property with inherently 'good' political significations. For instance, the language of minority identity politics (black, feminist and gay and lesbian) is currently being actively mobilized to argue against the demystification of difference and for the mystification of equality. As Mim Udovitch argues:

> To a greater or lesser degree, the assertions of Bly, Paglia, Levin, Jeffries, and advocates of the culture-of-victims model all turn on the premise that the oppressed are really the oppressors, a mental exercise many of us were raised on in its purest form as that eternal question: I know you are, but what am I?
>
> (1992: 28)

So in the masculinist rhetoric of Robert Bly's *Iron John* (1992), white heterosexual men are exhorted to demand *their* equality, denounce *their* oppression by women and reclaim *their* difference. In a not very subtle but obviously successful move, the 'norm' becomes the oppressed other. This

semiotic flip illustrates why Kobena Mercer advocates caution in performing 'a tactical inversion of the chain of equivalences' as the basis for the language of black emancipation (1987: 40). He argues that, 'However strategically and historically important, such tactics of reversal remain unstable and contradictory because their assertion of difference so often hinges on what is only the inversion of the same' (ibid.: 44). This type of logic leaves itself open to any number of unwelcome appropriations: 'who, in this postmodern mêlée of semiotic appropriations and counter-creolization, is imitating whom?' (ibid.: 52).

As Stuart Hall argues, this postmodern logic cuts deep into our sense of ourselves and seems to refuse any fixity:

> Thinking about my own sense of identity, I realise that it has always depended on the fact of being a *migrant*, on the *difference* from the rest of you ... Now that, in the postmodern age, you all feel so dispersed, I become centred. What I've thought of as dispersed and fragmented comes, paradoxically, to be *the* representative modern experience!
>
> (1987: 44)

Hall's argument highlights both the necessity of realizing the fictive nature of identities and the constitution of 'a politics of ... "unities-in-difference"'; 'rooted in a new conception of the self' this politics 'requires us to begin, not only to speak the language of dispersal, but also the language of, as it were, contingent closures of articulation' (ibid.: 45). The conjunctural exigency of speaking alternative selves thus contends with and operates within the necessity of deconstructing previous arbitrary and naturalized closures as articulated in a language of binary categories. Equality and difference cannot be spoken as opposites nor can they be collapsed as synonymous. Equality cannot be allowed to mean that white heterosexual men as a category can claim that they are oppressed. Nor can we continue to pose this category as the point against which various differences are positioned and measured. As Mercer and Issac Julian put it: 'What is at stake is the ability to politically intervene in this situation and assert that radical *equality* – at the basis of the vision of a socialist society – is the fundamental precondition of diversity and difference (1988: 101–102).

The simplicity and the enormity of this project are fairly clear, and yet, to complicate things further, let's go back to the gyrating Sandra, dressed as 'Aunt Sarah'. But even as we do so, a 'realer' Aunt Sarah comes to mind. In *Yearning* (1990), bell hooks describes the lectures her grandmother gave her on keeping her distance, 'of not allowing folks to get close enough "to get in your face"' (1990: 123). The importance of this was brought home by the presence of whites in the racially segregated South of hooks' childhood and the whites who came to visit her grandmother: 'Most of the white visitors called my grandmama Aunt Sarah, a more dignified version

of the word "auntie" used by whites to address black women in slavery, reconstruction, and the apartheid period known as Jim Crow' (ibid.). The masquerade of Sandra as 'Aunt Sarah' seems to prove the wisdom of hooks' grandmother: 'Sometimes the lectures were about putting yourself on the same level as someone who was different and then being surprised that they took certain liberties, even, say, that they treated you with contempt' (ibid.).

hooks' critique is aimed at 'white scholars writing about black people [who] assume positions of familiarity, as though their work were not coming into being in a cultural context of white supremacy' (ibid.: 124). However, in the case of Sandra the distinction of who is being treated with contempt is not quite so simple. On the one hand, it could be argued that in appropriating the persona of 'Aunt Sarah' (and even in making her into a 'persona'), Sandra is perpetrating the worst type of intrusionary and contemptible action. Yet at the same time, it is Sandra who is clearly represented as the object of contempt. In a certain sense, the entire film plays with the seemingly utter self-degradation of Sandra: from the opening line of 'how truly beautiful I am' that draws some of its meaning from the manifest fact that she does not conform to the blonde standard of American beauty, to her striptease before her object of desire who turns away in disgust. We then have to question whether the 'Aunt Sarah' sketch violates some sensibilities more than others. For example, is there an absolute difference in degree between Sandra's appropriation of 'the difference' of a black figure and her rendition of the persona of the big-boobed Gentile 'Babe'? This is, of course, rather tricky: where do we place the onus of difference? If we insist on the lack of difference in 'Babe's' case, do we begin to construct a hierarchical ordering of difference? The temptation here would be to oppose the representation of 'Aunt Sarah' as the embodiment of difference and the straight 'white-bread' family as the norm or the mean against which all difference is marked. This norm would then be positioned as the point with which we strive to achieve equality.

That this equation seems totally far-fetched is, in part, because of the way in which these two instances of identity are articulated and represented by Bernhard. Despite the ways in which the mythology of the blonde American ideal is ceaselessly reproduced in appealing forms, in Sandra's hands it becomes completely preposterous that anyone *could* be caught up in the romance of the middle-American white Protestant family. Sandra's perverse longing to be 'Babe' renders the white middle-class 'standard' family slightly exotic, kind of erotic and clearly neurotic (in her bedroom on Christmas Eve she whines to her brother 'Chip' 'I wish you weren't my brother so I could fuck you' as 'Mom' tells them 'I'm just so proud of you both'). As the advertising slogan for the film version of *The Addams Family* puts it, 'Weird is Relative'. Sandra's representation

works to question difference as it teases the norm and ever so slightly displaces it. Transformed out of its naturalized neutrality, the familiar is rendered odd; it is radically dis-figured.

But the line that separates the familiar and the odd is a fine one. Sandra's impersonation comes perilously close to endowing 'Babe' with 'Identity' and hence placing her within a currency of difference based in a liberal vision of equality, a possibility which is reinforced when the sketch ends with shots of a 'rainbow' choir of children singing Christmas carols. However, Sandra bends the line of the familiar in strange ways. She skewers a possible liberal articulation of difference by eroticizing her representation of the family and her embodiment of 'Babe'; Sandra wants 'Babe' more than she wants to be her. Facetious and short-lived as this desire might be (somehow the image of Sandra marking a tick next to WASP on her bedpost lingers in the imagination), it serves to disarticulate equality from 'normality'. In other words, when the norm is deconstructed it becomes difficult to envisage equality as designating a process wherein anyone (regardless of race or sexuality) can, if they try hard enough, come to be equal. The image of the 'normal' family is disrupted and displaced from its point as the mean to be achieved. While not quite performing what Wallace calls for as 'a profound critique of dichotomizing practices' (1991: 142), Bernhard nonetheless implicitly problematizes here the question of equal to, and different for, whom.

In a more explicit manner, the structure of the entire film makes it clear which difference is being sought. While Sandra may briefly seem to want 'Babe', she most definitely wants to be black. This longing is forcefully figured through a doubled yearning. While the '*You*' of the title operates on a common sense level to designate the audience, it signifies the black audience at the club and not us, the film audience. On a more profound level, it signifies both black culture in general and the black woman in particular. The title also plays with the fact that if Sandra's identity is dependent on her becoming black then she is indeed nothing. However, this fall into non-existence is checked by the ways in which her identity is momentarily created through her imagining herself black. A doubled construction of 'me' and 'you' is at work in the way in which the short scenes of the black woman are continually interspersed with Sandra's self-questioning and descent into 'nothing'. These shots of the black woman – as she walks in front of a piece of black folk art (the Watts Tower); or stands dressed in a red bustier in front of a kosher butcher; or in her bra in front of a bathroom mirror (listening to rap); or walking into a communal shower where white women are washing each other; or working in a lab – these short scenes act as hyphens connecting Sandra's various transformations. The separate representations of the two women work upon each other and build a momentary connection between them, which is again broken when the black woman is shown nonchalantly passing

through and out of camera range. The rhythm this creates syncopates with Sandra's (and our) excitement which breaks upon a overhead shot of Sandra (on the bottom) fucking with a black man. While this scene obviously stalls the lesbo-eroticism that has been mounting, it also teases us with the knowledge that there is more, that the brother is a temporary substitution for the ever evasive sister. As if to further emphasize the hope that the black woman is still to come, another shot of her precedes Sandra's monologue on 'the beat' that can't be killed – from Martin Luther King to Patti Smith, they all had the beat; 'the beat is the future of a forgotten song'. From there we segue into 'Do you want to funk with me?' and the beat becomes the funk – 'The funk fights fascism, racism, sexism, and homophobia.'

Now, to put it simply, one might say that this representation of the black woman is rather over coded, if not over loaded with connotations of exoticism and difference – in short, the Black Woman as Other. As the object of desire (there is a direct quotation from Buñuel's film in the final scene when a member of the audience suddenly metamorphoses into the elusive black woman), she is made to carry the weight of the film's signification. Without her the film would be nothing but clever parody, mired in cynicism and racism. Yet, in the name of love or lust, good or bad intentions, has a black woman once again been objectified? In the name of 'radical chic' is she being used to distract us from, or displace, a distasteful politics?

To put it simply, judging the politics of a particular text is not easy at the best of times. Personally, I like this film: at times it turned me on, made me laugh, and it forced me to think about what it means to be a white woman watching a white Jewish woman covet a black woman who manifestly doesn't want anything to do with her, with us or with me. If at times I empathized with Sandra's desire to be black, I was also made to feel the ways in which this desire is offensive. I was encouraged to imagine Sandra's rejection and exclusion as well as the black woman's suffocation as she is pinned down and erased by an impervious desire. In the face of such contradictory feelings, one can understand Miller's comment: 'But what's personal? Who decides? ... Do I wind up saying that "bad" politics aren't personal? Or am I saying, if I like it, it's personal, it caresses me; otherwise, it's just positional, it aggresses me' (1991: 19).

However, given the stakes involved in representing women together, we have to go further than this. The most obviously problematic aspect of Bernhard's film is that she can be said to be fetishizing not only the black woman but also several of the other personas she takes on: notably the black lounge singer and Diana Ross.[3] In her article 'Black Feminist Theory and the Representation of the "Other"'(1989), Valerie Smith incisively analyses the way in which black women's experiences are either ignored or are emptied of their own significance in order to become a sign in

another's discourse, a sign that, in a particularly galling way, is used to signify 'material' concerns. Smith cites a seemingly 'progressive' film, *Maid to Order*, where a rich white young woman (Ally Sheedy) is sent by her fairy godmother to work as a maid. In working with black and Latina maids, she is changed (this being presumably what the godmother intended). As Smith states: 'From the experience of deprivation and from her friendship with the black maid, she learns the value of love and labor; she is transformed, in other words, into a better person' (1989: 46). This sort of magic solution is, of course, inherent to the logic of Hollywood whereby structural inequalities are effaced by the redemption of one individual. However, as Smith makes clear, historically across a range of films, 'black women are employed, if not sacrificed, to humanize their white superordinates, to teach them something about the content of their own subject positions' (ibid.). In this way, black women are captured in a singular role or mission to humanize white women.

Smith extends her analysis of representation of black women in popular culture to argue that

> it is striking that at precisely the moment when Anglo-American feminists and male Afro-Americanists begin to reconsider the material ground of their enterprise, they demonstrate their return to earth, as it were, by invoking the specific experiences of black women and the writings of black women . . . When black women operate in opposi- tional discourse as a sign for the author's awareness of material concerns, then they seem to be fetishized in much the same way as they are in mass culture.
>
> (ibid.: 45–46)

Smith argues for the recognition of three crucial issues involved in the project of representing black women: the positioning of black women in popular culture; the ways in which their experiences are used (and abused) in the writings of white feminists and male Afro-Americanists; and the specificity of black feminist theory. She defines the latter as referring

> not only to theory written by black feminists, but also to a way of reading inscriptions of race (particularly but not exclusively blackness), gender (particularly but not exclusively womanhood), and class in modes of cultural expression.
>
> (ibid.: 39)

As a white woman I make no pretence of doing black theory but I do want to try to raise questions about the role of the black woman in *Without You I'm Nothing*. As we have seen, at a structural level, the scenes with the black woman serve to connect the various sketches in the film, and these sketches turn on Bernhard's appropriations of black popular culture: from

the jazz, lounge and traditional African singers, to Diana Ross and then funk, to her finale where she first sings, and then dances in G-string and pasties to Prince's 'Little Red Corvette'. Following Smith's critique, it can be said that the scenes of the black woman serve as a reality check. Against the fantastic permutations of Sandra as black, the shots of a 'real' black woman can be read as bringing Sandra 'down to earth'. It can also be said that they put her in her place. In line with Smith's argument, it is also clear that Sandra uses black culture and the black woman as signs in her discourse, that she builds an oppositional discourse through them. What is not so evident is the nature of the signification generated and elaborated through her wholesale appropriation of the words and the bodies of others.

What makes Bernhard's film so ambiguous on a political level is her doubled strategy of celebrating black culture through impersonation and desire. Through her costumes and make-up Bernhard tries to take on the outward signs of 'blackness'. The move to appropriate some aspects of Black culture within an essentially white framework is not uncommon in 'radical chic'; in fact, in a limited way it is now a feature of prime-time American popular culture. Yet it seems to me that in articulating black culture and politics with (white) homosexual culture and gay and lesbian politics, Bernhard goes beyond what Smith defines as the sacrificing of black women in white texts. While Bernhard can be attacked for reducing all political concerns to her narcissistic ends, this would ignore the ways in which her representation of herself as wanting to be Black is tied up with the strong erotic pull which charges the text with her desire for the black woman. Her political strategy could be interpreted as working through the desire to imagine, to inhabit, to caress, to be and to be with the other.

Delicious as this is, it would be racist as well as ridiculous to suggest that the invocation of lesbian desire somehow magically dissolves the possible racist overtones of Sandra's appropriations of black culture. After all, sexual difference does not necessarily lead to anti-racism (nor for that matter does anti-racism lead to anti-homophobia). As Audre Lourde stated in defeat, 'I had hoped the lesbian consciousness of having been "other" would make it easier to recognize the differences that exist in the history and struggle of black women and white women' (1981: 97). Moreover, while the recognition of inequality is a fundamental basis for any progress, it is, in and of itself, not enough. Indeed, an over-reification of difference can lead to paralysis. As a black lesbian Goldsby argues that

> Ironically, as lesbians attempt to dismantle the institutionalized illogic that assigns unequal meanings to neutral facts of identity such as colour, gender, and size, we mystify those facts even more . . . Earning political halos becomes its own kind of fetish in the recovery process

from patriarchal rule, a spoil of war that comes from toeing politically correct lines, even when those lines are nappy-edged with contradictions.

(1991: 216)

Against the stasis of good behaviour (practised in abstraction), Goldsby calls for renewed interventions by lesbians and gays of colour against racism. Her argument turns on the fact that black lesbians and gays cannot 'leave it solely to white lesbian and gay historians and literary and film critics to (re)define the meaning of race in the lives of lesbians and gays of color' (ibid.: 222). As she puts it: 'We know that when it comes to signifyin', testifyin', and throwing the dozens, no one can talk our talk. Snap!' (ibid.).

IMAGING IMAGINED DESIRE

While Goldsby's argument is against the intellectual kind of colonialism that still circulates in many academic circles, is it possible to make a distinction between those whites who would speak in the place of blacks and those who just want in on black culture? For example, Bernhard's self-representations are caught between wanting to talk that talk and, snap, wanting to want that woman; but they are self-representations and not really attempts to speak for anyone but herself. In any case both desires evade her as she is represented as not quite being able to enter black culture, nor is she capable of capturing the imagination of the black woman. And while the representation of the black woman as speechless and nameless is not going to earn Sandra any political haloes, she is also represented, represents herself as incredibly awkward. When it comes to 'signfyin', testifyin', and throwing the dozens', Sandra comes off as inept; she positions herself as inescapably white.

In the face of her inevitable whiteness, the black woman can be seen as holding out the promise of redemption from this tedious whiteness. While Sandra is probably more motivated by a quest for radical trendiness than the wish to give up her privileges as a white woman, it is certainly understandable that she would rather be black than white. However, this becomes problematic when we consider that the possibility of redemption from whiteness is articulated in terms of lesbian desire. This is doubly disturbing because Sandra never names it as such and even more so because the black woman is represented as sexuality. She is, moreover, sexuality for Sandra, for a white audience. She exists as a signifier of sexuality and she is used to imbue Sandra and us (white women) with a veneer of difference, to momentarily disturb our whiteness.

This 'borrowing' of sexuality is, of course, a strategy of the powerful with a long history. As Kobena Mercer and Issac Julian remind us,

'European culture has privileged sexuality as the essence of the self, the inner core of one's "personality" ... this "essentialist" view of sexuality ... *already contains racism*' (1988: 106–107). Caught up in the white frenzy of equating sexuality with a category of people we have relegated as Other, white men and women are caught (albeit differentially) in a trap of having to want the subjugated as a way of assuming an identity. Is it any wonder that Sandra so desperately wants black bodies? However, while Sandra and I as white women have been historically free to want the desire of a black woman (at least in our imaginations if not in actual deeds), our desires have wrought havoc and death upon the object desired. Havoc upon the constitution of black identities (an identity and a sexuality for another), and death in the form of lynching any black men suspected by white men of touching their female property. This economy whereby black identity is forever forestalled because of the ways in which they are positioned as the sign of sexuality for whites means that, as Mercer and Julian argue, 'as black people we are implicated in the construction of sexuality in a doubly oppressive manner' (ibid.).

Another immediate example of this doubled construction and double jeopardy of standing in for and allowing for white sexuality can be found in Robert Mapplethorpe's *Black Males*. Here the hegemonic construction of black male sexuality finds its contemporary artistic representation in Mapplethorpe's *Man in a Polyester Suit*. As a black lesbian looking at the economy of black and white gay relations, Goldsby describes her reaction to this photograph:

> But *Man in a Polyester Suit* bothers *me*. Mapplethorpe cuts off the model just below mid-torso in a frame so still that we don't know if we're viewing a live subject or a mannequin. Striking a catalogue-type pose, the model/mannequin is clothed in a freshly cheap three-piece suit whose co-ordinated symmetry is disrupted by an unzipped – or burst-open – seam, out of which hangs an uncut penis. Dark, thick, arching, bow bent but not broken by so much more life, by so much more sex than can possibly be restrained by the false trappings of commodified civilisation. Rousseau's noble savage revisited.
>
> (1991: 214)

Goldsby argues that, in the midst of the furore against Senator Jesse Helms' attack on the exhibition, certain issues were forgotten: the ways in which Mapplethorpe's photographs work through, but do not work over, the positioning of black bodies for white desires. As Mercer puts it:

> As a fantasy of power over black bodies, Mapplethorpe's work engineers artful authority over his subject by appropriating the function of the stereotype to affirm his own identity as the 'I' of the look, the sovereign, omnipotent eye with mastery over the other – it is as if the

photographs are saying, 'I/eye have the power to turn you, you base and worthless social subject into a work of art'.

(Mercer and Julian 1988: 145)

AS IF ... SHE WANTED ME

Faced with the deep and overwhelming structure of sexuality which represents and relentlessly recreates the object of desire as an other, questions about how we might imagine, and image, desire differently become both imperative and hard to imagine. As I long for the black woman in Bernhard's film, she remains isolated, captured in her onto-logical category of Other to my self. Silent in her contempt for Sandra, for me, her final gesture seems to say that 'To some extent, all [whites] are reified subjects, against whom it is impossible for blacks to mount passionate, self-affirming resistance or retaliation' (Willis 1989: 174).

Given this situation wherein the black woman is seemingly left stranded in her difference from me at the same time that she is indifferent to me, one might well ask if difference will always separate us, if difference will always turn on distrust. Does the fact that historically I have been reified as a white subject while she has been cast as my inferior forestall and foreclose for all time any movement between us? As I try to write about this film, I repeatedly come to a standstill. Locked in front of this text, I am both attracted and expelled from participating in the longing that is set up but never named, the abyss between me and the representation of the black woman seems to grow with each shot and with each sentence. My imagination keeps getting stilled before the enormity of the historical present that supports these representations, that makes them make sense to me in particular ways. There seems to be some part of me that can't quite reach beyond what I know in order to grasp what I want to know. I know that at several levels the representation of the black woman as the object of desire is only possible because of the racism that structures relations between black and white women. But at the same time, I know (or at least, affectively, I feel) that something else is going on here that cannot be reduced to racism. And I know that impoverished as my critical vocabulary is I want to find the words to say more than easy platitudes. And all these various 'knowledges' co-exist uneasily with more nameless feelings. Perhaps Christian is right when she worries that we can no longer respond to the communal/erotic 'because it is so difficult to reduce these forms to ideological wrangling' (1989: 73). Certainly, it would be easier to reduce *Without You I'm Nothing* to ideological wrangling. However, I am not quite ready to give up on the small moments where this film might seem to say, or be made to say something about a momentary move of empathy. Despite its deep contradictions, I want to make this film name what it can't. I want to make it say that it is about the desire of a white

woman for a black woman who does not want her. I want it to acknowledge that her desire and mine are not enough but that at the same time they may constitute the only place from which to begin a process of drawing each other in.

Arguing against a logic which would confine representations to categories of positive or negative, Jan Zita Grover writes that 'we must learn to look at representations both for what they forget and what they remember; photographic absences ("forgetting") are equally as meaningful as photographic presences ("remembering")' (1991: 185). While in general all representations can be said to forget certain crucial points, her argument centres on the ways in which lesbian (and in a different way, gay) subcultures are 'consistently un-represented, under-represented or mis-represented' (ibid.: 187). This then produces a situation of 'So few representations, so many expectations: the burden of scarcity' (ibid.). Certainly, it is the 'burden of scarcity' that drives me to Bernhard's film.[4] And yet, one of the obvious things the film forgets to mention is lesbian desire. For all her right-on rhetoric, Sandra never says anything directly about wanting the black woman, or for that matter any woman at all. Sure, she turns 'Me and Mrs. Jones' against itself into a lesbian torch-song. Sure, she does a 'Village People' disco skit that starts with 'Pretend it's 1978 and you're straight' and ends with 'It's 1989 and you can pretend to be straight', but, in actual fact, in actual words, she never quite comes out.

Faced with these silences, in the film but more generally in our everyday lives, we have to turn to our imaginations. This film can be seen as presenting us with images that both remember (evocations of desire, black culture) and forget (to name that desire as lesbian, to state clearly the racist connotations that come with objectifying a black woman). However, if we can remember what the film forgets, we can then find spaces in which our feelings are called into play. Scarce as these moments may be, they are certainly inviting to a lesbian imagination, and perhaps more importantly to women who have as yet not been able to imagine. As Deborah Bright, a lesbian photo-*monteur* (*menteur*), argues, our imaginations may outrun our means to be able to speak them. Bright's photographic work revolves around her wish 'to paste (not suture, please) her constructed butch-girl self-image into conventional heterosexual narrative stills from old Hollywood movies' (1991: 151). The impetus behind this work is the recognition that 'reception is driven by desire and what many young proto-dykes "saw" in these films in the early 1960s were concrete (if attenuated) suggestions of erotic possibilities that they could not name and that their own lived experience could not provide' (ibid.: 152).

As a wary conclusion, I want to take Bright's statement as one summation of what feminism with attitude has to be about. While I don't want to finish with grandiose flourishes, I do want to argue that in the face of difference as division we need to be emboldened by our theories and

experiences so that we can start seeing and speaking possibilities that are hard to name and that may extend beyond our individual and discrete lives. To argue for a way of seeing and speaking through imagination is to argue for different ways of knowing my self and her self, ways of knowing that insist upon alternative relations of alterity. It is to argue that my passion to know her does not have to be embedded in a will to control her. In trying to speak within the tensions of 'who is she? and who am I?' I want to disrupt any certainty that we know the answers in advance, or that either a good or bad politics can be guaranteed by such an equation. To engage our imaginations precisely opens us into a space where possibilities can be envisioned; a space where I may no longer recognize my self. After all, as Foucault put it, what is the point of wanting to know if that knowledge will leave me unchanged: 'What would be the value of the passion for knowledge if it resulted only in a certain amount of knowledgeableness and not, in one way or another and to the extent possible, in the knower's straying ahead of [her]self?' (1986: 8).

Based in the will to imagine and in the necessity of our imaginations, a feminism with attitude is grounded as a political project in the knowledge that 'without her I am nothing'. It takes some attitude to stretch our selves to the limit; as Golding reminds us, it takes street smarts and muscle. It means leaving behind possibly easier ways of living and knowing; instead of using guilt as a catch-all response to the world, attitude entails bending the ways in which we think we know; it means taking a chance on not knowing; it may also mean rejection (as when the black woman tells Sandra to 'fuck off'). But however hard attitude may sometimes be, it is always more positive than long-term dejection. And if we trust the desires of our imagination, our desires may also be materialized. Speaking our selves within layers of difference forces us to stray, however momentarily, ahead of ourselves, so that we may find other selves. Speaking with attitude puts into motion the doubledness of being and becoming; it empassions the necessity to continue to articulate together and in as many modes as possible the questions of 'who is she and who am I?' As Bright puts it, 'I fantasized pursuing, courting and making love with the heroine, while at the same time, I also fantasized *being* (like) her' (1991: 154).

NOTES

1 Much as I like Madonna, to tell the truth, I think that the world can do without another analysis of Madonna. For one of the first feminist analyses of Madonna, see Judith Williamson (1985).
2 For an in-depth analysis of how difference as a term has circulated within Québécois society, sociology and literary analysis, see Sherry Simon (1991). For an argument about speaking as a bilingual lesbian video artist in Québec society, see Marilyn Burgess (1991).
3 I am using 'fetishism' here in a rather colloquial way. However, for a precise

analysis of fetishism and lesbianism in psychoanalysis, see Elizabeth A. Grosz (1991).

4 While there are a few commercial films that do dare to name lesbian desire, the burden of scarcity is nonetheless considerable. When it comes to commercial films that represent desire between black and white women, the burden is even more pronounced. For an analysis of *She Must Be Seeing Things* (Sheila McLaughlin, 1987), see de Lauretis' analysis (1991) as well as the discussion following her piece where the issue of racial difference is raised in response to the way in which it is elided in de Lauretis' article. Strangely enough, prime-time American television has become a more fertile object for lesbian speculation. For a discussion of sexual choice on television, see my 'Choosing Choice: Popular Culture's "Winking" Images of Sexuality in Popular Culture' (1993a).

Conclusion
Sexing the self

In her wonderful novel, *Sexing the Cherry* (1989), Jeanette Winterson writes that

> The self is not contained in any moment or any place, but it is only in the intersection of moment and place that the self might, for a moment, be seen vanishing through a door, which disappears at once.
>
> (Winterson 1989: 80)

And, as her intrepid protagonist says, 'The journey is not linear, it is always back and forth, denying the calendar, the wrinkles and the lines of the body' (ibid.). At the end of these travels around, through and with various selves, it is tempting to say that my part of the journey is temporarily over and that I leave the reader to roam free of any final justification on my part of where I have been and what I have tried to do. However, much as I hate writing conclusions, I do appreciate the conclusions of others. So in the name of hopefully adding a few lines and connecting (or at least acknowledging) the crevices within and between the previous chapters, I shall try to proceed 'en guise d'une conclusion' (which roughly translates as 'in the manner of a conclusion', although I like the idea of being 'disguised as a conclusion' better).

In Winterson's book we know what sex the cherry is: 'the cherry grew and we have sexed it and it is female' (ibid.: 79). The self that I have been talking about is also female but, as with the cherry, it has to be sexed. And I understand sexing the self (like sexing chickens) as an elaborate process, in the sense that it is a critical and theoretical project that needs constant elaboration. Unlike those poor chickens who endure being sexed by others in the sole name of establishing biological sex for reproduction, what I have been arguing for are ways of engendering distinct positions in theory through various practices of speaking the self. I want to elaborate, in the sense of working out in detail as well as in that of building from simple elements, a theoretical account of certain uses of the self. The simple elements consist of some rather basic postulates, such as the primacy of gendered experience. Other building blocks include theories of the subject,

subjectivity and representation and are drawn from various moments in cultural studies' history and present, as well as from literary criticism, ethnography and philosophy. What I have tried to work out in some detail is how we can articulate a feminist theory of the movement of gender that can be captured, expressed and carried within certain speaking practices.

In the Winterson quotation we hear some of the movement of the self: from a particular intersection we may see the self as it vanishes through a disappearing door. In turn this image of the self moving through a door brings to mind Virginia Woolf's statement:

> One goes into the room – but the resources of the English language would be much put to the stretch, and whole flights of words would need to wing their way illegitimately into existence before a woman could say what happens when she goes into a room.
>
> (*A Room of One's Own*, cited in Tillman 1991: 100)

In the spirit of Woolf's words, let me say that we need to send up 'whole flights of words', words that 'wing their way illegitimately into existence' as we try to say what happens when feminists speak the self. If we need any reminding of the difficulty of this act, Hélène Cixous graphically describes what happens when a woman speaks:

> Listen to a woman speak at a public gathering (if she hasn't painfully lost her wind). She doesn't 'speak', she throws her trembling body forward; she lets go of herself, she flies; all of her passes into her voice, and it's with her body that she virtually supports the 'logic' of her speech. Her flesh speaks true. She lays herself bare. In fact, she physically materializes what she's thinking; she signifies it with her body. In a certain way she *inscribes* what she's saying, because she doesn't deny her drives the intractable and impassioned part they have in speaking. Her speech, even when 'theoretical' or political, is never simple or linear or 'objecti-fied', generalized: she draws her story into history.
>
> (1981: 251)

I used to think that this description summed up how I felt whenever I spoke in public. However, I now think that there is a small qualification that needs to be made; at least in my own experience, the terrifying feeling of throwing oneself bodily into speech occurs not when I am 'officially' speaking (for example, invited to speak with a prepared paper to give) but when, in annoyance or frustration, I launch into a question. The qualification thus has to do with where one speaks and why. And the trembling builds from the fact that 'I' am being propelled into an unsympathetic or even hostile enunciative ground. Most often, the questions that are seemingly wrenched out of my self have to do with various evacuations of feminism. Hiding shaking hands in my pockets, trying to keep the quaking out of my voice, I ask my question; I state my case; I open my self up.

The point is not so much that we do speak, nor is the point to glorify individual instances; rather I want to emphasize how and where we can put our selves to work in order to articulate a gendered enunciative practice. As Deleuze has argued, 'what comes first is a SOMEONE IS SPEAKING, an anonymous murmur in which sites are laid out for possible subjects: a great, ceaseless and disorderly buzzing of discourse' (1988: 42). I want to transform that 'someone' into a WOMAN IS SPEAKING. Much as I like Cixous' evocation of the woman speaker, I am more concerned with the materiality of the moments and contexts in which, theoretically and in practice, we produce ourselves as gendered speaking subjects. My project of speaking the self is motivated by the necessity of constantly renewing feminist discursive positions and the exigency of recreating new ones. As Stuart Hall has argued, in simple terms this means that

> Practices of representation always implicate the positions from which we speak or write – the positions of enunciation . . . though we speak, so to say 'in our own name', of ourselves and from our own experience, nevertheless who speaks, and the subject who is spoken of, are never identical, never exactly in the same place.
>
> (1990: 222)

The self that I have been elaborating is therefore a motivated set of practices that foreground and hopefully encourage the necessary movement of identities. Speaking the self thus can be made to be moving, both in the sense that it sets into motion a critical and analytical project and in the sense that the self can be made to move us, to touch us. So the self carries with it a doubled movement, it expresses 'a matter of "becoming" as well as of "being"' (ibid.: 225). While the self is not contained in any one moment or place, it can be made to appear at certain intersections. These intersections can only be found and produced when we recognize the materiality and the specific reality of discourse. The self is therefore never transcendent of its discursive reality, it is always caught up in what Foucault calls 'the heavy and fearsome materiality' of discourse (1971: 11).

Born in the positivity of the experiential, the self is nonetheless formed in the material limits of its discursive context. To my mind, Hall's definition of the work involved in constructing an articulation precisely captures the way in which we can put a self together:

> an articulation is thus the form of the connection that *can* make a unity of two different elements, under certain conditions. It is a linkage which is not necessary, determined, absolute and essential for all time.
>
> (1986: 53)

A self is formed in precise and historical conditions, and selves are formulated for conjunctural political reasons. Coherent for the exigencies of the moment, these selves are useful linkages. Keeping in mind that

discursive intersections form the conditions of possibility for certain selves, the critical task at hand is to figure ways in which we can use our selves critically in order to trouble the material conditions that literally give rise to 'us'.

Far from lauding an 'I' that would speak for you and for me, and far from constructing yet another abstract entity, I want to insist on the very ordinary nature of these speaking selves. While this self is unabashedly theoretical, it must always be re-lodged in the conditions that called it into action. One way to imagine this operation is to follow de Certeau's (1973) instruction that we relocate problematics back into the soil of the everyday. Simple as this sounds, 'a geography of the possible' to my mind entails a doubled critical practice. In part what I mean by this can be summed up by saying that practices of the self must be positioned within the tensions of the epistemological and the ontological. Without hypostasizing these terms, I do want to insist upon the necessity of bringing together a recognition of the ontological affectivity of being gendered and an epistemological critique of the production of that affectivity. This in turn requires that we problematize and put to work the felt facticity of material social being. In short, that we privilege the positivity of the experiential within the epistemological project of articulation.

Critical practices of the self work through my feeling and expression of being in the world as they work to render visible the social terrain out of and in which I speak. And as I speak, this terrain – this critical field – is brought into focus and I can see the social relations that position me in relation to her. For me the ontological/epistemological tension is captured in the articulation of the distinct questions of 'who am I and who is she?' The question of 'who am I?' cannot be spoken without an ontological tone, nor can it be allowed to stand alone. As with Deleuze's notion of how we 'bend' the line of force, we must also bend and fold this line of questioning so that it can be made to meet up with the question of 'who is she?' The full weight of the epistemological import can be felt if we rearticulate 'who am I?' into 'what am I . . . for her?' Far from being a recentring of myself in relation to herself, this is to question the very grounds that separate us.

In demanding that we pay attention to how our various selves are folded and pleated together, I simply want to renew the idea and practice of the care of the self within cultural studies. The care of the self expresses for me the doubling of analytic lines; as Foucault puts it, 'the "care of the self" is understood as experience and also as a technique which elaborates and transforms this experience' (1989a: 134). Thus the self is an ensemble of critical techniques but it also designates a certain critical stance that the theorist can embody. As Mark Poster says of Foucault's doubled project, 'the critique of the present is rendered possible by the contingent character of the construction of the critic's self' (1989: 361). In other words, a critical conception of myself as a theorist is imbricated in and allows for a wider

analysis of the historical present. On the one hand this necessitates an epistemological analysis of 'how the experience and the knowledge of the self, and the knowledge that gets formed of the self ... is defined, valorized, requested, imposed' (ibid.: 133). On the other hand, using the self critically involves the recognition and mobilization of a 'philosophical ethos inherent to an ontological critique of ourselves as a historico-practical testing of the limits that we can outrun, and hence as a task that we undertake for ourselves on ourselves as free beings' (Foucault, cited in Poster 1989: 362). In addition to these lofty ideals, it needs to be emphasized that the self as an analytic attitude is also a mundane activity, based in the constant 'matter of analyzing ... the *problematizations* through which being offers itself to be, necessarily, thought – and the *practices* on the basis of which these problematizations are formed' (Foucault 1986: 11). The epistemological level at which the self is put to work in its own prob-lematization is intimately doubled up with the everyday practices that constitute our selves, in Deleuze's words, our 'practices of seeing and practices of speaking' (1988: 45).

As an activity of theory and of being, the self is not an esoteric question; it is not to be held at a distance. Taking care of the self finds its social and critical meaning in the fact that 'being occupied with oneself and political activities are linked' (Foucault 1988b: 26). The care of the self thus can only be conceived of and performed within the exigency of caring for others and for and within our distinct communities. The self is not an end in itself, it is the opening of a perspective, one which allows us to conceive of transforming our selves with the aid of others. Far from being a self-centred or self-centring action, this is to radically de-centre our selves, to work at the extremity where my self can be made to touch hers. Stretched to the breaking point where individuality ceases, the self designates that point of possible contact when it is neither a question of 'who am I?', nor a separate one of 'who is she?' Pushed to the end of their distinct logics, these questions re-find themselves together at another point, at the point where we are both at the limits of our selves. Here the view is different, and from this perspective we again put our selves to 'the test of contemporary reality'. As Foucault puts it, this test is then to discern 'the chinks where change is possible and desirable, as well as to deter-mine the precise form that this change should take' (Foucault cited in Poster 1989: 361).

While I am sure that my use of Foucault will annoy both 'straight' readings of Foucault as well as feminist critiques of him, I insist on a concept of the self that can articulate the theoretical necessity of care, of love and of passion. As Deleuze argues, in Foucault's care of the self we find two ways of being and, I would add, of comporting ourselves as theorists: 'one is love, by people, the other is by intensity, as if people were founded in passion, not in an undifferentiated way, but in a field of

variable and continuous intensities always implicating the one and the other' (1990: 157). This is then to conceive of a mode of subjectification beyond the limits of individuality where passion can articulate us in other formations, where passion makes us speak in other tones.

Although inspired by Foucault, I do not ignore the fact that the ability to care about another's difference and to go from one's own experience to another's has been at the heart of other critical projects: notably feminism and cultural studies. Without this impulse to reach the other there seems little reason why we should 'go on theorizing'. In a climate which increasingly is marked by a lack of the care of the self, it seems terribly important to carry on the sort of questioning that Raymond Williams raised when he said that 'the suppression of tenderness and emotional response, the willingness to admit what isn't weakness – one's feelings in and through another; all this is a repression not only of women's experience but of something much more general' (1989b: 319). Of course, one's feelings in and of themselves are not enough. And in many ways the mere mention of 'feelings' can set us off in directions that are problematic. A sole and singular privileging of experience can lead to a construction of whose experience counts more, whose feelings have been the most hurt and ignored. But without acknowledging the primacy and the very ordinariness of the ontological strata we surely lose what Williams called 'a ratifying sense of movement and the necessary sense of direction' (1961: 60).

It is also 'ratifying' to remember that at the same time that Williams was writing these words, there was, as Showalter reminds us, a whole generation of women graduate students in literature who used women's fiction to elaborate a 'literary self'. Certain aspects of Showalter's formulation of 'gynocriticism' make me want to ratify the role of gendered experience as a linkage that is formed between the reader, the text and the wider social conditions in which the reader recognizes herself as gendered. Reading Showalter, I understand in hindsight the ways in which I read as a young girl. However, it is in reading bell hooks' description of how she read as a girl that I remember the passionate necessity of reading. And reading hooks makes me want to rectify the homogeneous nature of Showalter's description of the generation of women who became gynocritics.

Reading hooks and other feminists of colour as well as lesbian theorists reminds me forcefully of the limits of a previous feminist use of experience as unproblematic; experience as a transparent rallying call to all women regardless of our very long histories of difference. It also forcefully brings home the extraordinary ways in which we can use our ordinary selves. Against the foreclosure of the self as an ontological category, against the deadening nature of 'the feminine' as constructed by certain individuals in cultural studies, I am inspired to use my imagination. However, as

opposed to some of the more rampant self-reflexivity in ethnography, the point here is not to use my self as a mediating term whereby the experiences of others are rendered similar or familiar to my own. Rather, in using our imaginations, in practising empathy as a critical stance, we may radically de-familiarize experience. In articulating our selves at the very limits of our selves, I want to set into motion a critical process that destabilizes and renders *unheimlich* the conditions of possibility for our separate enunciations.

In appropriating Michèle Le Doeuff's theory of the work of the image within discourse, I hope to make clear that the self is both 'mine' and yet divorced from 'me'. Grounded in the experiential, it cannot be limited to a register of authenticity: there is no necessary correspondence between the image of myself as a woman and a unified image of woman. Just as Deleuze emphasizes that the self is constituted and works through the bending and the folding of the 'outside' ('le dehors') and the 'inside' ('le dedans'), the self as image serves to refract any straight line of equivalence. The image of the self put into discourse cannot be reduced to 'me', nor can it be extrapolated to found an ontological category of woman.

The image of the self is, however, propelled by imagination; it is thrust along the lines of imagination without which it simply stalls into mere academicism. This imagined and imaged self serves to figure a point where we could talk about 'she and me'. This is not a naive hope but rather a disingenuous project wherein the 'truth' of selves gets lost. Pushed to the limits of ourselves, we do lose our selves and stray from them, but this is not to say that 'we' become interchangeable. Because of the material conditions of our selves we can not indulge in the fantasy of dialogism wherein 'you' can be 'me', and 'I' can be 'you'. 'I' am not 'she' but articulating a working image of the self may allow for a movement of empathy between us. Working within the tensions of a doubled question of 'who is she? and who am I?' forces us to recognize distinction and requires that we work over relations of alterity.

Lest this sound merely utopian instead of radically feasible and necessary, I will bring the image of the self down to earth with a final evocation of the necessity of empathy and caring for the self. As we try to continue to put ourselves forward as feminists in the intellectual climate of the 1990s we are increasingly confronted with tangible manifestations of what some tout as 'the crisis of authority', the 'crisis of representation'. Whether in Montréal following the massacre or in Washington during the Thomas/Hill hearings, material aspects of the difficulty of speaking out as a woman and as a feminist are felt in both academic and public spheres. From the left, we wonder whether we should speak at all, and from the right, we are silenced by inflated arguments about political correctness. Spreading like wildfire and fanned by countless journalistic accounts, it should not have

surprised me that an anti-political correctness wave should also hit my university. However, what is particularly galling is that the anti-PC arrived before we had got to the point of even imagining a politically correct line. Anti-PC quips have become part of a situation, an institutional economy that is marked by a minor silence when it comes to feminist content in courses and a major silence, an absolute 'ignorance' in the French sense, when it comes to incorporating lesbian and gay issues and theories. Without singling out my own university as particularly bad, I do want to draw attention to the very real difficulties of speaking in the actual context.

For instance, at another university, a panel that was to deal with the lack of women professors and the absence of feminist teaching is now to be on 'PC'. Again as an exemplar and not as a condemnation of one instance, this example brings home the staggering way in which feminism is being displaced. Even closer to home, as an invited member of the panel, I was seduced by the subject; it immediately struck me as more fun to speak about PC than about the hard facts of why there still is so little feminist content in the traditional social sciences curricula. The seduction is understandable: the proffered speaking position would allow me to speak in the displacement of what needs to be bluntly said.

This is a stifling discursive and material situation which seemingly offers feminists very few speaking positions. Our selves are hemmed in by the constant need to speak up for issues that should be regarded as basic, curtailed by the exigencies that as feminists we speak in a certain way, that we embody the position of watchdog. As a consequence of this, it is not unusual to feel winded, speechless. However, against and in the midst of speaking a tired self, we need to use our imaginations, strike a pose for other positions and instil feminisms with attitude. We need to keep moving and to keep speaking our selves in ways that will encourage other movements, that will recreate alternative positions. Brought to a breathless and motionless standstill, we need to remember the 'grain' of the self. I hear another self, I hear myself, she speaks and in the movement of other images of selves, alternative speaking positions appear as possible. I am drawn to them and re-find them in the motions of selves. As Barthes writes of the 'grain', it is 'the body in the voice as it sings, the hand as it writes, the limb as it performs' (Barthes 1977: 188).

As my self does all the complex and mundane manoeuvres required of it, the sound of other sexed selves beckons and empassions. Wrought in the experiential and in the theoretical, these selves carry with them the movement of bone, of body, of breath, of imagination, of muscle, and the conviction of sheer stubbornness that there are other possibilities. These selves are made to speak of transformation, refracted they provide glimpses of other positions, lodged in the terrain of the social they rearticulate a geography of the possible. Speaking out with our selves and

against our selves, catching the movement of being gendered, folding the lines between our selves so as to open up new perspectives, inscribing and bending images of our being into positions of becoming, all these are ways for me of extending the 'grain' of the self: the grain of a political project of care and of hope.

Bibliography

Allor, Martin (1984) 'Cinema, Culture and Social Formation: Ideology and Critical Practice', unpublished dissertation. Urbana-Champaign: University of Illinois.

—— (1987) 'Projective Readings: Cultural Studies from Here', *Canadian Journal of Political and Social Theory*. Vol. 11, Nos. 1–2, pp. 134–138.

Althusser, Louis (1970) 'The Object of *Capital*', in Althusser and Etienne Balibar *Reading Capital*. Translated by Ben Brewster. London: NLB.

Ang, Ien 'Beyond Self-Reflexivity', *Journal of Communication Inquiry*. Vol. 13, No. 2, pp. 27–29.

Anzaldua, Gloria (1987) *Borderlands/La Frontera: The New Mestiza*. San Francisco: Spinsters/Aunt Lute.

Appignanesi, Lisa (1987) 'Editor's Note', *The Real Me: Postmodernism and the Question of Identity*, ICA Documents. No. 6. London: Institute of Contemporary Arts, p. 2.

Arac, Jonathan (1986) 'Introduction', in Arac (ed.) *Postmodernism and Politics*. Minneapolis: University of Minnesota Press.

Barrett, Michèle (1987) 'The Concept of Difference', *Feminist Review*. No. 26, pp. 29–42.

Barthes, Roland (1972) *Mythologies*. London: Jonathan Cape. Translated by Ben Brewster. London: NLB.

—— (1977) *Image-Music-Text*. Translated by Stephen Heath. New York: Hill and Wang.

—— (1989) *The Rustle of Language*. Translated by Richard Howard. Berkeley: University of California Press.

Baudrillard, Jean (1980) 'The Implosion of Meaning in the Media and the Implosion of the Social in the Masses', in Kathleen Woodward (ed.) *The Myths of Information: Technology and Postindustrial Culture*. Madison: Coda Press.

—— (1982) *A l'ombre des majorités silencieuses . . .* Paris: Denoel/Gonthier.

—— (1983) *In the Shadow of the Silent Majorities . . . or the End of the Social and Other Essays*. Translated by Paul Foss, Paul Patton and John Johnston. New York: Semiotext(e) Foreign Agents Series.

—— (1985) *La Gauche Divine*. Paris: Bernard Grasset.

—— (1986) *Amérique*. Paris: Bernard Grasset.

Bellour, Raymond and François Ewald (1988) 'Signes et événements, un entretien avec Gilles Deleuze', *magazine litteraire*. No. 257 (septembre), pp.16–29.

Berger, John (1980) *About Looking*. New York: Pantheon Books.

Bérubé, Michael (1991) 'Just the Fax, Ma'am: Or, Postmodernism Journey to Decenter', *The Village Voice Literary Supplement*. October.

Blackman, Inge and Kathryn Perry (1990) 'Skirting the Issue: Lesbian Fashion for

the 1990s', *Feminist Review. Perverse Politics: Lesbian Issues*. No.34, pp.67–78.

Bly, Robert (1992) *Iron John*. New York: Vintage Books.

Braidotti, Rosi (1989) 'The Politics of Ontological Difference', in Teresa Brennan (ed.) *Feminism and Psychoanalysis*. London and New York: Routledge.

—— (1991) *Patterns of Dissonance*. Translated by Elizabeth Guild. Oxford: Basil Blackwell and Polity Press.

Braxton, Joanne M. (1989) *Black Women Writing Autobiography: A Tradition within a Tradition*. Philadelphia: Temple University Press.

Bright, Deborah (1991) 'Dream Girls', in Tessa Boffin and Jean Fraser (eds) *Stolen Glances: Lesbians Take Photographs*. London: Pandora.

Bristow, Joseph (1991) 'Life Stories: Carolyn Steedman's History Writing', *New Formations*. Vol. 13, pp. 113–131.

Brown, Richard Harvey (1987) *Society as Text: Essays on Rhetoric, Reason, and Reality*. Chicago: University of Chicago Press.

Bulkin, Elly, Minnie Bruce Pratt and Barbara Smith (1984) *Yours in Struggle: Three Feminist Perspectives on Anti-Semitism and Racism*. Ithaca, NY: Firebrand Books.

Burgess, Marilyn (1991) 'Comment "je" entre dans le texte', *Possibles*. Vol. 15, No. 4, pp.173–180.

Butler, Judith (1990) *Gender Trouble: Feminism and the Subversion of Identity*. London: Routledge.

Cahiers Confrontations (1989) 'Après le sujet: Qui vient?' No. 20.

Carby, Hazel V. (1982) 'White Woman Listen! Black Feminism and the Boundaries of Sisterhood', in *The Empire Strikes Back: Race and Racism in 70s Britain*. London: Hutchinson.

Christian, Barbara (1988) 'The Race for Theory', *Feminist Studies*. Vol. 14, No. 1 (Spring), pp. 67–79..

—— (1989) 'But What Do We Think We're Doing Anyway: The State of Black Feminist Criticism(s) or My Version of a Little Bit of History', in Cheryl A. Wall (ed.) *Changing Our Own Words: Essays on Criticism, Theory, and Writing by Black Women*. New Brunswick, NJ: Rutgers University Press.

Cixous, Hélène (1981) 'The Laugh of the Medusa', in Elaine Marks and Isabelle de Courtivron (eds) *New French Feminisms*. New York: Schocken Books.

Clifford, James (1978) '"Hanging Up Looking Glasses at Odd Corners": Ethno-biographical Prospects', in Daniel Aaron (ed.) *Studies in Biography*. Cambridge MA: Harvard University Press.

—— (1986a) 'On Ethnographic Allegory', in Clifford and George Marcus (eds) *Writing Culture*. Berkeley: University of California Press.

—— (1986b) 'Introduction: Partial Truths', in Clifford and George Marcus (eds) *Writing Culture*. Berkeley: University of California Press.

—— (1988) *The Predicament of Culture*. Cambridge MA: Harvard University Press.

Coward, Rosalind (1985) *Female Desires: How They're Sought, Bought and Packaged*. New York: Grove Press.

—— (1989) *The Whole Truth: The Myth of Alternative Health*. London: Faber and Faber.

—— and John Ellis (1977) *Language and Materialism*. London: Routledge and Kegan Paul.

de Certeau, Michel (1973) *La culture au pluriel*. Paris: Inédit 10/18.

—— (1984) *The Practice of Everyday Life*. Berkeley: University of California Press.

de Lauretis, Teresa (1984) *Alice Doesn't: Feminism, Semiotics, Cinema*. Bloomington: Indiana University Press.

—— (1986) 'Feminist Studies/Critical Studies: Issues, Terms, and Contexts', in de Lauretis (ed.) *Feminist Studies/Critical Studies*. Bloomington: Indiana University Press.

—— (1987) *Technologies of Gender: Essays on Theory, Film and Fiction*. Bloomington: Indiana University Press.

—— (1991) 'Film and the Visible', in Bad Object-Choices (eds) *How Do I Look: Queer Film and Video*. Seattle: Bay Press.

Deleuze, Gilles (1977) 'Intellectuals and Power', in Donald F. Bouchard (ed.) *Language, Counter-memory, Practice*. Translated by Bouchard and Sherry Simon. Ithaca, NY: Cornell University Press.

—— (1986) *Foucault*. Paris: Minuit.

—— (1988) 'Strata or Historical Formations: the Visible and the Sayable (Knowledge)', in Don Barry and Stephen Muecke (eds) *The Apprehension of Time*. Sydney: LCP.

—— (1989a) 'Un concept philosophique', in *Cahiers Confrontations*, No. 20.

—— (1989b) 'Qu'est-ce qu'un dispositif?', in *Michel Foucault, philosophe*. Paris: Seuil.

—— (1990) *Pourparlers*. Paris: Minuit.

Dews, Peter (1987) *Logics of Disintegration: Post-structuralist Thought and the Claims of Critical Theory*. London and New York: Verso.

Doane, Mary Ann (1982) 'Film and the Masquerade: Theorizing the Female Spectator', *Screen*. Vol. 23, Nos 3–4, pp. 74–87.

Dodd, Philip (1986) 'Criticism and the Autobiographical Tradition', in Dodd (ed.) *Modern Selves: Essays on Modern British and American Autobiography*. London: Frank Cass.

Ducrot, Oswald and Tzvetan Todorov (1972) *Dictionnaire encyclopédique des sciences du langage*. Paris: Seuil.

Dumont, Jean-Paul (1978) *The Headman and I: Ambiguity and Ambivalence in the Fieldworking Experience*. Austin: University of Texas Press.

Dyer, Richard (1986) *Heavenly Bodies: Film Stars and Society*. New York: St Martin's Press.

Eagleton, Terry (1976) *Criticism and Ideology*. London: Verso.

—— (1987a) 'Response', in Alice Jardine and Paul Smith (eds) *Men in Feminism*. New York: Methuen.

—— (1987b) 'The Politics of Subjectivity', ICA Documents. No. 6. London: Institute of Contemporary Arts.

—— (1989) 'Base and Superstructure in Raymond Williams', in Eagleton (ed.) *Raymond Williams: Critical Perspectives*. Cambridge: Polity Press.

Ewald, François (1989) 'L'individualisme, le grand retour', *magazine littéraire*. No. 264 (avril).

Finney, Brian (1986) 'Sexual Identity in Modern Autobiography', in Philip Dodd (ed.) *Modern Selves: Essays on Modern British and American Autobiography*. London: Frank Cass.

Fiske, John (1987) *Television Culture*. London: Methuen.

—— (1990) 'Ethnosemiotics: some personal and theoretical reflections', *Cultural Studies*, Vol. 4, No. 1, pp. 85–99.

Flax, Jane (1989) 'Postmodernism and Gender Relations in Feminist Theory', in M. R. Malson, J. F. O'Barr, S. Westphal-Wihl and M. Wyer (eds) *Feminist Theory in Practice and Process*. Chicago and London: University of Chicago Press.

Foucault, Michel (1966) *Les mots et les choses: une archéologie des sciences humaines*. Paris: Gallimard.

—— (1971) *L'ordre du discours*. Paris: Gallimard.

—— (1973) *The Order of Things*. New York: Vintage Books.

—— (1975) *I, Pierre Rivière, Having Slaughtered my Mother, My Sister and My Brother* Translated by Frank Jellinek. New York: Pantheon Books.

—— (1976) 'The Discourse on Language', in *The Archaeology of Knowledge*.

Translated by A.M. Sheridan Smith. New York and London: Harper Colophon Books.

—— (1977a) *Language, Counter-memory, Practice*, ed. Donald F. Bouchard. Translated by Bouchard and Sherry Simon. Ithaca: Cornell University Press.

—— (1977b) 'Nietzsche, Genealogy, History', in Donald Bouchard (ed.) *Language, Counter-memory, Practice*. Translated by Bouchard and Sherry Simon. Ithaca, NY: Cornell University Press.

—— (1977c) 'What is an Author?', in Donald F. Bouchard (ed.) *Language, Counter-memory, Practice*. Translated by Bouchard and Sherry Simon. Ithaca, NY: Cornell University Press.

—— (1979) *Discipline and Punish: The Birth of the Prison*. New York: Vintage Books.

—— (1980a) *The History of Sexuality, Vol. 1*. Translated by Robert Hurley. New York: Vintage Books.

—— (1980b) *Herculine Barbin: Being the Recently Discoverd Memoires of a Nineteenth-Century French Hermaphrodite*. Translated by Richard McDougall. Brighton: Harvester Press.

—— (1980c) *Power/Knowledge: Selected Interviews and other Writings, 1972–1977*, ed. Colin Gordon. New York: Pantheon Books.

—— (1981) 'Questions of Method', *I & C*, No. 8, pp. 3–14.

—— (1984a) 'The Subject and Power', in Brian Wallis (ed.) *Art After Modernism: Rethinking Representation*. New York: The New Museum of Contemporary Art, and Boston: David R. Godine.

—— (1984b) 'What is Enlightenment?', in Paul Rabinow (ed.) *The Foucault Reader*. New York: Pantheon Books.

—— (1985) 'Sexuality and Solitude', in Marshall Blonsky (ed.) *On Signs*. Baltimore: Johns Hopkins University Press.

—— (1986) *The Use of Pleasure. The History of Sexuality, Vol. 2*. Translated by Robert Hurley. New York: Vintage Books.

—— (1988a) 'Technologies of the Self', in Luther H. Martin, Huck Gutman and Patrick H. Hutton (eds) *Technologies of the Self*. Amherst: University of Massachusetts Press.

—— (1988b) *The Care of the Self. The History of Sexuality, Vol. 3*. Translated by Robert Hurley. New York: Vintage Books.

—— (1989a) *Resumé des cours: 1970–1982*. Paris: Julliard.

—— (1989b) *Foucault Live: Interviews, 1964–84*, ed. Sylvere Lotringer. Translated by John Johnston. New York: Semiotext(e) Foreign Agents Series.

Frank, Arthur W. (1990) 'Bringing Bodies Back in: A Decade in Review', *Theory, Culture & Society*. No.7, pp. 131–162.

Frank, Wattman, Francine, and Paula A. Treichler (1989) 'Introduction: Scholarship, Feminism, and Language Change', in Wattman and Treichler (eds) *Language, Gender, and Professional Writing*. New York: The Modern Language Association of America.

Freedman, Estelle B., Barbara C. Gelpi, Susan L. Johnson and Kathleen M. Weston (eds) (1985) *The Lesbian Issue: Essays from Signs*. Chicago: University of Chicago Press.

Friedman, Susan Stanford (1988) 'Women's Autobiographical Selves: Theory and Practice', in Shari Benstock (ed.) *The Private Self: Theory and Practice of Women's Autobiographical Writings*. Chapel Hill: University of North Carolina Press.

Fusco, Coco (1990) 'Managing the Other', in *Lusitania: A Journal of Reflection and Oceanography*. Vol.1, No.7, pp. 77–84.

Fuss, Diana (1989) *Essentially Speaking: Feminism, Nature and Difference*. London: Routledge.

—— (1991) *Inside/Out: Lesbian Theories, Gay Theories*. New York: Routledge.

Gallop, Jane (1988) *Thinking through the Body*. New York: Columbia University Press.

Gardiner, Judith Kegan (1981) 'On Female Identity and Writing by Women', *Critical Inquiry*. No. 8, pp. 347–361.

Geertz, Clifford (1973) *The Interpretation of Cultures*. New York: Basic Books.

— (1988) *Works and Lives: The Anthropologist as Author*. Stanford, CA: Stanford University Press.

Ginzberg, Carlo (1982) *The Cheese and the Worms*. Translated by John and Anne Tedeschi. Harmondsworth: Penguin Books.

Golding, Sue (1991) 'James Dean: The Almost-Perfect Lesbian Hermaphrodite', in Tessa Boffin and Jean Fraser (eds) *Stolen Glances: Lesbians Take Photographs*. London: Pandora.

Goldsby, Jackie (1991) 'What it Means to Be Coloured Me', in Tessa Boffin and Jean Fraser (eds) *Stolen Glances: Lesbians Take Photographs*. London: Pandora.

Green, Michael (1975) 'Raymond Williams and Cultural Studies', *Cultural Studies*. No. 6. Birmingham, pp. 31–48.

Grossberg, Lawrence (1975) 'Cultural Interpretation and Mass Communication', *Communication Research*. Vol. 4, No. 3.

—— (1987) 'The In-Difference of Television', *Screen*. Vol. 28, No. 2, pp. 28–46.

—— (1988a) *It's a Sin: Postmodernism, Politics and Culture*. Sydney: Power Publications.

—— (1988b) 'Putting the Pop back into Postmodernism', in Andrew Ross (ed.) *No Respect: Intellectuals and Popular Culture*. London: Routledge.

—— (1989) 'On the Road with Three Ethnographers', *Journal of Communication Inquiry*. Vol.13, No.2, pp. 23–26.

——, Cary Nelson and Paula Treichler (eds) (1992) *Cultural Studies*. London and New York: Routledge.

Grosz, Elizabeth A. (1989) *Sexual Subversions: Three French Feminists*. Sydney: Allen and Unwin.

—— (1991) 'Lesbian Fetishism?', *Differences*. Vol. 3, No. 2, pp. 39–54.

Grover, Jan Zita (1991) 'Framing the Questions: Positive Imaging and Scarcity in Lesbian Photographs', in Tessa Boffin and Jean Fraser (eds) *Stolen Glances: Lesbians Take Photographs*. London: Pandora.

—— (1992) 'AIDS, Keywords, and Cultural Work', in Lawrence Grossberg, Cary Nelson and Paula Treichler (eds) *Cultural Studies*. New York: Routledge.

Guillaumin, Colette (1978) 'Pratique du pouvoir et idée de Nature (2) Le discours de la Nature', *Questions féministes*. No.3, pp. 5–28.

Gunn, Janet Varner (1982) *Autobiography: Toward a Poetics of Experience*. Philadelphia: University of Pennsylvania Press.

Hall, Catherine (1985) 'Private Persons versus Public Someones: Class, Gender and Politics in England, 1780–1850', in Carolyn Steedman, Cathy Urwin and Valerie Walkerdine (eds) *Language, Gender and Childhood*. London: Routledge and Kegan Paul.

Hall, Stuart (1980) 'Cultural Studies: Two Paradigms', *Media, Culture and Society*. Vol. 2, pp. 57–72.

—— (1985) 'Signification, Representation, Ideology: Althusser and the Post-Structuralist Debates', *Critical Studies in Mass Communication*. Vol. 2, No.2, pp. 91–114.

—— (1986) 'On Postmodernism and Articulation: An Interview with Stuart Hall', ed. Lawrence Grossberg, *Journal of Communication Inquiry*. Vol. 10, No. 2, pp. 45–60.

—— (1987) 'Minimal Selves', *The Real Me: Postmodernism and the Question of Identity*. *ICA Documents*, No. 6. London: Institute of Contemporary Arts.

—— (1990) 'Cultural Identity and Diaspora', in Jonathan Rutherford (ed.) *Identity, Community, Culture, Difference*. London: Lawrence and Wishart.

Harding, Sandra (1986) 'The Instability of the Analytical Categories of Feminist Theory', in M. R. Malson, J. F. O'Barr, S. Westphal-Wihl and M. Wyer (eds) *Feminist Theory in Practice and Process*. Chicago and London: University of Chicago Press.

Heath, Stephen (1986) 'Joan Riviere and the Masquerade', in Victor Burgin, James Donald and Cora Kaplan (eds) *Formations of Fantasy*. London: Methuen.

Hebdige, Dick (1985) 'Some Sons and their Fathers: an Essay with Photographs', *Ten-8*, 17, pp. 30–9.

—— (1986) 'Postmodernism and "The Other Side"', *Journal of Communication Inquiry*. Vol. 10, No. 2, pp. 78–98.

—— (1987a) 'The Impossible Object: Towards a Sociology of the Sublime', *New Formations*. No. 1, pp. 47–76.

—— (1987b) 'Digging for Britain: An Excavation in 7 Parts', in *The British Edge*. Boston: The Institute for Contemporary Arts.

—— (1989) *Hiding in the Light: On Images and Things*. London: Comedia/Routledge.

Heilbrun, Carolyn G. (1986) 'Woman's Autobiographical Writings: New Forms', in Philip Dodd (ed.) *Modern Selves: Essays on Modern British and American Autobiography*. London: Frank Cass.

Henriques, Julien, *et al*. (1984) *Changing the Subject: Psychology, Social Regulation and Subjectivity*. London: Methuen.

Higgins, John (1986) 'Raymond Williams and the Problem of Ideology', in Jonathan Arac (ed.) *Postmodernism and Politics*. Minneapolis: University of Minnesota Press.

Hirsch, Marianne and Evelyn Fox Keller (1990) 'Conclusion: Practicing Conflict in Feminist Theory', in M. Hirsh and E. F. Keller (eds) *Conflicts in Feminism*. New York and London: Routledge.

Hoggart, Richard (1963) 'A Question of Tone: Some Problems in Autobiographical Writing', *Critical Quarterly*. Vol. 5, No. 1, pp. 73–90.

hooks, bell (1984) *Feminist Theory: from Margin to Center*. Boston: South End Press.

—— (1989) *Talking Back: Thinking Feminist, Thinking Black*. Boston: South End Press.

—— (1990) *Yearning: Race, Gender, and Cultural Politics*. Toronto: Between the Lines.

—— (1991) 'Narratives of Struggle', in Philomena Mariani (ed.) *Critical Fictions: The Politics of Imaginative Writing*. Seattle: Bay Press.

—— (1992) 'Representing Whiteness in the Black Imagination', in L. Grossberg, C. Nelson and P. A. Treichler (eds) *Cultural Studies: An Introduction*. New York and London: Routledge.

Huyssen, Andreas (1986) 'Mass Culture as Women: Modernism's Other', in Tania Modleski (ed.) *Studies in Entertainment: Critical Approaches to Mass Culture*. Bloomington and Indianapolis: Indiana University Press.

Jakobson, Roman (1972) 'Linguistics and Poetics', in Richard and Fernande DeGeorge (eds) *The Structuralists from Marx to Lévi-Strauss*. Garden City, NY: Doubleday.

Jardine, Alice (1985) *Gynesis: Configurations of Woman and Modernity*. Ithaca, NY: Cornell University Press.

—— (1988) 'In the Name of the Modern: Feminist Questions "d'après gynesis"', in Susan Sheridan (ed.) *Grafts: Feminist Cultural Criticism*. London: Verso.

—— and Paul Smith (eds) (1987) *Men in Feminism*. New York: Methuen.

Jardine, Lisa and Julia Swindells (1989) 'Homage to Orwell: the Dream of a Common Culture, and Other Minefields', in Terry Eagleton (ed.) *Raymond Williams: Critical Perspectives*. Cambridge: Polity Press.

Jelinek, Estelle C. (1986) *The Tradition of Women's Autobiography: From Antiquity to the Present*. Boston: Twayne Publishers.

Johnson, Richard (1979) 'Histories of Culture/Theories of Ideology', in Michèle Barrett *et al.* (eds) *Ideology and Cultural Production*. New York: St Martin's Press.

Juteau, Danielle and Nicole Laurin (1989) 'From Nuns to Surrogate Mothers: Evolution of the Forms of the Appropriation of Women', *Feminist Issues*. Vol.9, No.1, pp. 13–40; 206.

Keats, John (1977) *The Complete Poems*, ed.. John Barnard. Harmondsworth: Penguin Books.

Kennard, Jean E. (1981) 'Personally Speaking: Feminist Critics and the Community of Readers', *College English*. Vol. 43, No. 2, pp. 140–145.

—— (1986) 'Ourself behind Ourself: A Theory for Lesbian Readers', in Patrocinio P. Schweickart and Elizabeth A. Flynn (eds) *Gender and Reading: Essays on Readers, Texts, and Contexts*. Baltimore: Johns Hopkins University Press.

Kipnis, Laura (1986) '"Refunctioning" Reconsidered: Towards a Left Popular Culture', in Colin MacCabe (ed.) *High Theory/Low Culture: Analysing Popular Television and Film*. Manchester: Manchester University Press.

Kristeva, Julia (1986) *The Kristeva Reader*, ed. Toril Moi. Oxford: Basil Blackwell.

Kroker, Arthur and David Cook (1986) *The Postmodern Scene: Excremental Culture and Hyper-Aesthetics*. New York: St Martin's Press.

—— and Marilouise Kroker (1985) 'Feminism Now: Theory and Practice', *Canadian Journal of Social and Political Theory*. Vol. 9, Nos. 1–2.

Laurin, Nicole, Danielle Juteau and Lorraine Duchesne (1991) *A la recherche d'un monde oublié: Les communautés religieuses de femmes au Québec de 1900 à 1970*. Montreal: Le jour, Editeur.

Le Doeuff, Michèle (1979) 'Operative Philosophy: Simone de Beauvoir and Existentialism', *I&C*. No. 6, pp. 47–58.

—— (1981–82) 'Pierre Roussel's Chiasmas', *I&C*. No. 9, pp. 39–70.

—— (1989) *L'étude et le rouet*. Paris: Seuil.

Lipovetsky, Gilles (1983) *L'Ere du vide: essais sur l'individualisme contemporain*. Paris: Gallimard.

Lourde, Audre (1981) 'An Open Letter to Mary Daly', in Cherri Moraga and Gloria Anzaldua (eds) *This Bridge Called My Back: Writings by Radical Women of Color*. Watertown, MA: Persephone Press.

Lovell, Terry (1989) '"Knowable Pasts, Imaginable Futures"', *History Workshop Journal*. No. 27.

MacCabe, Colin (ed.) (1986) *High Theory/Low Culture: Analysing Popular Television and Film*. Manchester: Manchester University Press.

Malette, Louise and Marie Chaloux (eds) (1990) *Polytechnique, 6 décembre*. Montreal: Editions du remue-ménage.

Malson, Micheline R., Jean F. O'Barr, Sarah Westphal-Wihl and Mary Wyer (eds) (1989) *Feminist Theory in Practice and Process*. Chicago and London: University of Chicago Press.

Mani, Lata (1992) 'Cultural Theory, Colonial Texts: Reading Eyewitness Accounts of Widow Burning', in L. Grossberg, C. Nelson, and P. A. Treichler (eds) *Cultural Studies*. New York: Routledge.

Marcil-Lacoste, Louise (1982) 'Reason and Violence: Three Figures of their Relationships', *Canadian Journal of Political and Social Theory*. Vol.6, No.3 (Autumn), pp. 170–183.

Marcus, George E. and Michael M.J. Fisher (1986) *Anthropology as Cultural Critique*. Chicago: University of Chicago Press.

Marcus, Laura (1987) '"Enough About You, Let's Talk About Me: Recent Autobiographical Writing"', *New Formations*. No. 1, pp. 77–94.

Mariani, Philomena (1991) (ed.) *Critical Fictions: The Politics of Imaginative Writing.* Seattle: Bay Press.

Martin, Biddy (1988a) 'Lesbian Identity and Autobiographical Difference(s)', in Bella Brodzki and Celeste Schenck (eds) *Life/Lines: Theorizing Women's Autobiography.* Ithaca, NY: Cornell University Press.

—— (1988b) 'Feminism, Criticism, and Foucault', in Irene Diamond and Lee Quinby (eds) *Feminism and Foucault.* Boston: Northeastern University Press.

Martin, Luther H. (1988) 'Technologies of the Self and Self-Knowledge in the Syrian Thomas Tradition', in Luther H. Martin, Huck Gutman and Patrick H. Hutton (eds) *Technologies of the Self.* Amherst: University of Massachusetts Press.

Martin, Rux (1988) 'Truth, Power, Self: An Interview with Michel Foucault', in L.H. Martin, H. Gutman, P. H. Hutton (eds) *Technologies of the Self.* Amherst: University of Massachusetts Press.

Mason, Mary, G. (1980) 'The Other Voice: Autobiographies of Women Writers', in James Olney (ed.) *Autobiography: Essays Theoretical and Critical.* Princeton: Princeton University Press.

Mathieu, Nicole-Claude (1989) 'Identité sexuelle/sexuée/de sexe? Trois modes de conceptualisation du rapport entre sexe et genre', in A.-M. Daune-Richard, M.-C. Hurtig and M.-F. Pichevin (eds) *Catégorisation de sexe et constructions scientifiques.* Aix-en-Provence: Université d'Aix-en-Provence.

McRobbie, Angela (1980) 'Settling Accounts with Subcultures', *Screen Education.* No. 34, pp. 37–50.

—— (1982a) 'The Politics of Feminist Research: Between Talk, Text and Action', *Feminist Review.* Vol. 12, pp. 46–57.

—— (1982b) '*Jackie*: an Ideology of Adolescent Femininity', in Bernard Waites, Tony Bennett and Graham Martin (eds) *Popular Culture: Past and Present.* London: Croom Helm and The Open University Press.

—— (1985) 'Strategies of Vigilance: An Interview with Gayatri Chakravorti Spivak', *Block 10,* pp. 5–9.

—— (1988) 'Second-Hand Dresses and the Role of the Ragmarket', in Angela McRobbie (ed.) *Zoot Suits and Second-Hand Dresses: An Anthology of Fashion and Music.* Boston: Unwin Hyman.

Mercer, Kobena (1987) 'Black Hair/Style Politics', *New Formations.* No. 3, pp. 33–54.

—— and Issac Julian (1988) 'Race, Sexual Politics and Black Masculinity: A Dossier', in Rowena Chapman and Jonathan Rutherford (eds) *Male Order: Unwrapping Masculinity.* London: Lawrence and Wishart.

Miller, Nancy K. (1991) *Getting Personal: Feminist Occasions and Other Autobiographical Acts.* New York: Routledge.

Millett, Kate (1970) *Sexual Politics.* New York: Avon Books.

Minh-ha, Trinh T. (1989) *Women, Native, Other: Writing Postcoloniality and Feminism.* Bloomington and Indianapolis: Indiana University Press.

Modleski, Tania (1983) 'The Rhythms of Reception: Daytime Television and Women's Work', in E. Ann Kaplan (ed.) *Regarding Television: Critical Approaches – An Anthology.* American Film Institute Monograph Series. Los Angeles: University Publications of America, Vol.2.

—— (1986) 'Feminity as Mas(s)querade: a Feminist Approach to Mass Culture', in Colin MacCabe (ed.) *High Theory/Low Culture: Analysing Popular Television and Film.* Manchester: Manchester University Press.

—— (1991) *Feminism Without Women: Culture and Criticism in a 'Postfeminist' Age.* New York and London: Routledge.

Moraga, Cherri and Gloria Anzaldua (eds) (1981) *This Bridge Called My Back: Writings by Radical Women of Color.* Watertown, MA.: Persephone Press.

Morris, Meaghan (1982) 'A Review of Michel Foucault's *La Volonté de Savoir*', in Mike Brake (ed.) *Human Sexual Relations: Towards a Redefinition of Sexual Politics*. New York: Pantheon Books.

—— (1988a) *The Pirate's Fiancée: Feminism, Reading Postmodernism*. London: Verso.

—— (1988b) 'Banality in Cultural Studies', *Discourse* X. 2, pp. 3–29; 76–101.

Mort, Frank (1988) 'Boy's Own? Masculinity, Style and Popular Culture', in Rowena Chapman and Jonathan Rutherford (eds) *Male Order: Unwrapping Masculinity*. London: Lawrence and Wishart.

Mulvey, Laura (1975) 'Visual Pleasure and Narrative Cinema', *Screen*. Vol. 16, No. 3, pp. 6–18.

Nicholson, Linda J. (ed.) (1990) *Feminism/Postmodernism*. New York: Routledge.

O'Connor, Alan (1989) *Raymond Williams: Writing, Culture, Politics*. Oxford: Basil Blackwell.

Olney, James (1972) *Metaphors of the Self*. Princeton: Princeton University Press.

—— (1980) 'Some Versions of Memory/Some Versions of "Bios": The Ontology of Autobiography', in Olney (ed.) *Autobiography: Essays Theoretical and Critical*. Princeton: Princeton University Press.

Owens, Craig (1983) 'The Discourse of Others: Feminists and Postmodernism', in Hal Foster (ed.) *The Anti-Aesthetic: Essays on Postmodern Culture*. Port Townsend, WA: Bay Press.

—— (1987) 'Outlaws: Gay Men in Feminism', in Alice Jardine and Paul Smith (eds) *Men in Feminism*. New York: Methuen.

Parmar, Pratibha (1990) 'Black Feminism: the Politics of Articulation', in Jonathan Rutherford (ed.) *Identity: Community, Culture, Difference*. London: Lawrence and Wishart.

Poster, Mark (1989) 'Foucault, le présent et l'histoire', in *Michel Foucault, philosophe*. Paris: Seuil.

Pratt, Mary Louise (1986) 'Fieldwork in Common Places', in James Clifford and George E. Marcus (eds) *Writing Culture: The Poetics and Politics of Ethnography*. Berkeley: University of California Press.

Probyn, Elspeth (1987) 'The Anorexic Body', in Arthur and Marilouise Kroker (eds) *Body Invaders: Panic Sex in America*. Toronto: Oxford University Press.

—— (1990) 'Travels in the Postmodern: Making Sense of the Local', in Linda J. Nicholson (ed.) *Feminism/Postmodernism*. New York: Routledge.

—— (1991a) 'Ghosts in the (Missing) Text', in Marisia Lewandowska (ed.) *The Missing Text*. London: Chance Books.

—— (1991b) 'This Body Which Is Not One: Speaking an Embodied Self', *Hypatia*. Vol. 6, No. 3, pp. 111–124.

—— (1992) 'Technologizing the Self: A Future Anterior in Cultural Studies', in Lawrence Grossberg, Cary Nelson and Paula Treichler (eds) *Cultural Studies*. London and New York: Routledge.

—— (1993a) 'Choosing Choice; "Winking" Images of Sexuality in Popular Culture', in Kathy Davis and Sue Fisher (eds) *Negotiating in the Margins*. New Brunswick, NJ: Rutgers University Press.

—— (1993b) 'TV's *unheimlich* Home', in Brian Massumi (ed.) *The Politics of Everyday Fear*. Minneapolis: University of Minnesota Press.

Rabinow, Paul (1977) *Reflections on Fieldwork in Morocco*. Berkeley: University of California Press.

—— (1983) 'Humanism as Nihilism: The Bracketing of Truth and Seriousness in American Cultural Anthropology', in Norma Haan, Robert N. Bellah, Paul Rabinow and William M. Sullivan (eds) *Social Science as Moral Inquiry*. New York: Columbia University Press.

—— (1986) 'Representations are Social Facts: Modernity and Post-Modernity in

Anthropology', in James Clifford and George E. Marcus (eds) *Writing Culture*. Berkeley: University of California Press.

Radway, Janice (1984) *Reading the Romance: Women, Patriarchy, and Popular Literature*. Chapel Hill: University of North Carolina Press.

—— (1988a) 'Reception Study: Ethnography and the Problems of Dispersed Audiences and Nomadic Subjects', *Cultural Studies*. Vol. 2, No. 3, pp. 359–367.

—— (1988b) 'The Book-of-the-Month Club and the General Reader: On the Uses of "Serious" Fiction', *Critical Inquiry*. Vol. 14.

—— (1989) 'Ethnography Among Elites: Comparing Discourses of Power', *Journal of Communication Inquiry*. Vol.13, No. 2. pp. 3–11.

Renaut, Alain (1989) *L'Ere de l'individu*. Paris: Gallimard.

Rich, Adrienne (1981) 'Compulsory Heterosexuality and Lesbian Existence', *Signs*. No. 5, pp. 631–660.

—— (1986) 'Notes toward a Politics of Location', in *Blood, Bread, and Poetry*. New York: W.W. Norton.

Rivière, Joan (1986) 'Womanliness as a Masquerade' (1929), in Victor Burgin, James Donald and Cora Kaplan (eds) *Formations of Fantasy*. London: Methuen.

Robinson, Sally (1989) 'Misappropriations of the "Feminine", in *SubStance*. No. 59, pp. 48–70.

Rose, Jacqueline (1987a) 'The State of the Subject (II): The Institution of Feminism', *Critical Quarterly*. Vol. 29, No. 4, pp. 8–15.

—— (1987b) 'The Man Who Mistook his Wife for a Hat', ICA Documents. No. 6. London: Institute of Contemporary Arts.

Rowbotham, Sheila (1985) 'Revolt in Roundhay', in Liz Heron (ed.) *Truth, Dare or Promise: Girls Growing Up in the Fifties*. London: Virago.

Rutherford, Jonathan (ed.) (1990) *Identity, Community, Culture, Difference*. London: Lawrence and Wishart.

Ruthven, K. K. (1990) *Feminist Literary Studies*. Cambridge: Cambridge University Press.

Said, Edward (1979) *Orientalism*. New York: Vintage Books.

Samuel, Raphael (1989) '"Philosophy Teaching by Example": Past and Present in Raymond Williams', *History Workshop Journal*. No. 27, pp. 141–153.

Sawicki, Jana (1991) *Disciplining Foucault: Feminism, Power and the Body*. New York: Routledge.

Schmid, Wilhelm (1989) 'Foucault: la forme de l'individu', *magazine litteraire*. No. 264 (avril), pp. 54–56.

Schweickart, Patrocinio P. (1986) 'Reading Ourselves: Toward a Feminist Theory of Reading', in Schweickart and Elizabeth A. Flynn (eds) *Gender and Reading. Essays on Reader, Texts and Contexts*. Baltimore: Johns Hopkins University Press.

Sedgwick, Eve Kosofsky (1990) *Epistemology of the Closet*. Berkeley and Los Angeles: University of California Press.

Segrest, Mab (1985) *My Mama's Dead Squirrel: Lesbian Essays on Southern Culture*. Ithaca, NY: Firebrand Books.

Sheridan, Alan (1980) *Foucault: The Will to Truth*. London: Tavistock.

Showalter, Elaine (1986) 'Shooting the Rapids'. *Oxford Literary Review*, pp. 218–224.

—— (1987a) 'Women's Time, Women's Space: Writing the History of Feminist Criticism', in Shari Benstock (ed.) *Feminist Issues in Literary Scholarship*. Bloomington: Indiana University Press.

—— (1987b) 'Critical Cross-Dressing: Male Feminists and the Woman of the Year', in Alice Jardine and Paul Smith (eds) *Men in Feminism*. New York: Methuen.

Silverstone, Roger (1989a) 'Let Us Then Return to the Murmuring of Everyday Practices: A Note on Michel de Certeau, Television and Everyday Life', *Theory, Culture & Society*. Vol. 6, pp. 77–94.

—— (1989b) *'Let us Then Return to the Murmuring of Everyday Practices*: a Note on Michel de Certeau, Television and Everyday Life', paper presented at the International Communications Association Annual Conference, San Francisco, May.

Simon, Sherry (1991) 'Espaces incertains de la culture', in Sherry Simon, Pierre l'Hérault, Robert Schwartzwald and Alexis Nouss (eds) *Fictions de l'identitaire au Québec*. Montreal: XYZ Editeur.

Slack, Jennifer Daryl and Laurie Anne Whitt (1992) 'Ethics and Cultural Studies', in L. Grossberg, C. Nelson and P. A. Treichler (eds) *Cultural Studies*. New York and London: Routledge.

Smith, Dorothy E. (1987) *The Everyday World as Problematic: A Feminist Sociology*. Toronto: University of Toronto Press.

Smith, Paul (1987) 'Men in Feminism: Men and Feminist Theory', in Alice Jardine and Paul Smith (eds) *Men in Feminism*. New York: Methuen.

—— (1988) *Discerning the Subject*. Minneapolis: University of Minnesota Press.

Smith, Sidonie (1987) *A Poetics of Women's Autobiography: Marginality and the Fictions of Self-Representation*. Bloomington: Indiana University Press.

Smith, Valerie (1989) 'Black Feminist Theory and the Representation of the "Other"', in Cheryl A. Wall (ed.) *Changing Our Own Words: Essays on Criticism, Theory, and Writing by Black Women*. New Brunswick, NJ: Rutgers University Press.

Sommer, Doris (1988) '"Not Just a Personal Story": Women's *Testimonios* and the Plural Self', in Bella Brodzki and Celeste Schneck (eds) *Life/Lines: Theorizing Women's Autobiography*. Ithaca, NY: Cornell University Press.

Spelman, Elisabeth V. (1990) *Inessential Woman: Problems of Exclusion in Feminist Thought*. London: The Women's Press.

Spivak, Gayatri Chakravorty (1986) 'Imperialism and Sexual Difference'. *Oxford Literary Review*. Vol. 8, Nos 1–2, pp. 225–240.

—— (1987) *In Other Worlds: Essays in Cultural Politics*. New York: Methuen.

—— (1988) 'Can the Subaltern Speak?', in Cary Nelson and Lawrence Grossberg (eds) *Marxism and the Interpretation of Culture*. Urbana: University of Illinois Press.

—— (1990) *The Post-Colonial Critic: Interviews, Strategies, Dialogues*, ed. Sarah Harasym. London: Routledge.

Steedman, Carolyn (1985) 'Landscape for a Good Woman', in Liz Heron (ed.) *Truth, Dare or Promise: Girls Growing Up in the Fifties*. London: Virago.

—— (1987) *Landscape for a Good Woman: A Story of Two Lives*. New Brunswick, NJ: Rutgers University Press.

—— (1988) *The Radical Soldier's Tale*. London: Routledge.

——, Cathy Unwin and Valerie Walkerdine (1985) *Language, Gender and Childhood*. London: Routledge and Kegan Paul.

Stuart, Andrea (1990) 'Feminism: Dead or Alive?' in Jonathan Rutherford (ed.) *Identity, Community, Culture, Difference*. London: Lawrence and Wishart.

Szekely, Eva (1988) *Never Too Thin*. Toronto: The Women's Press.

Tillman, Lynne (1991) 'Critical Fiction/Critical Self', in Philomena Mariani (ed.) *Critical Fictions: The Politics of Imaginative Writing*. Seattle: Bay Press.

Toynbee, Arnold (1934–61) *A Study of History*, 12 vols. London: Oxford University Press.

Udovitch, Mim (1992) '1991: Believe it or Not', *The Village Voice* (January 7, 1992).

Valaskakis, Gail Guthrie (1988) 'The Chippewa and the "Other": Living the Heritage of Lac du Flambeau', *Cultural Studies*. Vol. 2, No. 3, pp. 267–293.

Vernant, Jean-Pierre (1989) *L'Individu, la mort, l'amour*. Paris: Gallimard.

Walkerdine, Valerie (1984) 'Developmental Psychology and Child-Centred Peda-

gogy: the Insertion of Piaget into Early Education', in Julien Henriques *et al. Changing the Subject: Psychology Social Regulation and Subjectivity.* London: Methuen.

—— (1985) 'Dreams from an Ordinary Childhood', in Liz Heron (ed.) *Truth, Dare or Promise: Girls Growing Up in the Fifties.* London: Virago.

—— (1986) 'Video Replay: Families, Films and Fantasy', in Victor Burgin, James Donald and Cora Kaplan (eds) *Formations of Fantasy.* London: Methuen.

Wall, Cheryl A. (1989) (ed.) *Changing Our Own Words: Essays on Criticism, Theory, and Writing by Black Women.* New Brunswick, NJ: Rutgers University Press.

Wallace, Michele (1990) *Invisibility Blues: From Pop to Theory.* London: Verso.

—— (1991) 'Conference Presentation', in Philomena Mariani (ed.) *Critical Fictions.* Seattle: Bay Press.

—— (1992) 'Negative Images: Towards a Black Feminist Cultural Criticism', in Lawrence Grossberg, Cary Nelson and Paula Treichler (eds) *Cultural Studies.* London and New York: Routledge.

Wandor, Michelene (1990) *Once a Feminist: Stories of a Generation. Interviews by Michelene Wandor.* London: Virago.

Weeks, Jeffrey (1991) *Against Nature: Essays on History, Sexuality and Identity.* London: Rivers Oram Press.

White, Hayden (1978) *Tropics of Discourse: Essays in Cultural Criticism.* Baltimore: Johns Hopkins University Press.

Williams, Raymond (1954) (with Michael Orrom) *Preface to Film.* London: Film Drama.

—— (1961) *The Long Revolution.* Westport, CT: Greenwood Press.

—— (1977) *Marxism and Literature.* London: Oxford University Press.

—— (1979) *Politics and Letters.* London: Verso.

—— (1980) 'The Welsh Industrial Novel', in *Problems in Materialism and Culture.* London: Verso.

—— (1983) *The Year 2000.* New York: Pantheon Books.

—— (1989a) *Critical Perspectives*, ed. Terry Eagleton. Cambridge: Polity Press.

—— (1989b) *Resources of Hope: Culture, Democracy, Socialism*, ed. Robin Gable. London and New York: Verso.

—— (1989c) *What I Came to Say*, ed. N. Belton, F. Mulhern and J. Taylor. London: Hutchinson Radius.

Williamson, Judith (1985) 'The Making of a Material Girl', *New Socialist* (October), pp. 46–47.

Willis, Susan (1989) 'I Shop Therefore I Am: Is There a Place for Afro-American Culture in Commodity Culture?', in Cheryl A. Wall (ed.) *Changing Our Own Words: Essays on Criticism, Theory, and Writing by Black Women.* New Brunswick, NJ: Rutgers University Press.

Winterson, Jeanette (1989) *Sexing the Cherry.* London: Bloomsbury; Vintage Paperback; page references are to the Vintage edition.

Wittig, Monique (1980) 'La pensée straight', in *Questions féministes.* No.7 (février), pp. 45–51.

—— (1990) 'The Straight Mind', in R. Ferguson, M. Gever, T.T. Minh-ha and C. West (eds) *Out There: Marginalization and Contemporary Cultures.* New York: The New Museum of Contemporary Art.

Women's Studies Group, Centre for Contemporary Cultural Studies (1978) *Women Take Issue: Aspects of Women's Subordination.* London: Hutchinson and the Centre for Contemporary Cultural Studies, University of Birmingham.

Young, Robert (1990) *White Mythologies: Writing History and the West.* London: Routledge.

Index